# The Art of Time, The Art of Place

This book is dedicated to the memory of my beloved parents,
who encouraged me throughout their lives to keep on learning.

In memory of my father, the late Herman Fischer,
with his artist's soul
In memory of my mother, the late Hannah Lea Fischer,
whose love was boundless

In memory of all the members of my extended family
who perished in the Holocaust, whose memory and world,
I hope, is somewhat preserved through this work.

RUTH DOROT

# The Art of Time, The Art of Place

## Isaac Bashevis Singer and Marc Chagall — A Dialogue

Translated from the Hebrew by Micaela Ziv
Edited by Nili Laufert

**sussex**
ACADEMIC
PRESS
*Brighton • Portland • Toronto*

2 4 6 8 10 9 7 5 3 1

*First published 2011 in Great Britain by*
SUSSEX ACADEMIC PRESS
PO Box 139
Eastbourne BN24 9BP

*and in the United States of America by*
SUSSEX ACADEMIC PRESS
920 NE 58th Avenue, Suite 300
Portland, Oregon 97213-3786

*and in Canada by*
SUSSEX ACADEMIC PRESS (CANADA)
90 Arnold Avenue, Thornhill, Ontario L4J 1B5

This book is based on the thesis written by Ruth Dorot for her Ph.D.:
"Jewish Themes and their Structural Configurations in the Works of
Isaac Bashevis-Singer and Marc Chagall – a Comparative Study",
Bar Ilan University, Ramat Gan, Israel, December 2004.

*British Library Cataloguing in Publication Data*
A CIP catalogue record for this book is available from the British Library.

*Library of Congress Cataloging-in-Publication Data*
Dorot, Ruth.
  The art of time, the art of place : Isaac Bashevis Singer and Marc Chagall :
a dialogue / Ruth Dorot.
      p.    cm.
  Includes bibliographical references and index.
  ISBN 978-1-84519-409-3 (h/c : alk. paper)
  1. Singer, Isaac Bashevis, 1904–1991—Criticism and interpretation.
  2. Chagall, Marc, 1887–1985—Criticism and interpretation. I. Title.
PJ5129.S49Z6413 2011
  839'.133—dc22

                                                    2010042820

Typeset and designed by Sussex Academic Press, Brighton & Eastbourne.
Printed by TJ International, Padstow, Cornwall.
This book is printed on acid-free paper.

# Contents

*List of Illustrations and Acknowledgements*

Introduction     1

Chapter One     **The Jewish Experience**     12
   "The Old Man"     15
   *The Cattle Dealer*     18
   **Comparative Analysis**: "The Old Man" and *The Cattle Dealer*     20
   "The Little Shoemakers"     23
   *Vitebsk, The Blue House*     27
   *Vitebsk, The Gray House*     29
   Houses Speak     31
   **Comparative Analysis**: "The Little Shoemakers" and *Vitebsk, The Blue House*     33

Chapter Two     **Jewish Artists and Their Works**     38
   *The Magician of Lublin*     40
   *Self-portrait with Seven Fingers*     47
   **Comparative Analysis**: *The Magician of Lublin* and *Self-portrait with Seven Fingers*     50

Chapter Three     **Love and Lovers**     54
   "Sam Palka and David Vishkover"     57
   *Lovers over the Town*     59
   **Comparative Analysis**: "Sam Palka and David Vishkover" and *Lovers over the Town*     61
   *Shosha*     64
   *Between Darkness and Light*     67
   **Comparative Analysis**: *Shosha* and *Between Darkness and Light*     68

Chapter Four     **The Holocaust (*Shoah*) and War**     71
   *Enemies, A Love Story*     73
   *The Falling Angel*     76
   **Comparative Analysis**: *Enemies, A Love Story* and *The Falling Angel*     79

Chapter Five     **Religion and Mysticism**     83
   *The Slave*     86
   The Stained-glass Windows at the Hadassah Medical Centre, Jerusalem     91
   **Comparative Analysis**: *The Slave* and The Stained-glass Windows     104

*Bibliography and Index*

# List of Illustrations

The author and publisher gratefully acknowledge the following for permission to reproduce copyright material.

## Cover Illustrations

*Front*: Marc Chagall painting Bella in the Studio, 1934. Getty Images/Roger Viollet. Isaac Bashevis-Singer, courtesy of the Harry Ransom Humanities Research Center, The University of Texas at Austin.

*Back*: Marc Chagall, *La maison bleue* (The Blue House), 1917. Oil on canvas (97 × 66 cm). Musée des Beaux Arts, Liège, © ADAGP, Paris and DACS, London 2009. Photo: akg-images / Erich Lessing. Isaac Bashevis-Singer, *Passions* book cover, handwritten letter, courtesy of the Harry Ransom Humanities Research Center, The University of Texas at Austin.

## Plates

1. *The Cattle Dealer*, Marc Chagall, 1912, oil on canvas (200 × 96 cm), Kunsthalle, Basel. Photo Scala, Florence © ADAGP, Paris and DACS, London 2009.
2. *La maison bleue* (The Blue House), Marc Chagall, 1917. Oil on canvas (97 × 66 cm). Musée des Beaux Arts, Liège, © ADAGP, Paris and DACS, London 2009.
3. A photograph of Vitebsk. Private Collection.
4. *La maison grise* (The Gray House), Marc Chagall, 1917, oil on canvas (74 × 68 cm). Thyssen-Bornemisza Museum, Madrid, BI, ADAGP, Paris/Scala, Florence © ADAGP, Paris and DACS, London 2009.
5. *Village Street*, Marc Chagall, 1909 (38 × 28.8 cm). Corbis/Araldo de Luca © ADAGP, Paris and DACS, London 2009.
6. *Etude pour 'La Pluie'*, Marc Chagall, 1911, pencil and gouache (31 × 23.7 cm). Galerie Tretiakov, Moscow © ADAGP, Paris and DACS, London 2009.
7. *Vitebsk*, Marc Chagall, *c.*1914, gouache and Indian ink (24.8 × 19.2 cm). Private Collection, © ADAGP, Paris and DACS, London 2009.
8. *Remembrance* (Souvenir), Marc Chagall, 1914, pencil and gouache (31.8 × 22.2 cm). Corbis/Araldo de Luca © ADAGP, Paris and DACS, London 2009.
9. *My Village*, Marc Chagall, 1923–1924, gouache (62 × 49 cm). Collection Catz, Milwaukee, © ADAGP, Paris and DACS, London 2009.

10 *Autoportrait aux sept doigts* (Self-portrait with Seven Fingers), Marc Chagall, 1912, oil on canvas (128 × 107 cm). Stedelijk Museum, Amsterdam, BI, ADAGP, Paris/Scala, Florence © ADAGP, Paris and DACS, London 2009.

11 *Á la Russie, aux ânes et aux autres* (To Russia, Asses and Others), Marc Chagall, 1911, oil on canvas (157 × 122 cm). Musée National d'Art Moderne – Centre Pompidou, Paris, BI, ADAGP, Paris/Scala, Florence © ADAGP, Paris and DACS, London 2009.

12 A photograph of Chagall painting Bella in the Studio 1934. Getty Images/Roger Viollet.

13 *Lovers over the Town* (Over the Town), Marc Chagall, 1914–1918, oil on canvas (198 × 141 cm). © ADAGP, Paris and DACS, London 2009.

14 *Entre chien et loup* (Between Dog and Wolf; also indexed as *Between Darkness and Light* (Twilight)), Marc Chagall, 1938–1943, oil on canvas (100 × 73 cm). Private Collection, BI, ADAGP, Paris/Scala, Florence © ADAGP, Paris and DACS, London 2009.

15 *La chute de l'ange Allegorie representant la perte de l'ange de son statut divin* (The Falling Angel), Marc Chagall, 1923–1933–1947, oil on canvas (189 × 148 cm). Musée des Beaux-Arts, Basel; White Images/Scala, Florence © ADAGP, Paris and DACS, London 2009.

16 Jerusalem Hadassah Medical Centre, stained glass windows from the twelve tribes of Israel by Marc Chagall © ADAGP, Paris and DACS, London 2009.

17 Jerusalem Hadassah Medical Centre, stained glass window of Reuben from the twelve tribes of Israel by Marc Chagall. Sonia Halliday Photographs © ADAGP, Paris and DACS, London 2009.

18 Jerusalem Hadassah Medical Centre, stained glass window of Judah from the twelve tribes of Israel by Marc Chagall. Sonia Halliday Photographs © ADAGP, Paris and DACS, London 2009.

19 Jerusalem Hadassah Medical Centre, stained glass window of Joseph from the twelve tribes of Israel by Marc Chagall. Sonia Halliday Photographs © ADAGP, Paris and DACS, London 2009.

The publishers apologize for any errors or omissions in the above list and would be grateful to be notified of any corrections that should be incorporated in the next edition or reprint of this book.

# Acknowledgements

**To Prof. M. L. Mendelson – Bar Ilan University and the University Center Ariel, in the Shomron**
For his enlightening comments along the winding paths of my writing,
For revealing to me the secrets of art in all their beauty,
For helping me find the balance between the spiritual and the practical,
For teaching me to look at a work of art and discover its magic,
For the uniquely original teaching methods he passed on to me so that I might pass the magic on to others. Thank you!

**To Prof. Hillel Barzel – Bar Ilan University**
Who has so generously accompanied me with his great wisdom and wealth of knowledge.
For his fascinating teaching style, through which I learnt that literature is a very special mixture of precision and emotion, structure and 'soul', Thank you!

**To Prof. Dov Landau – Bar Ilan University**
For his infinite patience, his support and belief in me, and most of all, for his open-mindedness towards the concept of reciprocity between literature and art. Thank you!

**To Micaela Ziv**
Who put her heart and soul into translating both the words and the spirit of the original Hebrew text. Thank you!

**To Rafi and Nili Laufert – the dearest of friends**
Who have accompanied the production of this book with endless love and dedication, which shine on and through every line of the book with heart and spirit.

**To Nili**
Whose dedication cannot be defined, for it defies description,
Whose devotion and contribution know no boundaries,
Whose infinite energy created the motivation for all involved,
For orchestrating and conducting the birth of this book. Thank you!

**Last but not least – to my beloved family**
My husband, Moshe, and especially to my son Tzvika, whose contribution was worth its weight in gold! This book would not have been published without his technical input. To both of them for their ongoing support – a heartfelt thanks!

*". . . Art seems to me to be above all a state of soul."*

Marc Chagall

"The very essence of literature is the war
between emotion and intellect . . ."

Isaac Bashevis-Singer

# Introduction

Two artists are compared in this book – both Jews – who are among the most prominent creative talents of the twentieth century: the magician-storyteller, Isaac Bashevis-Singer (1904–1991) and the creator of visual magic, Marc Chagall (1887–1985). Bashevis-Singer's fiction and Chagall's creations are poems in prose and painting. The art of writer and painter are naturally distinct, but contextually the works of both display similarities: both artists share a common spiritual source, the Jewish culture and tradition of their birthplace in Eastern Europe of the late nineteenth century (Chagall) and early twentieth century (Bashevis-Singer). Bashevis-Singer revealed in an interview:

> Well, I'm not as religious as my parents were. From the religious point of view, you can say I'm assimilated but from a cultural point of view, I'm not. I stay with my people. My Jewishness is not something of which I'm ashamed but the very opposite. I'm proud of it. I keep accentuating all the time that I am a Jew. I write about Jews. I write in Jewish languages. I began to write in Hebrew.[1]

The subjects of Chagall's art are also to be found, to a large extent, within the Jewish world, in his own past and in the conceptual world of the Jewish family as he himself testified: "Were I not a Jew, I would not have become an artist . . ."[2]

The comparison focuses on historical and biographical circumstances, and connections in content, form and aesthetics, in order to shed light on the similarities and differences in their works.[3]

Bashevis-Singer was born in Poland into an ultra-Orthodox family. His father was a rigidly pious rabbi and his mother, too, obeyed the religious commandments devoutly. Theirs was a strict home, devoid of luxury but one that was rich in *Hassidic* ambience, filled with traditional legends. The house served as a religious court where matters of marriage and divorce and other routine legal issues were adjudicated. From his father, Bashevis-Singer absorbed the mystical *Hassidic* ambience immersed in legends, while from his mother he learnt the rationalist approach of the *Misnagdim*, the opponents of the *Hassidic* movement. This wonderful mixture infused his literary soul and influenced his life throughout his childhood and youth. His home background is clearly described in his well-known story, "Why the Geese Shrieked", in the collection *In My Father's Court*.[4] A Jewish woman rushes to the house of the narrator's father in a panic. She is holding a slaughtered goose in each hand, both already decapitated and disembowelled, but when she throws the geese on top of each other, they continue to shriek. The mother, who comes from a family of *Misnagdim*, claims that slaughtered geese do not shriek. However, the woman tosses the geese several times, and miraculously a sound is heard each time. The household offers two conflicting tendencies: the mother seeks a logical solution,

while the father tends to believe in what has just occurred – a more supernatural explanation. In the end it is logic that triumphs. With surgical precision she rips the windpipes from the geese's necks and they stop shrieking. The story ends with the declaration: "Your mother takes after your grandfather, the rabbi of Bilgoray. He is a great scholar but a cold-blooded rationalist. People warned me before our betrothal" (ibid., p. 16).

For most observant Jews in Poland at that time, Yiddish was the language spoken at home and in the community. Yiddish, with its rich linguistic nuances, its puns and colourful and melodic sayings, was Bashevis-Singer's mother tongue.[5] However, it was probably even more than that for him. It was a language that ran through his veins and shaped his literary work, a language from which he drew his imagery and his spiritual wealth. This was also the reason why Yiddish continued to be the language he wrote in till the day he died. It was only after he was completely satisfied with the original work that he allowed it to be translated into English, and very often worked with the translator or did some of the translation himself.

While *In My Father's Court* is not an autobiography, it does reflect the atmosphere in which the young Bashevis-Singer grew up while living on Krochmalna Street in Warsaw: mysticism, *Hassidism* and heartfelt joy tempered by rationalism. He absorbed the *Torah*, Jewish learning, its stories and legends, its myths and commandments, and a great many features of life in a Jewish neighbourhood.

Marc Chagall was born into an Orthodox Jewish home, though not a rabbinical one. His father was a poor, hard-working fishmonger and his mother was the mainstay of the home. His birthplace was Vitebsk in what was then White Russia, where the *Hassidic* movement had already been well established since the end of the eighteenth century, shortly after its foundation by Rabbi Israel Baal Shem-Tov.

The *Hassidic* movement incorporated elements of mysticism and the *Kabbalah*, and in this respect lies in contrast to the intellectual approach of the *Talmud*. *Hassidism* encourages an intuitive relationship with the Creator and devotion to Him – made possible by freeing oneself from sadness – and promotes universal love towards all beings. Chagall absorbed the *Hassidic* atmosphere of happiness, passion, dance, ecstasy and enthusiastic joy, and expressed them in his work. For Chagall, mysticism was far more than a path of artistic expression. He considered himself a mystic and expressed this notion explicitly:

> Mystic! How many times have they hurled this word in my face,
> just as formerly they have scolded me for being 'literary'. But
> without mysticism would a single great painting be created? . . . It
> is precisely the lack of mysticism that almost destroyed France.[6]

The similar Jewish cultural soil in which the two artists grew and blossomed are clearly evident in their work. In colour and word, both depict the vibrant life in the *shtetl*[7] (the Jewish village) and the Jewish ghetto. Their depictions of the landscape of their childhood, adolescence and adulthood are largely retrospective; events are described in softer colours, with a nostalgic tinge, especially by Chagall.

Another feature the two have in common is their ties to Western culture. In their descriptions of Jewish life in the *shtetl* – 'from fasts to feasts' – and sometimes also of the non-Jews, Chagall and Bashevis-Singer offered a glimpse of the art and culture

of the Western world. The double influence of Jewish themes and general culture affected the content of Singer's writings and in Chagall's case the style more than the content.

Bashevis-Singer, so thoroughly immersed in the Jewish world, was less influenced by modern styles than was Chagall, but his works, nevertheless, contain philosophical, psychological and theological aspects as well as elements associated with all manner of science, medicine, law, writing and art from around the world. Secular knowledge had a great influence on Bashevis-Singer at the outset of his career. His brother, Joshua Singer, himself a well-known writer, was a kind of intellectual mentor to him and influenced him in this respect. Modern Hebrew literature and the political atmosphere of the turn of the century were part of the climate in which Bashevis-Singer lived. He made frequent visits to the 'artists' studio' where his brother Joshua spent time. It was there, probably for the first time, that he was exposed to secular circles whose thinking and behaviour differed greatly from the atmosphere in which he had grown up at home. When he started writing, Bashevis-Singer was also influenced by the lyric prose of Norwegian Nobel Prize winner Knut Hamsun, whose semi-autobiographical book, *Hunger*, published in 1890, described his decline into a state of almost complete insanity following a life of poverty and starvation. He received worldwide acclaim for this highly influential book.

Jewish author and playwright David Bergelson was another influence. It is quite likely that Bergelson's influence derived from the similarities in their personal background. Born in the Ukraine, Bergelson also grew up in a *Hassidic* household but besides his *Torah* education, he benefited from a more universal education.

Yet another writer who influenced Bashevis-Singer was Edgar Allen Poe. Like Poe, who wrote about the fantastic – about visions and events evolving out of the power of one's imagination – Bashevis Singer's works possess a unique blend of Realism mixed with Metarealism. This feature of his writing would accompany him throughout his career. Bashevis-Singer himself pointed this out:

> And a fiction writer must see to it that there shouldn't be any flaws, that the story should sound as probable and real as it can sound, even though it is a mystical story, even if it is a story about the supernatural because even the supernatural has to be embedded in real life.[8]

Isaac Bashevis-Singer's close friendship with author, poet and playwright Aaron Zeitlin was to affect his writings most profoundly. Through Zeitlin, he came ever closer to the world of the supernatural. The metaphysical, the secret of the Creation of the universe; demons, 'white mysticism' dealing with the occult, the *Kabbalah* and its mysterious symbols were part of that world. Isaac Bashevis-Singer wrote the Preface to Zeitlin's book dealing with facts and events from the realm of the fantastic – *Hametziut Ha'acheret* (*The Other Reality*).[9]

Bashevis-Singer considered this to be *the* book of morality of our time, one that guides psychology research in the right direction. In his preface, he admits the strong influence of Zeitlin and his book on his own literary path:

> I would like to add a personal note here. My literary path could have been quite different had I not been fortunate enough to meet Aaron Zeitlin. I see this meeting and the friendship that developed between us as Divine Intervention. In many ways he directed my literary orientation and helped me become what I am. *The Other Reality* was my guiding light even before he had put it to paper. It constitutes the underlying premise for the literary works of both of us.[10]

Although a Yiddish writer in his very soul, Singer's reputation and acclaim belong to his works in English in the United States. Had he kept writing only for the Yiddish newspaper, the *Forward*, he would quite likely not have become the most important Jewish writer to wave a magic wand and use charmed words to describe the life of bygone years in Eastern Europe. His books were adapted to an American readership, and from English were then translated into other languages. Thus, no matter how important the source language – in this case Yiddish with all the richness of its imagery[11] – English was the key to Bashevis-Singer's success: "More than any Yiddish writer in his time, Bashevis-Singer thrived on translation: it was his ship-ticket to success."[12]

English could also be considered a source language, since the author involved himself in the translation of his works from Yiddish into English. A first-hand explanation of his work methods in both languages is provided by his son, Israel Zamir, who wrote the following in the preface to the book *The Key*:

> Father writes in Yiddish but insists that his books be translated from English. This is the reason he gives: 'When my story lies before me in the English translation it is bare, as it were. I read it again and suddenly I notice all its drawbacks and flaws which the Yiddish, because of its wealth and descriptive language, has succeeded in hiding from me. Now I go back to the story and correct it.'[13]

The problem of translation is discussed in a paper by Itamar Even-Zohar and Chone Shmeruk, who claim that Bashevis-Singer was of the opinion that Yiddish was an appropriate vehicle for describing the past but did not lend itself naturally to describing the present. This is perhaps why he preferred his stories to be published in English.[14] The Yiddish language with its rich variety of nuances was of fundamental importance to both Chagall and Bashevis-Singer. Clearly its significance was more profound for the latter, since language was his medium. But both mentioned in their autobiographies[15] how important Yiddish was for them and how it was imprinted in their works.

Like Bashevis-Singer, Chagall was exposed to a broad variety of influences. The effect of Russian-Slavic art known as Lobok is evident in his works, as is Russian iconic art and Byzantine art. In his youth, he studied at the Zvanseva Art School which was considered quite modern in its day and directed by artist Leon Bakst. Here, for the first time, he came into contact with aspects of modern art. In 1906–1907 he studied with Jewish artist Yehuda Pen and then moved to St. Petersburg. In 1910, Chagall travelled to Paris for the first time and got to know the

artists, their works, and the Parisian spirit of Modernism. He encountered the schools of Impressionism, Fauvism and Cubism, and then 'translated' them through his own personal filter so they would express his dreams, Jewish humour, Jewish life and Jewish sayings. In the process, he created his unique Chagall mixture. He lived through the stormiest years of twentieth-century art and there was hardly any new artistic current he was not exposed to. The turn-of-the-century approaches he had absorbed at the beginning of his career were followed by Dadaism and Surrealism. He also witnessed the growth of the Russian avant-garde movements of Constructivism and Suprematism, as well as the latest Abstract Expressionism and Pop Art in America. From all of these he adopted the artistic values that suited him and helped him formulate his own exceptionally original style.

Despite the storms and battles, Chagall decided that there was one special value to which he would always adhere. This was human love, a value that characterised his personal style.[16] Chagall expresses the profound meaning of the value of love in the following statement: "In our life there is a single colour, as on an artist's palette, which provides the meaning of life and art. It is the colour of love" (*My Life*).[17]

An interesting point of comparison between the two artists is their depiction of themselves in their own works, at times precisely as they were, at others only through hints or with modifications but, nevertheless, retaining a resemblance to their real selves. However, perhaps the most surprising similarity between them is the way they combine reality with imagination and fantasy, which naturally leads them to Metarealism. Chagall's point of origin is realistic in terms of the basic subject he chooses to depict: the Sabbath, walking to the market, the village, characteristic Jewish figures, etc. These are then enhanced by his fertile imagination, which leads to the world beyond the real. Bashevis-Singer, even more than Chagall, describes a real situation and mentions actual place names, dates and historical events, to which he then adds imagined elements that add dimensions of the supernatural. Consequently, the theory of Metarealism described below can be applied to the works of both artists. This is a theory which focuses on the physical world as well as the metaphysical dimension with its ties to mysticism and the world of the occult, juxtaposing reality and fantasy. Each artist has his own links to both worlds. In his book of conversations, poet André Verdet says:

> They've called you a painter of the unreal and a painter of the surreal and a painter of the super-natural . . . Now I think you said . . . that your painting isn't realistic, but that its roots are deep in the concrete world.[18]

Like Chagall's, Bashevis-Singer's world was close to the realm of the transcendental – a world imbued with *Kabbalistic* undertones.

> In his world *Kabbalah* was one component in a 'soup of mystical philosophies', as he put it. Despite the clear attraction to the world of the *Kabbalah*, there is a partition of pessimistic rationalism, separating the writer from that world . . . A thematic perspective one can clearly perceive is Bashevis-Singer's use of the *Kabbalistic* notion of 'the descent into the realm of the husks' that's intended to raise the

sparks of holiness which had fallen into the depths of darkness during the shattering of the vessels, as described in the *Kabbalah* of Rabbi Yitzhak Lurie.[19]

The many points of connection – their proximity in time and space, their similar cultural backgrounds, their deep ties to the Eastern European Jewish *shtetl*, the Yiddish language and later to the Jewish culture of Western Europe and the United States – make a comparison between Marc Chagall and Isaac Bashevis-Singer an obviously worthwhile undertaking. This book presents a comparative examination of major Jewish motifs in their works. As far as is known, the two were not personally acquainted, so any connection found between them will be neither personal nor conscious.[20]

It is important to remember that Chagall was on intimate terms with the world of literature and with the written word. Besides his autobiography, which he wrote in Russian and illustrated, he wrote poems in Yiddish, which he illustrated as well; he also illustrated books, including Gogol's *Dead Souls* and La Fontaine's *Fables*. The poems deal with many of the topics that provided motifs for his paintings, and even evoked his dream-like, poetic and associative way of thinking. Furthermore, Chagall was close to the world of ballet and theatre, for which he created scenery, as for the Yiddish theatre, for example. Both of these art forms consist of an intimate combination of the written word with the visual world.

Bashevis-Singer, on the other hand, was on intimate terms with the visual world. His many short stories and novels possess a plastic, visual dimension. His precise, detailed descriptions and the way he manages to breathe life into his texts lend his works such a dimension, akin to the world of painting. Bashevis-Singer even testified that as a child: "I also loved to draw – horses, houses, dogs."[21] In one of his stories dealing with painting, entitled "The Captive",[22] he even mentions Chagall.

Many books have been written on the connection between literature and painting from different perspectives.[23]

> People who value and cherish more than one of the arts often draw comparisons between them but none of these comparisons has had the same important history as the comparison between painting and poetry, which are often referred to as 'sister' arts.[24]

The reciprocity, closeness and mutual influence between the various arts are highly fascinating to anyone interested in this field in general, and to the arts researcher in particular. These connections expand one's horizons and in-depth understanding; they shed light on certain phenomena in each field. Among the better-known connections is literature and the other arts, and in particular, poetry and painting.

One often encounters an artist who deals with more than one of the arts: a painter who writes – Marc Chagall; a musician who paints – Paul Klee; a sculptor who is a painter, architect and writer – Michaelangelo. Artists create their works within a certain ambience, a certain milieu. It is thus not surprising to find some fundamental elements or reciprocal influences in the different arts. The most natural bonds would seem to be those occurring in the same or proximal geographic locations during a given period. The *Zeitgeist*, the topics and influences from outside the

world of literature and art, will be evident in both the artists and their works. Even though unity between the arts is highly dialectic and movement flows between attachment and detachment: the unification between the arts and the aspiration towards isolation and prominence of each on its own:

> . . . perhaps a fertile tension of unity and division between the arts? On the one hand, the conventional historical separation: a theater critic is neither a music critic, an art critic, nor a dance critic. Along the same vein, the audience usually differs from one medium to another. For the most part, the space for each medium usually has its own definition – gallery, museum, theater, concert hall . . . But on the other hand, there are contradictions – a concert held in a museum, singers on a Tel Aviv museum rooftop . . . The Pompidou Centre in Paris serves all forms of art and is a model for other museums around the world . . . We say dialectics, a two-faced, paradoxical truth.[25]

The philosopher Martin Buber taught us that a flourishing culture unites the arts, and a withering culture divides them. The book does not enter into theoretical comparisons but into a concrete analysis of a given text and a given picture – art versus art. "Two artists, two works one next to the other so as to observe the similar and the different."[26]

The theory of Metarealism will be the second 'tool' by means of which the comparison will be analysed. Hillel Barzel, in his *Metarealistic Hebrew Prose,*[27] describes the features of this approach in twentieth-century literature, with Kafka and Camus providing the best examples. In Hebrew literature Agnon is without a doubt the greatest metarealistic author, one who greatly influenced all subsequent Hebrew writers. There are, of course, various shades and varieties of Metarealism and of the literature it influenced. The term '*metarealistic*' has its origins in a term coined by Felix Welch in his *Franz Kafka: Religiosity and Humor in His Life and Works.* There he uses the term '*Metamaterialism*' to denote Kafka's observation of the material world.

Hillel Barzel writes about the physical and the metaphysical and shows that a metarealistic work observes both worlds simultaneously. It deals both with earthly reality and *at the same time* with the transcendental. This style of writing has recognisable features, which can appear in a number of variations and can be divided into four major categories, each of which can be divided into sub-categories:

A.  Extreme inventiveness and imagination combined with a strict adherence to facts and reality
B.  A link to a metaphysical sphere
C.  Symbolic and allegorical elements
D.  Inscrutability

## A.  Extreme inventiveness and imagination combined with a strict adherence to fact and reality

"Metarealistic fiction makes a claim of credibility for itself on the basis of facts."[28] Kafka, for instance, provides the names of the streets or the cities where his heroes

live. He makes no particular effort to hide the fact that the novel *The Trial* takes place in Prague or that the story "America" takes place in the United States.

1. The story itself is extremely far-fetched but adheres to facts such as dates, place names and events.
2. The story is constructed logically and events follow one another in logical sequence.
3. The author uses various devices for introducing variety into his imaginary, fictional account, such as instant transfer from one place to another, abolition of the boundaries between animals and human beings or between animals and plants.

### B.  A link to a metaphysical sphere

Metarealistic works have a 'second facet', i.e. they possess a hidden meaning. The hidden facet beneath the surface is connected to the infinite. It may deal with the present but it relates to eternity. To use Nietzsche's comment on tragedy, it reveals "the present – from the perspective of the eternal."[29]

1. The physical and the metaphysical coexist side by side.
2. The metaphysical appears as a hidden layer, which needs to be exposed and with which the overt layer maintains a constant dialogue.

### C.  Symbolic and allegorical elements

Metarealistic stories are based on a duality consisting of what the text itself says and the hidden meaning located outside the story. This is very different, for example, from Heidegger's view that a work of art is 'one thing'.

1. Various devices are used to link the overt elements of the story to the hidden elements outside it, such as:
   a) Synecdoche – a figure of speech where a part stands for the whole, e.g. 'bread' instead of 'food'
   b) Archetypal links
   c) Conventional symbolism
   d) Private symbolism
   e) Symbol-centric patterns – a literary or artistic pattern focusing on the use of symbols.
2. At the heart of the story a strange or wondrous figure may appear.

### D.  Inscrutability

At the end of a metarealistic work the reader is left feeling mystified. As Bertrand Russell's close friend Alfred Whitehead defines it, sensory perception leading to full awareness means complete knowledge, whereas sensory perception leading to an awareness of symbols means partial knowledge.

1. Works in which the emphasis is on symbolism leave the reader uncertain with respect to all possible solutions. Works in which the emphasis is on allegory let the reader feel quite certain at the end of reading and interpretation that all secrets have been understood. The reason for this is that a

symbolic composition is not purposely constructed by the author as a puzzle, whereas an allegorical work is constructed with the use of 'camouflage stratagems' known to the author. Works which contain a mixture of symbolic and allegorical elements are the hardest for readers and even for literary experts to interpret.

2. Although a work of art can possess many different facets, it must contain one which is clear enough for the reader to understand and identify.

The metarealistic element in the works of Bashevis-Singer and Marc Chagall seems natural to them. An illustration of the penetration of the transcendental and the world of the occult into the real world is given through Singer's friendship with poet Aaron Zeitlin.[30]

The same element has been aptly characterised by his son Israel Zamir:

> Something of the typical things said by my father, the writer Isaac Bashevis-Singer, when we used to walk down the avenue, scatter seeds and discuss his creed in which the upper and lower worlds were glued and sealed together inseparably. His legs walked in the twentieth century but his ears heard the hidden voices of all manner of demons, spirits, devils and angels from the past, many of which he took and wove into his many stories.[31]

Chagall's lyrical visions enabled him to perceive the universe as metaphorical, mysterious and magical. Chagall compared his soul to something lighter than a flame, lighter than a shadow. There are images in his works in which everything merges, in which the spiritual world blends with the material world. As for Chagall himself when asked, for example, why he painted seven fingers in his self-portrait Chagall replied: ". . . to make fantastic elements appear beside realistic elements."[32]

Metarealistic works are by nature enigmatic and the reader/observer will retain some feeling of mystery even at the end of reading or observation. This comparison adds a new layer of interpretation and understanding and thus helps to attain a more profound appreciation of the works in question.

# Notes

1   See: Richard Burgin, *Conversations with Isaac Bashevis-Singer*, Doubleday & Company Inc., Garden City, N.Y., 1985, p. 60.

2   See: Marc Chagall, "Leaves from My Notebook", The Vitebsk Listok (leaflet), 1918, No. 1030.

3   A number of the visual and literary works of both artists often appear in different chapters, since they are presented from different perspectives. For example: the novel *Shosha* is discussed in the chapter on love and also in the chapter on the Holocaust and war.

4   See: Isaac Bashevis-Singer, *In My Father's Court*, Farrar, Straus and Giroux, New York, 1962.

5   The quotations from Isaac Bashevis – Singer are taken from the English except for when there are differences between the Hebrew and the English versions: but when interpreting the works, I refer to English, Yiddish or Hebrew as necessary.

6   See: Charles Sorlier (ed.), *Chagall by Chagall*, Harry Abrams, N.Y., 1979, p. 12.

7   Benjamin Harshav, *Marc Chagall and the Lost Jewish World*, Rizzoli, N.Y., 2006, p. 12: "The distinction between three categories: city, town (*shtetl*), and village reflected demographic and ethnic differences and must not be confused." In the book I will use *shtetl* and 'village' interchangeably whenever I refer to an area in a town or village with a predominantly Jewish population.

8   See: "Isaac Bashevis-Singer on literature and life." An interview with Paul Rosenblatt and Gene Koppel, University of Arizona Press, Tucson, Arizona, 1979, p. 10.

9   Aaron Zeitlin, *The Other Reality*, Preface: Isaac Bashevis-Singer, Translation: David Faience, Yavneh, Tel Aviv, 1966.

10  Ibid., p. 12.

11  Seth L. Wolitz discusses this question in the preface to a book of articles he edited dealing with the works of Bashevis-Singer in Yiddish: *The Hidden I.B.S.*, University of Texas Press, Austin, 2001, p. xxvii.

12  See: Irving Saposnik, "A Canticle for Isaac: a Kaddish for Bashevis", in: *The Hidden I.B.S.*, University of Texas Press, Austin, 2001, p. 4.

13  Israel Zamir, in the preface to *The Key*, Isaac Bashevis-Singer, Translation: Israel Zamir, Sifriat Poalim, Tel Aviv, 1990.

14  Itamar Even-Zohar & Chone Shmeruk, "Authentic language: Hebrew and Yiddish", *The Literature 30–31*, 1981, p. 85.

15  Isaac Bashevis-Singer, *Lost in America*, Translation: Z. Arad, Tel Aviv, 1984. Marc Chagall, *My Life*, Orion Press, N.Y. 1960.

16  Benjamin Harshav deals with this particular combination in Chagall's work in his article: "The role of language in modern art on texts and subtexts in Chagall's paintings," *Modernism / modernity*, Vol. 1, Issue 2, Johns Hopkins University Press, 1994, pp. 51–87: "At first, Russian Neo-Primitivism, the Russian reception of the famous, and the 'world of art' decorative style, then Cubism and Suprematism. In its sources, Chagall's art represents cultural and stylistic eclecticism", p. 84.

17  Marc Chagall, *My Life*, Orion Press, N.Y., 1960, p. 25.

18  See: André Verdet, *Chagall's World – Conversations with André Verdet*, The Dial Press, Garden City, N.Y., 1984, p. 21: "They've called you a painter of the unreal and a painter of the surreal and a painter of the super-natural . . . Now I think you said . . . that your painting isn't realistic, but that its roots are deep in the concrete world."

19  Bilha Rubinstein, *The Concealed Beyond the Revealed – Kabbalist* infrastructure in the works of Yehoshua Bar-Yosef and Isaac Bashevis-Singer, Hakibbutz Hameuchad, Tel Aviv, 1994, p. 181.

20  After research and my personal conversations with people close to Chagall and Bashevis-Singer, it turned out that there is no information of any acquaintanceship or meeting between the two. I spoke with Bashevis-Singer's son, author Israel Zamir, who is also unaware of any such connection. I also spoke with the late Yiddish poet Abraham Sutzkever, who was a close friend of Chagall, and likewise there is no evidence that Chagall ever met or knew Bashevis-Singer in person. The same conclusion emerges from a conversation with the late Prof. Yosef Bar-El, head of the Yiddish Chair at Bar Ilan University, who knew Bashevis-Singer personally.

21  Isaac Bashevis-Singer, *A Day of Pleasure*, Translation: Israel Zamir, Adam Publications, Tel Aviv, 1985.

22  Isaac Bashevis-Singer, *I.B.S. Collected Stories: A Friend of Kafka to Passions*, The Library of America, N.Y., 2004, p. 308.

23  See: W.J.T. Mitchell (ed.), *The Language of Images*, The University of Chicago Press, Chicago and London, 1985.
    Ronald Paulson, *Book and Painting: Shakespeare, Milton and the Bible*: Literary Texts and the Emergence of English Painting, Knoxville, Tenn., 1980.
    Ronald Paulson, *Literary Landscape: Turner and Constable*, New Haven: Yale University Press, 1982.
    Mario Praz, *The Romantic Agony*, Oxford University Press, 1934.
    Mario Praz, *Mnemosyne – The Parallel between Literature and the Visual Arts*, Oxford University Press, London, 1980.
    Robert Rosenblum and W. H. Janson, *Art of the 19th Century*, London and N.Y., 1984.
    Murray Roston, *Renaissance Perspectives in Literature and the Visual Arts*, Princeton University, 1987.
    Murray Roston, *Changing Perspectives in Literature and the Visual Arts*, London: Princeton University Press, London, 1990.
    Elizabeth A. Schultz, *Unpainted to the Last, Moby Dick and Twentieth-Century American Art*, University Press of Kansas, 1995.
    P. Seghers (ed.), *L'Art de la Peinture*, Seghers, Paris, 1957.
    Wylie Sypher, *Four Stages of Renaissance Style* (Transformations in Art and Literature 1400–1700), Doubleday & Company Inc., N.Y., 1955.
    Wylie Sypher, *Rococo to Cubism in Art and Literature*, Random House, N.Y., 1960.
    René Wellek and Austin Warren, *Theory of Literature*, Harcourt Brace, N.Y., 1956.
    Ephraim Gothold Lessing, Laocon, Sifriat Poalim and the Hakibbutz Hameuchad, Tel Aviv, 1983.

24  See: Jean Hagstrum, *The Sister Arts*, University of Chicago, Chicago, 1974, p. 13.

25  Gideon Ofrat, *The Artistic Medium*, Stavit, Tel Aviv: 1986, p. 6.

26 Hillel Barzel, *Ways to a New Interpretation*, Bar Ilan Publications, Ramat Gan: 1990, p. 280.

27 Hillel Barzel, *Metarealistic Hebrew Prose*, Sifriat Makor, Israel Association of Hebrew Writers, Masada Publications, Ramat Gan, 1974.

28 Ibid., p. 12.

29 Ibid., p. 16.

30 Aaron Zeitlin, whom Isaac Bashevis-Singer considered an authority on the subject of occultism and the transcendental, addresses in his book *The Other Reality* the issue of occultism: "It very often happens that the same person who completely scorns all occult phenomena suddenly remembers something that happened to him that he cannot explain. I know from my experience, that there is hardly anyone who has not had such an experience in his life . . . is interested in forgetting the whole thing and in hiding it away in the archives of forgotten experiences . . . Someone who does not want to remember, immediately forgets again and draws no conclusion from the facts. People have a name for such facts: 'one of those things' meaning that they don't deserve one's attention." Aaron Zeitlin, *The Other Reality*, Yavneh, Tel Aviv, 1966, p. 10.

31 Israel Zamir, in the preface to *The Key*, Isaac Bashevis-Singer, Translation: Israel Zamir, Sifriat Poalim, Tel Aviv, 1990.

32 Aleksander Kamensky, *Chagall – The Russian Years 1907-1922*, Thames & Hudson Ltd., London, 1989, p. 135.

Chapter **ONE**

# The Jewish Experience

One of the most prominent motifs in the works of Bashevis-Singer[1] and Chagall is the Jewish *shtetl*. Both artists describe everyday life and holidays, the ordinary towns-folk and the more eccentric ones. For the most part, they portray the world through hindsight, examining past reality through a prism of lyric nostalgia, longing and, on occasion, particularly in the case of Bashevis-Singer, sharp criticism.

*Shtetl* life is a theme in many of Bashevis-Singer's novels and short stories, though his attitude towards it is somewhat ambiguous. He can be positive, directly or indirectly critical, or express his love and longing for this old world. This ambiguity renders his descriptions both complex and multilayered.

Bashevis-Singer's family home served as a rabbinical court for issues of marriage, divorce, dietary laws (*kashrut*) matters of faith and business dispute resolutions.[2] There were discussions about the relationship between man and his Creator as well as between man and his fellow man. These inevitably revolved around the topics of charity, forces of evil, laughter and tears and are treated in his works with a mixture of realism, humour and criticism. When dealing with insoluble problems, his deliberations are often presented somewhat tongue-in-cheek, almost as if from a child's viewpoint, while on other occasions he presents them from the broad and loving perspective of an adult.

In *The Magician of Lublin* the viewpoint is particularly complex. Sometimes the novelist's descriptions suggest identification and compassion, as in the case of Yasha Mazur, who feels the excitement of brotherhood in the synagogue after a lengthy period of neither attending synagogue nor donning phylacteries (*tefillin*). A similar attitude can be seen in the portrayal of Esther, his wife, a symbol of the chaste, loyal Jewish wife.

In *Enemies, A Love Story*, although the plot takes place in America after World War II, the author raises the spirit of the Jewish village through Yadwiga, the Gentile who miraculously adopts the Jewish lifestyle she grew up in as a maid in the home of Herman's parents before the war.

Krochmalna is a name of a street, a typical one, in the Jewish quarter in Warsaw, which figures prominently in the novel *Shosha*, where it is described through the eyes of an adult who recalls different periods of time – at first when he and Shosha were children, and later as a young man returning to his childhood sweetheart. Krochmalna, where Yiddish rather than Polish is heard, is enveloped in the aromas (barley and *borscht*) emanating from Shosha's mother's kitchen and offers not just visual scenes but also the entire experience of the pre-war lifestyle.

The approach towards the *shtetl* in *The Family Moskat* is also complex. This novel of broader scope describes Jewish life both in a small town and in the big city of

Warsaw, with the arrival of the protagonist, Ozer Heschel. Bashevis-Singer manages to invoke the entire spectrum of village life – its wealthy, its poor, the *Hassidim* and the *Misnagdim*, the power struggles and the vibrant mosaic of community life.

The short story "The Son from America"[3] exemplifies the author's love and empathy. He views this world through emotion-filled eyes, offering a warm, picturesque and realistic description of Lentshin, a place that has remained unchanged for generations. Everything is just as it was – with all its naïveté, honesty, faith and contentment with the little one has. Shmuel, the son, who returns from America after a very long absence, intending to contribute to his parents and to the community, quickly discovers that there is no need – for everyone is happy just as they are; his parents have not touched the money he sent them over the years and the town has no bank, as there is no need for one. Lentshin has no thieves; telegrams are not a particularly pressing need and are delivered too late, if at all. They don't even need an old-age home because everybody already "has a place". Bashevis-Singer chooses to emphasise the beauty of this innocence and simplicity as he lovingly shows his images of this micro-world frozen in time. Conversely, it is progress, symbolised by the son who returns from America, that is shown in a less positive light. He hints at the notion that since Shmuel has so distanced himself from the Jewish way of life, there will be no one to carry on the beautiful existence of the old world.

Another very empathetic and poetic portrayal of the Jewish village can be found in "The Little Shoemakers",[4] where Bashevis-Singer carefully describes the home in which a dynasty of shoemakers has lived for countless generations, as an integral part of the hustle and bustle of traditional Jewish community life.

Channah Basha, heroine of "Sam Palka and David Vishkover",[5] preserves the old lifestyle in her new homeland. When walking into her home in Brownsville, New York, one can smell the Old World and feel its characteristic naïveté, simplicity and kindness.

In what is perhaps his best known story, "Gimpel the Fool",[6] the Jewish villagers are described with greater sobriety. Bashevis-Singer is highly critical of the community, its leaders and rabbis. He reveals their wickedness and foolishness and how poorly they treat those who are different or unusual. The story has several layers and multiple meanings – on the one hand, the apparent concern for Gimpel, the unusually strange orphan, and for Elka, to whom the community is trying to marry him off – and on the other hand, the cruelty underlying this seemingly worthy intention, since everyone knows the truth about Elka's immoral behaviour. A vibrant life seemingly still in existence is described here, even though it is a reality long gone.[7]

Portrayals of religious and secular life in the *shtetl* abound in Chagall's works, too. His treatment of this theme parallels the development of his personal artistic style. At first his approach was mainly realistic – a descriptive and sometimes mildly critical documentation that later on became symbolic and more expressive as a result of the Parisian influence of Modernism. In the final phases of his career he became more forgiving, while revealing a sense of nostalgia and yearning.

Chagall conveys an almost realistic sense of daily life with a hint of criticism in *The Dead Man* (1908), a relatively early painting. A man lies dead in the middle of the street, surrounded by six burning candles, while people carry on with their daily routines: someone is sweeping the street, a fiddler is playing on a roof and another

is disappearing into an alley. It is only the woman crying out with arms raised that relates to the atmosphere of death.

There is similar treatment in the sketch, *View of Vitebsk* (1908), in which Chagall realistically portrays the crowded, lopsided small houses of the Jewish part of Vitebsk with the spires of the local church figuring in the background. In *The Window* (1908), Chagall paints a similar image as seen through an open window; though more colourful and lively, the realistic approach still allows the village to be easily identified.

After his first visit to Paris in 1910, Chagall paints a series of Jewish figures – simple folk or rabbis. His portrayals testify to his spiritual identification, sprinkled with humour and criticism. One of these is *The Father* (1910), who might represent Chagall's own father. The artist paints this Jew with great sensitivity, a figure that is fragile and vulnerable, influenced by the harsh reality of his exhausting daily routine, yet wrapped in a dream, immersed in his thoughts and yearning for the spiritual. These effects are obtained through the picture's expressive, colourful distortion, especially in the man's eyes.

*A Jew Sniffing Tobacco* (1923–1924) shows a typical Orthodox village Jew in traditional garb, sidelocks and beard. His setting is somewhat sanctified – between a cloth curtain covering the Holy Ark in the background (*parochet*) and a prayer book or some other sacred text. Chagall distorts colours and shapes to convey an expression of gravitas and concentration but also of humour, with just a hint of criticism as to how the man relates to the tobacco sniffing.

A whole sector of working Jews is represented in *The Newspaper Vendor* (1944). The vendor's face is deeply wrinkled, with two dark patches at the corners of his mouth. He looks sorrowful and dissatisfied. The road and town are dark and the background sky is crimson red. The contrast of colours accentuates the tragic nature of the scene. The stark facial expression reflects his hard life and projects a sense of misery.

One of Chagall's better-known works, *Solitude* (1933), presents the Jew against the backdrop of the town. It portrays an individual in a melancholic atmosphere who represents a type as well. On the left side of the painting the Jew is seated on the ground in a mournful, lamenting position with his back to the town. A thunderous, gloomy sky hovers over his head. He is weighed down, wrapped up in his own narrow little world, cloaked in his white prayer shawl, in deep reflection about the tragedies Europe is accosted by, with only a *Torah* scroll clutched to his heart. Parallel to him on the right side of the painting is a cow with similar colouring. Next to the cow lies a violin. In this picture, Chagall presents the Jew as one who has perhaps chosen to live in isolation as a way of life, for he disregards the angel above by whom he could be saved, ignoring the cow representing a female figure and music that could uplift his spirits.

The Eternal, Wandering Jew, the '*luft mentsch*', with his disproportionate presence, a beggar's sack on his back, cap on his head, walking stick in his hand, soaring above the houses of Vitebsk, is moving in the opposite direction to the church which dominates the composition, in the renowned painting *Over Vitebsk* (1914). This is an individual but at the same time an archetypal figure symbolic of Jewish pain and detachment, of sombre memories, of someone constantly on the move but spiritually far above and beyond his hopeless and alienating reality, as most of him floats

in an airy, lyrical sky. He is heavy but weightless and so by virtue of the hovering, the Jew is able to rise above the material reality. This is a case of victory over gravity.

*The Green Fiddler* (1923) illustrates the lyricism and experience of the Jew who, this time through music, is elevated above a cold, geometric reality. The Jewish musician plays highly emotive folk music that expresses his inner spiritual world. Unlike the prosaic, mundane work that is down-to-earth, where his feet are firmly planted, his head is up in soft puffs of clouds, with the muse above him. His face expresses concentration, carried away by the music on the wings of imagination into the spheres of the unreal.

Over the years, Vitebsk appears in many versions in oil paintings, sketches and gouache colours as a nostalgic memory and perhaps Chagall's deepest mental resource. In a speech he made on February 15, 1944 titled "To My City, Vitebsk", on the occasion of the liberation of Vitebsk from German occupation, Chagall referred to its 'status' in his heart by saying: "I did not have one single painting that did not breathe with your spirit and reflection."[8]

*Red Roofs* (1958), in which Chagall simultaneously connects and separates his worlds where the common unifying source is his town of Vitebsk, is an obvious example of how the painter refers to his village. It appears in a broad red band through the middle of the composition with his new world – Paris – on one side and Vitebsk in the snow on the other. Chagall describes himself as a young man in love with his bride, who is part of himself; as an Orthodox Jew fleeing the *pogroms* while clasping a *Torah* scroll; and as a painter returning to the place of his birth. His entire being, his roots and his motifs all stem from his village, the crowded, lopsided village he portrays so expressively. Religion, spirituality, love and art also stem from this place to which he returns as a famous artist in order to bow down to it in deepest respect and appreciation. In this picture, as in so many others, Chagall combines simplicity and sophistication. He manages to weave an original and harmonious fabric linking the various planes, making him the "genius of simplicity"[9] as the poet Abraham Sutzkever called him.

## "The Old Man"

"The Old Man"[10] is a short story describing a journey of both physical and symbolic survival for Reb Moshe Ber, an exceptional old man who undergoes almost intolerable trials and tribulations. Singer tells of the old man's wanderings, his unbearable experiences of intense cold and unrelieved hunger, his survival, and his triumph against all odds. It is a complicated and wondrous life story described meticulously with chiselled precision. The realistic style of writing enables the author to present a mercilessly accurate description of the old man and his son, Chaim Sachar, and through them of the conditions of poverty and deprivation of the Jews in Poland during World War I. The descriptive Realism Bashevis-Singer uses is well illustrated in his depiction of the old man with ugly and repulsive details:

> Although his eyes were a murky blue, like the eyes of a blind man,
>     he needed no glasses, still retained some of his teeth, yellow and

> crooked as rusty nails and awoke each day on the side on which he
> had fallen asleep. (Ibid., p. 113)

His illness and the vicissitudes he and his son experience are also presented in all their stark reality. It is a critically satirical Realism that paints a picture of an extremely irrational situation. Nevertheless, this is not just realistic but also symbolic, and representative of the burdened Jew who prevails and triumphs both physically and spiritually. It is the Diaspora Jew of both the *shtetl* and the big city: "... a story in which the real and unreal coexist, juxtaposed, in perfect harmony."[11] This work embraces the metaphysical world as much as it does the physical one: "The concept does not displace the real, but places it close to the upper sphere."[12] Alongside the description of the old man's troublesome life due to his deteriorating physical condition, as he lies groaning in his bed for two whole days with no one coming to his aid, the author discreetly interjects his realistic and harsh criticism of Jewish society, which abandons the old man to his woes. With this down-to-earth account, there is also the story of the upper sphere:

> At night he heard scratching noises as though a cat were trying to
> climb the walls; a hollow roar seemed to come repeatedly from
> underground ... he thought he saw the door open suddenly,
> admitting a horse with a black sheet on its back. It had a head as
> long as a donkey's and innumerable eyes. The old man knew at
> once that this was the Angel of Death. (Ibid., p. 115)

Then, when the old man thinks he is being taken to his funeral, he remembers the verse he must recite to the angel Duma: "What man is he that liveth and shall not see death? Shall he deliver his soul from the grave?" (Psalm 89:49) According to tradition, in order to be saved one must recite the verse that begins and ends with the letters of the dying person's name.

To enable this miraculous survival and to render the story credible and coherent, the double miracle to come is foreshadowed throughout the plot: Reb Ber's physical survival to the age of 100 years and his becoming a father at that age. Right at the start, walking through the streets of Warsaw, the old man says: "... and speak of Hungary, where more than seventy years before, he had lived in his first father-in-law's house" (ibid., p. 113). Thus, the author makes the reader fully aware that the plot will include the miracle of a second marriage. Elsewhere, when the old man thinks he is lying in the hearse: "He was sure this was his hearse and it worried him that he had no heirs to say the mourner's prayer *(Kaddish)* and that, therefore, the peace of his grave would be disturbed" (ibid., p. 116). This is a hint about the birth of his second son at the end. (Chaim, the son mentioned earlier, is dead.) A logical sequence of events is maintained. The old man's behaviour is consistent; he recovers from his illness and sets out on his way, on foot, across war-torn Europe, in order to reach Josefov for Yom Kippur. He does everything he can to achieve his goal, despite all the obstacles. In this manner the author adheres to the objective and to the great determination of the protagonist. This quality is very typical of a metarealistic story.

The tendency to use a wealth of symbolic underpinnings is also one of the indications of a metarealistic work; for example, the name of the town the old man

wants to get to by Yom Kippur – Josefov – originates in the name Joseph, in Hebrew, symbolising blessings and success.

The two names the narrator gives the protagonist, 'old man' and 'Reb Moshe Ber', are archetypically significant. Each time the protagonist is inactive, choosing a passive stance particularly when matters are challenging and there is no solution in sight, he is referred to as 'old man'. Whenever he approaches salvation or when he survives, he is referred to as Reb Moshe Ber, a symbolic name connected with the Yiddish word for 'bear', signifying physical strength. Obviously, the name given to him has an inverse meaning in terms of the old man's life with all the ailments and illnesses that befall him. The name Moshe (Moses in English) connects to the figure of the prophet Moses indicating qualities of leadership and spiritual force. It is only externally that the old man appears weak, since in actual fact he is resilient and has immense mental fortitude. Reb Moshe Ber is a wonderfully strong individual who endures on the plane of the real while at the same time presenting an archetypal figure of the eternally wandering Jew, the *'luft mentsch'*. Tossed hither and thither from one *pogrom* to another, this Jew – who is often almost annihilated – does not succumb but survives, nonetheless, and even sees a glimmer of hope, which is reinforced and strengthened by the birth of his son Isaac, named for one of the Biblical Patriarchs. The connection between the Isaac in the story and the Patriarch figure is very explicit: " 'And Abraham was a hundred years old' he recited, 'when his son Isaac was born unto him.' And Sarah said: 'God hath made me laugh so that all who hear will laugh with me.' He named the boy Isaac" (ibid., p. 121).

Like the Patriarch, Isaac has to face adverse conditions in life: a father who is 100 years old, and a 40-year-old mother with a hearing disability. Given this situation, one cannot help but ponder what the future holds in store for Isaac and how he will deal with his lot. Bashevis-Singer leaves the future unresolved with no clear response to the problematic issues raised but shows optimism in the very existence of continuity. A sense of puzzlement overtakes the reader, who is amazed by the unexpected ending.[13] The tale of the old man has 'other facets', which is one of the definitions of a metarealistic story. It is not just a tale of one old man in a Diaspora *shtetl* but one with a hidden layer, the significance of which must be sought.[14] The heart of this piece is the wondrous character determining its essence – the eternal Jew, thriving in spite of all obstructions in his path.

Alongside the plot, there is an intentional imbalance in time and in the author's description of each part of the story. The great miracle – the birth – is described only briefly. The ten long years of the old man's family history and his first marriage are related in just a few lines. In contrast, the author devotes half the text to the six months in which the protagonist journeys from Warsaw to Josefov. The reason for this disproportion appears to lie in Bashevis-Singer's emphasis on the journey the old man undertakes, stressing its mental aspect, as this is one of the characteristics of the Diaspora Jew. Similarly, the purpose is to impress upon the reader the plight of the unsettled Jew and how Reb Moshe Ber retains the spiritual tools stemming from the strength of his willpower, which enables him to go on. Despite all the hurdles, the old man continues to recite the *Talmud* and "He prayed to God to spare him until *Nilah* prayer, so that he might reach heaven purified of all sin" (ibid., p. 120). The moral and mental fibres of his personality accompany the old man

throughout his journey, and it is this spiritual aspect that makes him 'disregard' his chronological age. His son – Chaim Sachar – who was involved only with the earthly and the practical – died at a much younger age. It seems that Bashevis-Singer hints at the miracle that presents itself to a Jew who combines the physical with a righteous existence. Personal and general redemption can only come when linked to faith, religious ritual and Divine Providence.

## *The Cattle Dealer*

In many of Chagall's paintings, the starting point is a presentation of reality intermingled with imagination, poetics and humour, all of which embody an aspect that is symbolic,[15] archetypal or mystical. One example is *The Cattle Dealer*[16] (1912). The cattle dealer is travelling to market to sell or slaughter the animal, or perhaps he is fleeing a stressful and dismal reality. The figure of the dealer is realistic and individual but at the same time typifies the inhabitants of the *shtetl*. Hence the painting can be looked at on two levels:

1. Realistic:[17] a cattle dealer travelling to market, since the activity of the cattle dealer is part of the mundane life of Jews at that time
2. Symbolic: a cattle dealer representing the fearful Jew fleeing for his life, looking back with longing and all the while hoping to survive.

A procession of a cart and a mare, a dealer, a cow, and the dealer's wife carrying a calf around her neck, is in progress. They are all moving forward but looking back out of concern and fear, as if fleeing for their lives. The sense of flight and impending doom is strengthened by the ominous dark background, and by the earthy, violent non-Jewish couple appearing in the lower part of the painting, with their satirical, disharmonious and threatening facial expressions. The woman is holding a rock-like object in her outstretched hand, which adds to the suggestion that the dealer is actually in danger and in flight.

The painting is stylised, but, nevertheless, its various details are taken from everyday life and are an integral part of the topic itself: the cart, the animals and the road, which give a sense of progress even though Chagall outlines only a small patch of ground. The tree in the background behind the mare also adds a touch of reality. The picture describes the basic existential condition of people travelling from one place to another with all that is implied: the Jew wandering because of his gloomy existence.

However, closer observation reveals symbolic and surrealistic elements that would be unacceptable in realistic art: one of the cow's horns is green for reality while the other is yellow for sanctity: a foetus visible in the mare's abdomen,[18] the dealer-driver turning his head counter to the direction of travel and the woman on foot with an animal around her neck, while the cow sits in the cart.

The painting, which is mainly flat, is laid out in a rectangular form to indicate a connection of form to content: the walking, the journey to market. The work is comprised of several pairs, such as the woman with the calf on her shoulders, and the colt inside the mare while each pair relates differently to the procession.

The Jew in one of his typical daily activities is painted retrospectively, like so many others of Chagall's works. It is a memory, a dream and a yearning for the world he left behind in Vitebsk. The date, 1912, shows that it was painted in Paris. However, it has a certain dream-like, childlike quality, expressed in how the wheels of the cart are painted, as they look somewhat imperfect, as if handmade; as well as in the flatness, which adds a certain childish naïveté. However, the content is anything but naïve. Chagall renders the realistic image of rural life in the *shtetl* a profound and symbolic meaning. Though the convoy is moving forwards (the cart and especially the wheels indicate forward motion, as do the woman's body and the horns of the cow on the cart – to mention but a few examples), the driver is looking backward, as is the woman; the cow, too, is sitting counter to the direction of the journey, with its front knee and hind legs pointing likewise. 'Forward' and 'backward' are concepts of direction also connected to time: 'backward' – the past; 'forward' – the future. The concept of the cyclicality of time is also connected to the circle hinted at in the background behind the driver and to the constantly turning wheels of the wagon. It seems the participants in the procession are either looking longingly towards their previous life, which they are leaving behind, or they might be escaping their harsh life and are therefore looking back in fright and in panic. Though their future is unknown and their destiny uncertain, the white colour expresses purity and sanctity, and the foetus indicates the turning of a new leaf.

The picture is neither decorative, nor is it just Diasporic folklore of the *shtetl*, devoid of profound meaning; it is a discreetly symbolic event about the condition and fate of the Jew. The Jewish theme is indicated by Chagall's placing of a white square with slats, which could represent the fringes worn by a Jew, in front of the dealer's jacket. The mare has a head covering with 'curls' down the side that also look like fringes; there is a white rectangular shape on its back reminiscent of the prayer shawl – a suggestion that is accentuated when one notices the black and white lines on its harness. The mare's eye is particularly large and made-up, giving it a human expression. Chagall describes the Jewish people in the Diaspora, their perambulations and the vicissitudes of destiny and time. This might be the reason for the wheels being painted in yellow – the colour of the sun, bright and optimistic – as opposed to the darkness of the night.

Within the sombre and depressing reality, seeds of hope are sown: the white mare that has human qualities and is maternal with the fruits of its womb symbolises continuity. Similarly, Chagall paints colourful flowers, attached to the trunk of the tree behind the head of the mare.

The fate of the Jews is dichotomous, for despite all the despair and desolation, they still harbour hope symbolised by the white colour of the mare and expressed by the prayer shawl (*talit*), linked to their religion, belief and tradition. The Realism of the subject, on the one hand and its unrealistic design on the other are what make it a symbolic archetype,[19] linked to both the physical and the metaphysical: the theme of the painting – the convoy, the walking, the people and the animals – is all part of the former; however, the way Chagall portrays them – the blue circle in the back as if opening the sky, or the foetus in the transparent womb – are all indicative of the latter. With all the supernatural elements, the painting adheres nevertheless to the logic of what the figures are doing. It is possible that the animal on the cart

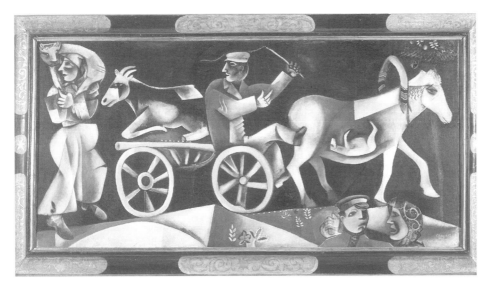

**1** *The Cattle Dealer*, Marc Chagall, 1912, oil on canvas (200 × 96 cm), Kunsthalle, Basel. Photo Scala, Florence © ADAGP, Paris and DACS, London 2009.

stands for sacrifice, and the mare for motherhood and continuity; the woman embracing the calf, who is quite likely pregnant herself, stands for femininity and caring, as well as the celebration of the unity between people and the animals around them.

Each of the three animals is portrayed in a different style: the rendition of the cow is primarily cubist; the mare is more surrealist, while the calf wrapped around the woman is more expressionist. Each of the styles adds a different layer to the hidden meaning of the painting.

An in-depth study of Chagall's works throughout his creative career cannot ignore the emotional expression of his uniquely original and unconventional colours – a phenomenon which is partly the result of the fauvist influence.[20] Colours are a central building block in the symbolism of his works. Through his choice of colour, he conveys feelings and ideas, creates an ambience or assigns a particular significance to his figures. For example, there is a difference between the white that stands for heavenly sanctity and the yellow that represents human sanctity. There is no doubt that in the picture *I and the Village* (1911), the green face of the 'I' has significance, as does the white face of the cow or the blue in *The Blue House* (1917). In *The Cattle Dealer* the horns of the cow are painted in different colours – green for reality, yellow for spirituality.

Symbolically speaking, in *The Cattle Dealer*, a many-layered painting, the observer is left puzzled even after a thorough examination and analysis. Despite all the deciphering, there is a sense of enigma, surprise and wonderment. Chagall manages to link well-known Jewish symbolism with his own personal meaning. These two aspects create a product of special originality and interest.[21]

## COMPARATIVE ANALYSIS
### "The Old Man" and *The Cattle Dealer*

These two works deal with topics related to the Jewish *shtetl* – the life and experience of the Eastern European Jew. A superficial examination might lead one to think that

these works deal only with Jewish folklore, but the story is not just a folkloric tale; it has an invisible essence that helps define it as metarealistic; it spans a long period of time and is archetypically and symbolically Jewish. Similarly, Chagall's painting is not just folklore, theatre scenery or a colourful poster. It has deep layers of symbolic Jewish[22] significance and has metarealistic patterns.

In both works, the artists present a template of the Jew who wanders, stumbles, rises again, tries to survive and sometimes even thrives. The centre of the action is the figure representing the conditions and circumstances of all Jewry in exile at a crucial moment of crisis that is fateful and almost tragic. This crisis befalls both protagonists – the old man and the dealer – in the midst of all their activity.

Having lost his entire family, the old man sets out on a journey that takes him from town to town. He is left all alone and destitute with no way of earning a living, and people around him scorn and mock him. When he asks about Josefov: "He inquired about the possibilities of getting there, but those he questioned merely shrugged their shoulders and each said something different . . ." (ibid., p. 116). Apparently his appearance, his condition and age prevent others from taking him seriously. The narrator adds: ". . . and whenever Reb Moshe Ber broached the subject of his trip, men smiled mockingly in their beards and waved their hands" (ibid., p. 116).

The cattle dealer is also wandering and in transition from one place to another – even though the painting gives no explanation for the move, it is obvious that they are leaving because of conditions similar to that of Singer's old man. This is shown through the foreboding background, the strong, stormy colours, the various shades of red, and particularly the fact that everyone is moving forward but looking backward with yearning and anxiety. The dissatisfied Gentile couple in the lower part of the picture add to the atmosphere of violence. The situation described could be the result of distress, *pogroms* or the attempt to save their lives.

As for the perception of time, in both cases the scene takes place in the present; there is longing for the past, while great significance is attributed to the future. Reb Moshe Ber wishes to go back in time and be in his old familiar place. When he reaches Josefov, he almost starts his life afresh at the age of 100. The *Hassidim* of Trisk recognise him, clothe and feed him, and even marry him off to a peasant woman. Though his story unfolds in the present, the old man is led into the future – thanks to his newborn son. Through the infrastructure of the Biblical story of Isaac, the author turns the newborn into an archetype and a symbol of the unbroken chain of the people of Israel.

The old man's marching forward is made possible only through the past and is expressed, among other things, in relation to tradition, religion and spirituality. For example, he fasted on Yom Kippur according to all the rules and regulations: "Several times during Yom Kippur, he was at the point of fainting, but he observed the fast until it ended" (ibid., p. 120). Both in the past and in the present he is connected to the study of the *Torah* and not just immersed in mundane daily life.

Chagall, like Singer, relates to all three time periods. The dealer and his entourage are fleeing the past, and they are seen in the present with the mare – carrying its foetus – looking forward as a sign of hope for things to come. Here, too, the

future is possible only thanks to their history, which is linked to tradition, religion and Divine Providence.

A metarealistic work connects to the metaphysical sphere. The present, spanning a lengthy period of time, is viewed from the perspective of eternity, sanctity and mystery. The metaphysical exists as an invisible layer but the overt layer maintains an ongoing dialogue with it, and it is the former that prevails. In both works there is a chance for continued physical existence, linked to a spiritual dimension. An example is the angel Duma, who comes from 'other worlds' to save the old man, involving the transcendental facet; in the painting, it is the white mare with the prayer shawl and the foetus in its belly.

Regarding the circumstances of the old man and the dealer, there are differences as well, mainly in the fact that the old man's hardships are more unbearable by far than the cattle dealer's. All that befalls him before he reaches Josefov – the abject poverty, the starvation, and the illness from which he miraculously recovers – is intolerable. These reported exaggerated afflictions also characterise the work as metarealistic: the readers and viewers feel they are in a world that is beyond their immediate comprehension. Thus, there is no real exaggeration in the tale itself, even though it seems there is. For the dealer, too, there are elements of exaggeration and distortion: the woman walking on foot with the calf around her head, while an animal rests on the cart; they are moving forwards but looking backwards, and the dealer's and the woman's faces are distorted.

In terms of style, in Bashevis-Singer one meets sharp Realism quite frequently. The credibility of the story is maintained despite the exaggerations and distortions, partly because of the anchoring of his stories and heroes in familiar locations and a convincing realistic milieu such as Josefov, Warsaw or Krochmalna Street, and the mention of the date of World War I and other precise details of time. This Realism is spiced with witty satire, criticism and humour. For example, there is the author's hidden criticism concerning how the townspeople made their living: "All of them had plenty of money, since they traded with Bosnian and Hungarian soldiers and sent flour to what had been Galicia in exchange for smuggled tobacco" (ibid., p. 120). There is humour in the description of the old man's wedding to a deaf 40-year-old peasant woman, and even in that of his still being virile at the ripe old age of 100.

In Chagall's work, there is an element of Realism in his subject but the painting itself is not as realistic as the story. Humour and satire are also to be found in the painting, though in a much more refined form, in comparison, through the woman on foot with the calf around her head, while the cow sits on the cart; and the angry faces of the Gentile couple below.

In addition to Realism, Chagall makes use of the most prominent artistic styles of the twentieth century, turning the whole into a unique Chagall creation. There are cubist elements, such as the dress and face of the woman, and the body and face of the cow. Then there are the surrealist elements of the foetus seen through the mare's transparent abdomen, the colouring of the cow and of the people's faces. The fauvist influence is visible in the strong, imaginative and poetic colours. The painting even has some expressionist features, as shown in the distortion of certain lines and shapes, meant to convey strong emotions. Bashevis-Singer is more conservative in his style, while Chagall is clearly more modern and revolutionary.

Both artists place a world of fundamental human emotions centre stage: panic, fear, violence and hope. They convey the notions of hunger, sickness, *pogroms* and death – linking them to the 'above and beyond'. Metarealism is the structure of the Jewish destiny.

## "The Little Shoemakers"

"The Little Shoemakers",[23] just like "The Old Man", "The Son from America", "Gimpel the Fool" and others, which deal with the Jewish *shtetl*, may initially be approached as a piece of folklore or a fable. Abba Shuster and his sons provide an obvious allusion to Snow White and the Seven Dwarfs. The song that reappears throughout the story may remind one of the pattern of the Passover song "Had Gadya" or of the English song "Ten Little Indians". But a deeper analysis reveals that the story is in fact archetypal and symbolic, presenting a prototype of the Eastern European Jew who emigrated to the New World between the two world wars.

The story is "at once a mourning over what has been lost and a celebration of what has survived and tries to encompass within a few pages the enormous upheavals which have gripped the Jews in modern times."[24] It is representative of that whole generation of Jews who participated in the mass migration from Eastern Europe to America: "It sums up the whole of contemporary Jewish experience; from tradition to modernity, from the old country to the new."[25] Abba Shuster and his sons, all shoemakers, are of a period and an experience common to many who fled from poverty, starvation and the aftermath of World War I, hoping for an opportunity to improve their lives.[26] While there is, of course, a wealth of immigrant literature describing the humiliation, confusion, frustration and other perplexities encountered by new immigrants in America from the end of the nineteenth century until after World War II, Bashevis-Singer succeeds in creating an original and meaningful presentation of the essential features of this fateful historical occurrence within a relatively short piece of writing.

Singer's stories characteristically take place within a realistic framework: there are actual place names such as Frampol, Yineb, Kershev, Bilgoray, and actions which often take place within an authentic time frame: "Abba Shuster, the founder of the line, appeared in Frampol some time after Chmielnicki's *pogroms*" (ibid., p. 69). In order to make the events more credible, the narrator adds: "The name of Abba Shuster is recorded, on parchment, in the annals of the Frampol Jewish community" (ibid., p. 69). The same is true of his recounting of the town, the hut (cabin) and the townspeople Abba could see as he looked out:

> He observed the groups of matrons who gathered every morning at
> the butcher stalls and the young men and idlers who went in and
> out of the courtyard of the synagogue; the girls going to the pump
> to draw water for tea, and the women hurrying at dusk to the ritual
> bath. (Ibid., p. 72)

Village life is vividly drawn in all its strengths and weaknesses but at the same time, the author injects a thread of sympathy and empathy, as if winking at the reader.

Interspersed among the numerous realistic details which add credibility to the story, Bashevis-Singer plants metarealistic elements, which observe both the physical and the metaphysical world simultaneously, and conceive of the 'here and now' as existing alongside the realm of the 'beyond'. Bashevis-Singer defines this special combination: "I'm realistic . . . In other words, while I may write a completely supernatural story, I try to make it as realistic as possible. This adds power to the mystical story, because even a mystical story should have realism."[27]

At the very beginning, when describing the grave of the dynasty's founder, Abba the shoemaker, the narrator chooses to provide an 'other-worldly' identifying landmark: "Nearby grew a hazelnut tree. According to the old wives, the tree sprang from Reb Abba's beard" (ibid., p. 69).

Again, when the narrator describes the prosaic items on the upper floor of the hut: the tables, chairs, shoemakers' benches, seals, bowls, etc., he adds:

> When he listened attentively he would hear a whispering, a murmuring and soft scratching, as of some unseen creature engaged in endless activity, conversing in an unearthly tongue. He was sure that the souls of his forefathers kept watch over the house.
> (Ibid., p. 75)

This is immediately followed by a mention of the small yard in which "The ground was unkempt, but an unseen hand guarded its fertility" (ibid., p. 76). Abba was a simple shoemaker; true, he prayed and read and listened to his wife as she read some chapters from the Bible to him in Yiddish, but he was not very learned. Nevertheless, he was close to the transcendental. He would look up to the heavens and with the power of his imagination would see all kinds of shapes: flocks of sheep, brooms, elephants, and then felt a Divine Presence, terrible yet full of compassion. With his eyes he saw:

> . . . the Almighty seated on His throne of glory, the earth serving him as a footstool. Satan was vanquished; the angels sang hymns . . . When he listened closely he was sure he heard the muffled cries of sinners and the derisive laughter of the evil host. (Ibid., p. 76)

The attitude towards his late wife also shows an intermingling of this world and the next. He talks to his wife's grave as if she were still alive: "He would stretch out alongside the mound and whisper into her ear, as if she were still alive, 'Gimpel has another grandchild. Tetzel's youngest daughter is engaged, thank God' " (ibid., p. 81). The different worlds are united even more in his mind when he believes that World War II is perhaps the war of Gog and Magog and that the Messiah and the resurrection are imminent: "He saw the graves opening and the little shoemakers stepping forth – Abba, Getzel, Treitel Gimpel, his grandfather, his own father. He called them all into his house and set out brandy and cakes" (ibid., p. 83).

On the voyage to America, too, Abba's vivid imagination places the real and the metareal in close proximity. On the ship: "The door of his cabin was constantly slamming to and fro, as though an imp were swinging on it" (ibid., p. 86). Most of the story is told in the third person, through Abba the patriarch and protagonist's eyes; Abba, like the story itself, represents the Jews of the Eastern European

Diaspora, making a living from one of the typical Jewish occupations at the time, such as tailor, butcher and milkman. He embodies the ethos of the Jew moving from his old, familiar country to the New World, which looks promising and hope-inspiring but at the same time frightening and foreign.

The hut is the symbolic heart around which events revolve. It belongs to the entire family of the little shoemakers but is especially significant for Abba. It is, in fact, the unifying symbol, tying the story together from its beginning, with the founding of the shoemaking dynasty, to its conclusion in America. This dilapidated abode, which symbolises the Jewish home in the Diaspora, has been this way for generations. Not one of the generations of little shoemakers who lived there changed anything in it, yet it survived. Abba Shuster himself does not change either, not even when he arrives in America. Surprisingly enough, one gets the impression that Bashevis-Singer does not criticise this lack of change, as he often does. Quite the contrary: his criticism is directed towards the descendants of the little shoemakers in America and even so, it is less biting than usual, although expressed with the author's usual cynical smile.

This patriarch feels a psychological, traditional and even a supernatural metarealistic connection to the cabin: "The walls were like an album in which the fortunes of the family had been recorded" (ibid., p. 75). In other words, he feels it is blessed. Located on a hilltop, it overlooks not only the entire village but even certain places further afield; from it one could observe the goings on, and through it the reader learns of the habits of the local populace. It stands for security and prosperity. Even the cat seems to protect the family and becomes part of the chain of generations that instilled a feeling of permanence and stability. She and her grandmother both hunted mice there.

The small, narrow, low-ceilinged structure, with a rickety floor, plaster flaking off the walls, a falling roof, mouse holes, worms and cockroaches everywhere, gives the impression of a work of art, a hand-crafted object which seems to possess a soul. Abba Shuster feels "that his little town was the navel of the universe and that his own house stood at the very centre" (ibid., p. 73). He is deeply fond of it – his family home of many generations. Tradition and contact with the family history are important to him and for this reason he refuses to leave it or make the changes his wife asks for. He believes in the cabin's power to bring good fortune, as if it were an amulet protecting him from the evil eye of others. In the end, his familiarity with every nook and cranny led to the saying that "This was good enough for Abba Shuster. There was nothing to change" (ibid., p. 76).

Abba's affection for and attachment to the hut is rational and irrational at the same time. At times the surrounding countryside and the clouds seem to him like a heavenly landscape. Here he connects to the transcendental and the supernatural through the hill and the hut and believes that when the Messiah comes, he will fly on a cloud to the Land of Israel every Friday and holiday eve, and then return to Frampol.

The family home, disintegrating at first from age and then from damage sustained by wars, is part of the *shtetl* and the old world, which are also collapsing. Bashevis-Singer describes this crumbling, primarily through the eyes of Gimpel, the firstborn son who wants to emigrate to America, but also through his other sons,

who gradually follow in their brother's footsteps. The author's criticism is expressed through Gimpel's complaints about the Jewish rabbinical leadership, the Kaiser and everything else connected to the old village's unchanging life, which is vanishing and with it the familiar Jewish world. All this is in sharp contrast to the 'New World'. The author blames the children's generation for emigrating to America, thus condemning the *shtetl* and its lifestyle to oblivion.

The reader becomes acquainted with New York in Gimpel's first letter. At first he describes what is special and different about the city: a large metropolis, tall houses reaching the clouds, trains rushing along the roofs. In every subsequent letter, New York increasingly becomes a symbol of modernity while diminishing the Old World and all it stands for.

Integration into life among the Gentiles in New York is related both humorously and critically. The narrator puts English words into Gimpel's mouth and his letters, which reveal pretentiousness, irony and perhaps even contempt for his parents, who do not understand English. To indicate that he no longer observes his religious traditions, the author has him use the term 'reverend' instead of 'rabbi'.

After incredible travails, Abba Shuster manages to reach his sons. He observes the same things that had struck Gimpel when he first arrived there, but everything novel his son considers desirable, Abba considers deviant and strange. The narrator is critical, ironic and scornful when describing the family – typical Jewish immigrants from Eastern Europe who abandon their origins once in America. The synagogue, the congregants, signs of technology, the honking cars, the radios, the noises of a modern city – all confuse Abba Shuster. The ringing of the telephone, as well as the black maids he sees for the first time in his sons' homes, all perplex him so much that he loses his sense of direction. The car he was in seemed to be moving much too fast: ". . . speeding like shot arrows over bridges, rivers, roofs. Buildings rose up and receded, as if by magic, some of the buildings touching the sky. Whole cities lay spread out before him; Abba thought of Pithom and Ramses" (ibid., p. 87). Small wonder, then, that Bashevis-Singer describes it thus: "Pharaoh, Joseph, Potiphar's wife, the Land of Goshen, the chief baker, and the chief butler" (ibid., p. 89). He sees them all as one. For him, America is as Egypt had been – the land of slavery and exile. There is a feeling of disorder and disarray in his mind. But although the Biblical connotation is negative, still joy and grief are intermingled, for it was because of Egypt that Jacob and his sons were saved from famine and Joseph rose to greatness. Such was the strange land of America in his eyes.

Abba comes to America, changing one exile for another out of necessity; it saves him, as it did many other Jews who sought refuge from anti-Semitism and Nazism or otherwise would have perished in the Holocaust and its aftermath. So it is only natural that while embracing one of his sons, he continues to compare himself to the Patriarch Jacob embracing Joseph upon arrival in Egypt. Just like Jacob, who asked that his bones be taken to the Land of Israel, he, too, aspires to live there; his past, his heritage, his goals are not forgotten.

The main point is neither the folklore nor the seven short, blonde sons; it is rather work, the connection to tradition, religion and faith. The first days in America are uneasy, to say the least, since in Abba's mind everything is not as it should be. He is bewildered by all the unfamiliar modernity and technology he is unaccus-

tomed to. It is only work – his tradition of craftsmanship, of mending shoes in the old-world style – that helps him regain his emotional balance. The moment he comes upon a sack containing his shoemaker's equipment, he feels like a new man, and with his cobbler's bench and his tools he returns to life. His sons join him in the cabin they build for him in the yard, which is reminiscent of the old hut he left behind. Although his sons and their children have forsaken the practice of their religion, the author ends the story on a note of a renewed closeness to it and to their Jewish roots by means of reconnecting to the past. The narrator says: "No, praise God, they had not become idolaters in Egypt. They had not forgotten their heritage, nor had they lost themselves among the unworthy" (ibid., p. 91). The story ends with a passage from a three-part song which, together with the hut, forms the story's main axis. The song is about a mother with her ten sons and describes them up to the fifth, Hersheleh, at which point Abba's sons all join in together as in a chorus. The obvious significance is that all are united and working together. The second part is sung by Abba alone, with connotations from the Passover song *Had Gadya* ("One Kid"). In actuality they had all dispersed already; Pesha died and then came the Nazis and the horrors of World War II. The third time the family sings together again is in New York. Their renewed togetherness strengthens, encourages and unites them, instilling them with optimism and hope. The saga is symbolic of the Jew who is always on the move, who prevails, then rebels against the old values in an attempt to become assimilated among the nations but at the last moment, at least partially, returns to the traditions of his people.

Although the song and the story end with "Oh, Lord, Judele!" (*"Oy vey"*) with a foreboding connotation, the story is still one of physical victory and spiritual triumph. Even nature itself cooperates with the clouds, the flies and the birds all rejoicing in this happy state, as it used to be in Frampol.

The song, which at first glance 'sounds' somewhat childish or folkloristic, is nevertheless profound. It reflects the shoemakers' situation at different stages. It thus becomes an axis of time and place. It begins with a description of the dynasty, goes on to tell of Abba's "toil, sweat and tears" and finally tells of the links forged between the generations. When the father joins his sons and they all work together again, even the members of the younger generation, who look, behave and speak differently from their grandfather, stare in amazement, refusing to leave while he ". . . began to instruct them in the elements of Hebrew and piety" (ibid., p. 91).

Bashevis-Singer's satirical observation of progress and modernisation encountered by the Eastern European Jews does not diminish the accomplishment of four generations being reunited, having emotional ties to a world left behind but not forgotten.

## *Vitebsk, The Blue House*

*The Blue House* is at once realistic and imaginary. It reflects Chagall's personality, his home and his town, as well as the relationship between them. In large measure it also represents the home of any Jew in any Jewish village, as opposed to the town of Vitebsk. On a small hill at the forefront of the canvas, occupying its whole height, there stands a peculiar house, very different from all the others because of its extraor-

**2** *La maison bleue* (The Blue House), Marc Chagall, 1917. Oil on canvas (97 × 66 cm). Musée des Beaux Arts, Liège, © ADAGP, Paris and DACS, London 2009.

dinary colour and its isolation. It is made mostly of wood; it is quite large relative to all else around it, and although it stands alone, it commands its surroundings and stands within sight of both the viewer and the centre of the town of Vitebsk.

The River Dvina flows next to the house, which appears to have been constructed by hand. The logs are not uniform in size or direction and the house is not the same height on all sides. It does not look new; in fact, it exudes an atmosphere of tradition and olden times, as if it could tell stories of those who had inhabited it. The bottom part seems about to collapse. The basement door is held up by a structure made of reddish-brown bricks, an element which adds colour, warmth and humanity to the structure and connects to the red bricks in the chimney, as well as to the colours of the public buildings in the town in the background.

This unique house, with its expressive 'countenance', is different from every other abode, a fact communicated mainly by the dynamic design of the door and the windows. The slanted lines, facing each other like eyebrows, give the impression that the house has 'eyes'. The door, too, is drawn like a living opening, a 'speaking mouth', almost human. These features reflect the owner as well; that is how the painter feels and how any Jew feels when in sight of a well-designed town whose buildings convey formality, order, authority and most of all, unity and attachment to the location. Chagall depicts Vitebsk's public buildings as quite similar to each other. Each building has well-ordered, similar geometrically-shaped windows. The public structures give a feeling of permanence, stability, security and officialdom but the uniformity of it all emphasises the lack of individuality and freedom – only the Baroque church towers stick out. The blue house, on the other hand, although solitary, expresses freedom and openness.

The blue house[28] seems lonely, fragile, 'sensitive', trembling, on the point of collapse; it 'feels', 'agonises', 'breathes' and is connected to the land, to the animals, the trees. Its uniqueness stems from the blue colour, hinting at its detachment while emitting an aura of spirituality rather than of materialness. The house is not set firmly into the ground like the others in the town; it is not stable. There is a kernel of realism in the way Chagall depicts both the house and the town but this is over-

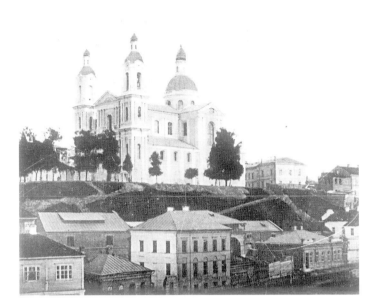

**3**  A photograph of
Vitebsk. Private Collection.

shadowed by the artist's fantasy and his feelings as an artist and as a Jew. The house is symbolic in its colour, style and meaning; it reflects the painter and the Jews whose existence is physically arduous, experiencing alienation, feeling abandoned, unsure of themselves and yet spiritually free. The house is in contrast to the town – surrounded by a wall, giving it an official identity, but in so doing rejecting its individualism.

High on a hill, the house is in harmony with its environment, rising up spiritually as well as physically, overlooking the surroundings. Chagall engages a number of modern art styles. There are expressionist elements in the lines and colours; geometric cubist elements in the sky, the ground and the buildings, and there is even something abstract in the way the town is reflected in the water. Its main artistic achievement lies in the artist's individual existence and that of the Jew in general, which are both conveyed to the observer in an original manner.

## *Vitebsk, The Gray House*

*The Gray House* was painted during the same period as *The Blue House* and deals with the same theme. The similarities and differences between them reveal something about the personal and Jewish symbolism of houses in Chagall's work. *The Gray House* presents a solitary structure that is contrasted with the official buildings in Vitebsk, which stand close together and exemplify the official graceful Russian church architecture with its domes, towers and conventional colours. The solitude of the house, which looks like other Jewish houses in the *shtetl*, is less extreme and more blurred. The gray house stands close to the viewer, at the side. It is a rickety dwelling, sunken, seemingly on the verge of collapse, coloured in various shades of gray and most importantly, full of expression and emotion – of an unbearably burdensome life. The devices Chagall employs are similar to those he utilises in *The Blue House*: it does not stand straight and the roof is angular with many diagonals, which generate a feeling of movement.

**4** *La maison grise* (The Gray House), Marc Chagall, 1917, oil on canvas (74 × 68 cm). Thyssen-Bornemisza Museum, Madrid, BI, ADAGP, Paris/Scala, Florence © ADAGP, Paris and DACS, London 2009.

The window frames contain tints of pinkish-reddish orange, which add to the windows' expressiveness. The one near the fence with its two open blinds looks like a pair of wide-open 'eyes', gazing, frightened and sorrowful. This window is completely open, revealing its distress and pain in contrast to the other, where one blind is closed, giving a rather withdrawn look, an 'eye' which peeps rather than gazes, the wind moving its blinds, demonstrating the window's fragility. Like the blue house, this one is unstable, with no firm foundations and at the same time also sunken, crooked but in contact with its environs.

The two paintings are distinct in that the gray house is less detached. It is closer to the town and its fence somehow forms an attachment between the two. There is a closeness between the colours of the house and those of the formal buildings. In this respect it can be said to be more realistic than the blue house;[29] its symbolism is less obvious and it appears less free and individualistic. The smoke rising from the chimney-stack creates a turbulent sky of a cubist circle of clouds, which reaches up to the tower at the right corner, of the painting, adding to the sense of foreboding, 'tying' the house to the centre of the town; still the house creates a sense of 'aloneness' and 'loneliness' because it is situated to the side and faces outwards. In front lie the logs to be used for heating during the bitterly cold Russian winter. This creates an even darker, grayer, more wintry atmosphere. In the lower left-hand corner there is a lonely figure that almost merges with these round log shapes and colors – a figure reminiscent of a Jew with hat, beard and sideburns, bearing the artist's signature and the date.

The Jew associated with the house is similar to it in colour, expression and physical state. Both are pushed into a corner: outsiders, alienated from their environment but yet human and alive. The gray house, despite its seclusion, is a kind of abstraction or a further step along the idea of distance and proximity, difference and similarity between the artist, the Jew and the Gentile world. Chagall emphasises here the unique and sublime traits of the Jew as compared to the town and the Russian establishment.

# Houses Speak

The Jewish *shtetl* and the Jewish home are among the major recurring motifs in Marc Chagall's work. He often evoked these themes through the use of various formulations, painting techniques and focuses in his paintings.

The following are paintings that support the symbolic-archetypal meaning.[30]

In Plate 5, a drawing dated 1909 and entitled *Village Street*, Chagall shows a typical street. The houses are low and look as if built by hand, slanted, sunken with age, asymmetrical, very different from each other yet very similar. Although the street is empty, except for one man huddled on a bench with his bundle in the cold, there is no sense of alienation. The reason for this lies in one of the painting's more prominent elements: the windows, a recurring motif in Chagall's depictions of the Jewish village. These are usually open, expressive in a way that suggests motion, giving an impression of watchful eyes or sometimes speaking mouths. Another recurring element is the crowding of the houses. They lean on one another, emphasising the sense of solidarity and oneness of the inhabitants.

**5**  *Village Street*, Marc Chagall, 1909 (38 × 28.8 cm). Corbis/Araldo de Luca © ADAGP, Paris and DACS, London 2009.

In Plate 6, a sketch for the painting *Study for Rain* (1911), Chagall shows the same kind of low, asymmetrical house with diagonal lines. It is both an expressive and sensitive portrayal. Here, too, the windows seem like a pair of eyes gazing outward. One sees the house in its surroundings, with a man and a goat hovering in the air, high above. Thus, Chagall suspends the law of gravity creating chaos as the house is being lifted from its foundation. The connection between man, house and beast is shown in this unique style.

**6**  *Etude pour 'La Pluie'*, Marc Chagall, 1911, pencil and gouache (31 × 23.7 cm). Galerie Tretiakov, Moscow © ADAGP, Paris and DACS, London 2009.

**7** *Vitebsk*, Marc Chagall, *c*.1914, gouache and Indian ink (24.8 × 19.2 cm). Private Collection, © ADAGP, Paris and DACS, London 2009.

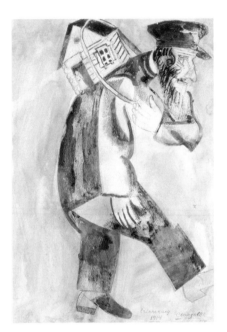

**8** *Remembrance* (Souvenir), Marc Chagall, 1914, pencil and gouache (31.8 × 22.2 cm). Corbis/Araldo de Luca © ADAGP, Paris and DACS, London 2009.

In Plate 7, the drawing *Vitebsk* (1914), there are once again clusters of low houses with mysterious, dark openings of doors and windows. A typical Jew en route with stick and bundle – another motif in Chagall's works – appears in the centre of the drawing. Above the town the name 'Vitebsk', in Hebrew characters, is the signature of the entire scene. The picture is a kind of miniaturised town and is a precursor for both *The Blue House* (1917–1920), and *The Gray House* (1917).

In Plate 8, *Souvenir* (1914), the painter's imagination and inventiveness reach new heights: a Jew, bowed down by a burdensome life, carries his house on his back as he roams. The house has the same features as in previous and future works. It is compact, whole, crooked, with windows that suggest sad eyes, and a woman standing at the entrance. But the house endures, both in fact and in memory, in the heart and imagination of the Jew. It is part of him. He is bent not only because of the house's weight but also in order not to let the house slide down off his back. He walks softly in order to preserve the memory or the gift, for the house indeed looks like a gift box with a string around it, which he is taking with him.

In Plate 9, *My Village* (1923–1924), all of these elements are combined. The isolated house in the forefront is connected to the surrounding green countryside. A man is standing in front, a woman is on the stairs, there are figures in one of the windows, and possibly the painter himself is on the roof not far from the chimney, peeking out from behind the slanted diagonal roof of unequal logs. The windows are very expressive. Farm animals can

be seen and round white clouds hover above, adding an element of completeness or Divine protection and light. At the end of the road, almost in the centre of the composition, stands a church, its physical presence very prominent, representing the town, with a geometrically-shaped, almost square, dark cloud above; and on the far side of the street, a row of typical houses, clustered together as if bound by fate. Elements of nature – trees, birds, people and animals – are also visible. Although there is a connection between the two sides of the street, it is the right side that is more personal, relating to the individual on the roof.

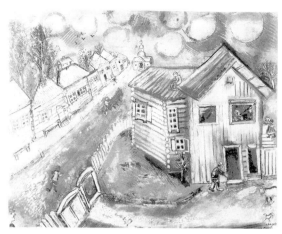

**9**  *My Village*, Marc Chagall, 1923–1924, gouache (62 × 49 cm). Collection Catz, Milwaukee, © ADAGP, Paris and DACS, London 2009.

## COMPARATIVE ANALYSIS
## "The Little Shoemakers" and *Vitebsk, The Blue House*

The *shtetl* is of great importance to both Chagall and Bashevis-Singer; the former dreams of Vitebsk while living in Paris and the latter writes about Frampol from America. They both relate to the Jewish village as a time and place that no longer exist.

The hut and the blue house are symbols of the archetypal Jew and his home in the Diaspora, representing the history and the tradition of the Jewish people. Both give the impression of being hand-crafted, which is the first indication of designating them as unique, for no two can be alike. Such is the Jewish nation – unlike any other nation and different from all other peoples.

Both abodes are situated, each on a hill, commanding their surroundings: the hut, being part of the Jewish village, observes the goings on of its inhabitants and the habits of the local populace. The house, on the other hand, is situated opposite the Gentile establishment, with the River Dvina separating them. The geometrically-designed official buildings and institutions convey authority, uniformity and order which is in sharp contrast to the individuality, freedom and openness of the solitary state of the house. Though the hut and house are characteristic of the typical town and Jew, still they possess their own particular identity. This is in large measure a representation of the home of any Jew in the village, as well as a reflection of the artists' personalities as individuals and as artists, particularly for Chagall.

The uniqueness of the two structures is evident not only in their isolation on a hill but also in the fact that the hut has been the family abode for generations upon generations: ". . . the walls were like an album in which the fortunes of the family had been recorded" (ibid., p. 75). In the case of the house it is unique in its exceptionally large size and uncommon colour.

Visually, the two dwellings look unstable, frail and fragile. The wooden beams of the cabin, which is sinking into the ground, are rotting from age. The front door is sunken, as are the doorposts and chimney stack. The logs of the mostly-wooden house are not uniform in size or direction and the house itself is not the same height on all sides. Because they exude an atmosphere of olden times, both structures appear to be able to tell stories of those who inhabited them generations ago – hence the connection to history, tradition, deep roots and the bonds with the past.

Though the hut and the house lack the stability and security of the public buildings (especially the blue house, situated across from them) they are certainly expressive. In the hut, the windows are no longer aligned but rather run diagonally, and in the house the dynamic design of the door and windows with the slanted lines facing each other like eyebrows give the impression that the house has weepy eyes, while the door is drawn like an open mouth. The basement door is held up by a structure made of reddish-brown bricks, adding an almost-human warmth.

The hut and the house seem lonely, not firmly attached to the ground, 'sensitive', 'breathing', 'agonising' structures, and though at the point of collapse and disintegration, one is struck by their aura of emotionality and spirituality rather than their material form. This personification echoes the oppressive misfortunes the Jews experienced in the *shtetl* since the *pogroms* of 1648–1649 (in the story) and of how the Jews were sustained for generations by spirituality when bearing up under mental and physical pressures, even though they were cut off from others. The house and the hut commune with nature: the bank of the River Dvina is next to the house as it communes with the pine grove along the road in the painting; in the story, overgrown moss colours the shingles on the roof, and the cat – being part of the family – seems to protect the hut, instilling a sense of permanence, since even her grandmother hunted mice there.

The gray, grinding life has extraordinarily uplifting moments which sustain the Jews. The spiritual aspect is especially evident in the blue house because of its rare and exceptional colour – that of the skies – a blue which emphasises dreariness and bleakness and a sensation of being abandoned and neglected, but also expresses the victory of the soul over the trials and tribulations presented by life. Similarly, in Abba's case, his work, the family and ties to the Jewish faith with its non-material values, eventually conquer all obstructions. In other words, both structures, the one looking desolate and forlorn, the other on the verge of collapse, manage to overcome adversity.

Spirituality leads right to the deeper level of Metarealism. Both works emerge from the physical but co-exist with and are linked to the metaphysical realm.

Abba Shuster believes that it is in the hut's power to bring blessings and good fortune to him and the family, as if it were an amulet protecting them from the evil eye. This is why he forbids any changes to be made in the hut lest they change his fortune.

Elements which transport the physical into the upper spheres of the transcendental are inserted into the story, for otherwise how is one to explain the miracle of the hut's survival in the face of the depredations of time, and more so of the fiery sparks emanating from its chimney? It is not exactly an everyday occurrence that a house communicates with its environment, but the blue house does. Its location in the front of the painting allows it to 'go out' to the viewer and conduct an ongoing

dialogue. Abba claims that the hut talks to him and he can hear the voices. The surrounding countryside and the clouds, at times, seem to him like a heavenly landscape. Just as his affection for and attachment to the hut is rational and irrational at the same time, so is the blue colour of the house realistic and unrealistic, all at once.

Abba connects the hut to the supernatural when he imagines himself in it, on his own hill, stepping into a cloud and flying on it to Jerusalem. This he imagines will occur when the Messiah comes. Thus the hut is connected to a dream, a miraculous salvation, in short, to redemption.

The impending disintegration of the hut is clear: the small narrow, low ceiling with the falling roof, the rickety floor and the plaster flaking off the walls, with mice, worms, roaches crawling everywhere, it is about to collapse. The blue house – made of wood in contrast to the official buildings made of mortar, bricks and concrete – is infirm and its 'demise' is imminent. Yet in both cases they prevail – testimony to that certain air of mystery and wonder as to the secret of their endurance. The answer must be in the realm of the 'beyond'.

The hut is the more tangible, realistic and prosaic of the two. The house, though it is someone's abode – (there is a woman near the entrance) – is more subjective, individualistic, aesthetic and free-spirited and is a projection of the artist's self and spirit. Yet, both have realistic as well as symbolic levels of interpretation.

The reader and the viewer are filled with appreciation and admiration for the 'tenants' who manage to survive in the face of the hardships with which the two structures are plagued.

For Abba Shuster, the village is the centre of the world and the hut is the focus of his existence, around which life revolves: ". . . that his little town was the navel of the universe and that his own house stood at the very center" (ibid., p. 73). The hut – so significant for the shoemaker – 'lives on' until his departure for America but in a way continues to exist in the new Diaspora with the help of Abba's ties to his tools and roots, once his sons build a similar hut for him. In fact, it may be said to have been resurrected there, consequently saving him and uniting his family – constituting an exile within an exile but a victory nonetheless.

The symbolism is obvious: the subject in both cases is Jewish survival in the face of desolation, devastation, disaster. The Jews throughout history defied isolation, alienation, being frightened in their 'own' exile or in a foreign, unfamiliar one, however promising and hope-inspiring it seemed. Not only were they able to withstand adversity but they overwhelmingly overcame calamity. It is clearly the triumph of spirit over matter.

This is the true sphere of the transcendental – never to be totally comprehended or deciphered.

## Notes

1   See: Irving H. Buchen in *Isaac Bashevis-Singer and the Eternal Past*, New York University Press, N.Y., 1968, p. 205: "The Shtetl is his pivot".
2   See: Isaac Bashevis-Singer, *In My Father's Court*, Farrar, Straus & Giroux, N.Y., 1962.

3    See: Isaac Bashevis-Singer, *Satan in Goray and Other Stories*, Noonday Press, N.Y., 1955.

4    Ibid., 307.

5    See: Isaac Bashevis-Singer, *Passions and Other Stories*, Farrar, Straus & Giroux, N.Y., 1975.

6    See: Isaac Bashevis-Singer, *Satan in Goray and Other Stories*, Noonday Press, N.Y., 1955.

7    See: Irving Howe, *Critical Views of Isaac Bashevis-Singer*, Irving Malin (ed.), New York University Press, N.Y., 1969, p. 102: "The Hassidim still dancing, the rabbis still pondering, the children still stuffing, the poor still hungering as if it had not all ended in ashes and death."

8    *Marc Chagall on Art and Culture*, Benjamin Harshav (ed.), Stanford University Press, California, 2003, p. 92.

9    See: Abraham Sutzkever, *The Golden Chain*, General Israel Labour Union Publications, Tel Aviv, 1978, booklets 95–96, p. 8.

10   See: Isaac Bashevis-Singer, *Satan in Goray and Other Stories*, Noonday Press, N.Y., 1955.

11   See: Hillel Barzel, *Metarealistic Hebrew Prose*, Sifriat Makor, Israel Association of Hebrew Writers, Masada Publications, Ramat Gan, 1974, Introduction page.

12   Ibid.,

13   See: Irving Howe, "I.B. Singer" in *Critical Views of I.B. Singer*, Irvin Malin (ed.), New York University Press, N.Y., 1969, p. 110: "Singer's ultimate concern is not with the collective experience of a chosen or martyred people but with the enigmas of personal fate."

14   See: Lawrence S. Friedman, *Understanding I.B. Singer*, University of South Carolina Press, 1988, p. 195: In his book, L. Friedman says about this story and the "Little Shoemakers": "Both stories are overtly allegorical accounts of miraculous rejuvenation. At their centers are Jewish patriarchs whose journeys and rebirths resonate with the promise of Jewish continuity."

15   See: Aleksander Kamensky, *Chagall – The Russian Years 1907–1922*, Thames and Hudson, London, 1989, p. 64: "Chagall gradually developed a set of symbols, a sort of alphabet of forms: apart from the violins there is a clock (the symbol of Time), the self-portrait (the symbol of the lover, the rover, the painter), the face of the beloved woman, the Jew wandering with his sack on his shoulder, cows, fish, cockerels, donkeys and other animals."

16   This painting, like many others by Chagall, has several different versions in different sizes, using different techniques and from different dates. Chagall exhibited the painting in 1914 in the Sturm Gallery in Berlin, when travelling back to Russia from Paris. German expressionists praised the painting, particularly Macke and Marc, who also painted animals.

17   See: James Johnson Sweeney, *Marc Chagall*, The Museum of Modern Art, N.Y., 1969, p. 26: In his book on Chagall, Sweeney claims that this painting was inspired by Chagall's memories of his youth when travelling with his uncle Noah by cart to buy cattle.

18   See: Benjamin Harshav, *Marc Chagall and the Lost Jewish World*, Rizzoli, N.Y., 2007, p. 63: In his book, Benjamin Harshav deals with the special meaning of animals in the world and paintings of Marc Chagall: "Chagall constructed his animals – usually outside their realistic context of function – as part of his culturally stereotyped but private fictional universe, never explicitly explained and never univalent. Animals for him could represent the warmth and endearing quality of a living being, symbolize the emotional but inarticulate impact of non-verbal communication or epitomize the ideal of humans living in close contact with nature."

19   See: Jacob Baal-Teshuva, *Marc Chagall*, Taschen, Köln, 2000, p. 60. Jacob Baal-Teshuva speaks, in his book, of symbolic meanings in this work: "Chagall's 'Cattle Dealer' is not only a vivid depiction of rural life in Russia at the turn of the century but also a symbolic picture on many levels."

20   See: Franz Meyer, *Marc Chagall Life and Work*, Harry N. Abrams Inc., N.Y., 1968, p. 95.

21   See: Dov Landau, *From Metaphor to Symbol*, Bar Ilan University Publications, R.G., 1979, p. 202: "One can see that Chagall's works are densely populated with symbols which the painter fashions to meet his needs, giving them his own content which often contradict the original meaning. In this manner he turns symbols of Jewish and Christian-European culture into symbols of his own."

22   Jackie Wullschlager, *Chagall*, Alfred A. Knopf, N.Y., 2008, p. 188: "Chagall's Jews are symbolic, transcendental figures because they are also modern, ironic ones, distorted by sharp contrasts . . . and defined by flamboyant nonnaturalistic colour that gives each picture its special tone."

23   Isaac Bashevis-Singer, *I.B.S. Collected Stories: Gimpel the Fool to the Letter Writer*, The Library of America, N.Y., 2004, p. 69.

24   Edward Alexander, *Isaac Bashevis-Singer*, G. K. Hall & Co., Boston, 1980, p. 131.

25   Irwin Howe, *Introduction to A Treasury of Yiddish Stories*, Viking Press, N.Y., 1953, p. 86.

26   Lawrence S. Friedman, *Understanding I.B. Singer*, University of South Carolina Press, 1988, p. 199. Talking about this story and about "The Old Man", Friedman says: "Together they attain a collective Jewish identity which inspires hope that Jewish communal life, wiped out in Europe, may be miraculously restored in America."

27   See: Richard Burgin, *Conversations with Isaac Bashevis-Singer*, Doubleday & Company Inc., Garden City, N.Y., 1985, pp. 127–128.

28   See: Jacob Baal-Teshuva, *Marc Chagall*, Taschen, Köln, 2000, p. 87: In his book, Baal-Teshuva claims that *The Blue House* is a product of the influence of Cubism; Chagall's new approach to colour and light.

29   See: Michel Makarius, *Chagall*, Hazan, Paris, 1987, p. 82: In this book, Michel Makarius claims that the realistic aspect of *The Gray House* is strengthened by the graffiti on the wall: "On the wall, the graffiti underlines the realism of the painting while a great tormented sky threatens."

30   See: Hillel Barzel, *Ways to a New Interpretation*, Bar Ilan University, Ramat Gan, 1990, p. 280.

# Jewish Artists and Their Works

The Jewish artist and his work is a recurring motif in the works of both Bashevis-Singer and Chagall, although they differ in their treatment of it. Bashevis-Singer takes a more prosaic view. The writer in the story is usually Bashevis-Singer's own alter ego; he takes on the role of narrator in many of the stories. He may be presented as a writer, a magazine editor, a lecturer and university professor, an author or a newspaper interviewer. The depictions of these characters are not as a rule heroic, idealised or mystical. They are not possessed by a muse or inspired by some spiritual world of the 'beyond'. At times Bashevis-Singer even uses these characters to poke fun at himself, at his inability to organise his own life, his profligacy, his forgetfulness, his poverty and his lack of literary success. There is a refined complex irony in his presentation of a kind of 'anti-hero' of modern literature. Bashevis-Singer's commentary on this matter is typically sophisticated, with several simultaneous meanings. While he makes fun of the writer-character, he still presents him as an intellectual, a wise person interested in and possessing a wealth of knowledge.

In the novel *Enemies, A Love Story*, Herman is the editor of Rabbi Lampert Milton's book, but in fact Rabbi Lampert lets Herman write his books, articles and speeches. Herman would write them in Hebrew or Yiddish and someone else would translate them into English, while a third person would edit the text.

He finds it difficult to stick to a schedule and always presents a rather sorry sight, quite the opposite of a hero or a great artist, although he is in fact an intellectual, wise and sensitive.

The narrator describes himself as a rather popular lecturer, quite well known in universities and Jewish organisations. In "The Briefcase"[1] he introduces himself as a writer, journalist and visiting professor at a mid-western university. But the character himself is quite ridiculous. He is absent-minded, a typical 'egg-head'. Here, Bashevis-Singer heaps ridicule on the figure of the writer. But in his own typically ambivalent way he describes Rosalie Kaddish, who tells the narrator that she plans to write a doctoral thesis about his books but is unable to find enough reference material about him. The author also criticises modern literature, wondering whether the literature of the subconscious and the absurd have a future. Singer does not hide his somewhat ambivalent attitude towards modern literature.[2]

Aaron Greidinger, the main character in the novel *Shosha*, is a playwright, and quite an unsuccessful one at that. He is impoverished as fame eludes him and is tormented by feelings of guilt because instead of working on the play for Betty, the actress from America, he spends his time with Shosha.

Author and character have an autobiographical connection. In his conversations with Richard Burgin, Bashevis-Singer mentions the difficulties he encountered in his writing career: the problem of language after he came to America, his age and the number of his published works during his first ten years in the United States: "I was then already an old, forgotten writer. When you're forty-one years old and have had only one single small book published, you're out of it. I considered myself a journalist, not an author."[3] Clearly, Bashevis-Singer's own feelings and his self-esteem as a writer in real life are reflected in the various writer-characters in his literary works.

"Musings on My Manuscript"[4] – a kind of autobiography – includes comments on the difficulties of being a writer. Singer's disappointment at his grim reality leads him to conclude that talent and knowledge are not enough; one also needs contacts, luck and the right acquaintances.

The "First Entry into the Writers' Association"[5] in the same collection describes the travails of a would-be writer at the beginning of his career. All kinds of people come and tell him strange tales from which, so he claims, he weaves the fabric of his stories. In "The Admirer"[6] Elizabeth Abigail de Soler, whose grandfather was the rabbi of Klandav in Poland, provides the narrator with material for a story out of admiration for his writing talents. This is one of many literary devices Bashevis-Singer employs to represent himself as the narrator.

Above all these characters there is the real figure of the author himself, Isaac Bashevis-Singer, the personality behind the various literary devices and compositions, a sophisticated artist, very knowledgeable in Jewish lore and Western culture, and in many other fields, all of which are reflected in his books: Jewish mysticism, occultism, Spinoza, Jung, Freud, Kafka and Joyce.

In order to weave all these elements into a lively, interesting and worthwhile tale as Bashevis-Singer does, a writer needs knowledge, talent, curiosity and profundity at one and the same time. This is why there is a gap between the character of the real life artist – writer Isaac Bashevis-Singer – and the character of the narrator in his writings, even though there are many similarities between them. It is his way of looking at himself and at his craft as a writer – one that often incorporates both humour and irony.

For Chagall, the artist and his image of the artist, as it frequently appears in various forms throughout his career, are in complete agreement. Quite often he depicts himself as a painter standing with his palette, with his muse or with the other sources of his inspiration. His approach is lyrical and poetic; he usually presents himself as a handsome young man, inspired by the transcendental. He called himself an unconscious conscious painter: "Je suis un peintre, inconscient conscient."[7] Unlike Bashevis-Singer, he usually makes an effort to portray himself in a more than naturally favourable light; his figure remains lyrical and young even towards the end of his career.

Chagall is a painter sitting in front of his easel: young, handsome and elegantly artistic in *The Apparition: Self-Portrait with Muse* (1917–1918). While working, he is surprised by the appearance of a woman-angel-muse, through the window, who is somewhat reminiscent of his wife, Bella. She appears to be dancing on soft clouds of shimmering blue. Although the painting hints at the physical objects you would

expect to find, the whole *atelier* takes on an ethereal appearance, with its floor surrounded by poetic clouds lending it a spiritual ambience, suffusing the room with a transparent unearthly light. Chagall perceives himself as receiving inspiration from above, through the enrichment of his imagination; he is a dreaming artist with links to the transcendental. The combination of the real and the metareal is exemplified in a dream Chagall describes in his autobiography:

> . . . And dreams oppressed me: a square empty room. In one corner a single bed and me on it. It is getting dark. Suddenly the ceiling opens and a winged being crashes down, filling the room with movement and the clouds . . . A rustle of trailing wings. I think: an angel! I cannot open my eyes; it's too light, too bright . . . Once again it is dark.[8]

In *The Painter to the Moon* (1917) the artist is an acrobatic, poetic figure in white, hovering above the real world. He appears to be floating through the air on an imaginary, dream-like trip with palette and paint brushes in hand, receiving his inspiration and visions from the universe.

A nostalgic view of the painter, who returns to the town of his birth to express gratitude for the inspiration and roots it has granted him, is presented in *Red Roofs* (1953). His figure is slim, elongated and somewhat distorted, creating a sense of finesse and nobility which transforms the artist, his town and the whole scene into something very special. This motif recurs in his later works as well. The older Chagall continues to paint himself as a young romantic, except that now things appear as if from a distance, more nostalgically, perhaps more as an ideal than a reality.

*The Dream* (1978) reflects this approach. The painter lies along the width of the painting with palette and brushes. Behind him and at his side one sees Paris, crowned by the Eiffel Tower. He is daydreaming about an encircled scene: the young artist with his bride, and above them a book and a figure of a fiddler with the head of a suckling.

## The Magician of Lublin

Like many of Chagall's paintings, Bashevis-Singer's novel deals with the figure of the artist: "He is no longer a wandering magician with a harmonica and a monkey, but an artist."[9] This leads the novel into the domain of the metarealistic, since Yasha Mazur is no ordinary man but a special and wondrous figure, preoccupied with the occult, the world beyond the sight of ordinary people. Yasha and his occupation are part of the novel's symbol-centred structure. However, all this occurs in close proximity to his real daily life and to those in his vicinity. Bashevis-Singer describes a prosaic reality alongside fanciful, extraordinary phenomena – Yasha Mazur as a magician who is very much a singular individual – while at the same time presenting him as the symbol of the Jewish artist in the Diaspora. His profession is not a common one among Jews, and so the reader is presented with dilemmas that pertain to the artist in general and the Jewish artist in particular. It is not an autobiographical novel but it *does* contain matters the author is drawn to or identifies with.

The novel's main character resembles the author in many of the things he does, says, thinks or is preoccupied with. Mazur also represents the inner struggles of modern man.[10]

> Bashevis-Singer is a master when it comes to presenting the conflicts within a person's soul. First he brings the man to the brink of depression and then he fires him up again with the desire for new miracles, new loves: . . . the storyteller's wisdom consists of this: not to leave the reader on the sidelines but to make him participate in the web, as if to say: 'for this way too, man, two kinds of life struggle: the real and the fake. And you are paying for both.'[11]

The novel describes a magician surrounded by a variety of experiences, a master of deception who is able to unravel mysteries. Yasha juggles, picks locks, can turn a somersault on a high wire, is drawn to other worlds and is torn between them, deliberates over different women – moving like an acrobat on a tightrope physically, metaphorically and symbolically. Walking this dangerous tightrope is a challenge that sharpens the acrobat's senses but also involves physical and mental hardships. The tension caused by the effort to maintain his actual balance and symbolic equilibrium is tremendous. Judging by his lifestyle and the various risks he takes, it would appear that he handles the danger quite well and perhaps even courts it. There seems to be a parallel between his professional and personal life: "He is always tense, as if he never stopped walking the tightrope" (ibid., p. 22).

Yasha was born into an Orthodox family, with a background that taught him about the Jewish world and its customs. His father was a scholar but because he lost his mother at a tender age and was raised only by his father, his childhood was different – a fact that followed him into adulthood: he wandered from one city to another, never striking roots. In addition, the fact that he and his wife Esther are childless deepens the feeling of rootlessness and lack of permanence. Despite the many women in his life, he feels that Esther is his only anchor; the orderly home and his loyal wife waiting for him are the only things that bring him stability. His frequent journeys from Lublin to Warsaw and elsewhere also affect his deliberations and aggravate his internal dilemmas regarding religion and faith. These visits to the big city and the fact that he mingles with Gentiles only deepen his inner strife: ". . . When he was in the tavern Yasha played the atheist, but, actually, he believed in God. God's hand was evident everywhere . . ." (ibid., p. 9).

Yasha's talent as a magician requires and allows him to be in diverse worlds donning various masks: sincere and false, religious and heretical. He lives in many worlds without belonging to any one of them and vicariously through different selves without becoming any one of them. One of the traits that characterise the novel's hero is his ongoing agonising search for self, through the soul-searching and existential questions constantly running through his head. Perhaps it is his familiarity with the mysterious world of the occult, resulting from his profession, that leads him to these deliberations. He never accepts anything at face value. He ponders: "What sense did all the fine words about positivism, industrial reform and progress make when it was all cancelled out in the grave?" (ibid., p. 81). This search for self reaches a climax when he meets Emilia, the Christian widow of a mathe-

matics professor who represents the Polish upper-middle class to which Yasha would very much like to belong. He has had many women but none attracted and affected him as Emilia does. She almost manages to drive him insane by demanding financial support for her family, that he desert his wife Esther and that he convert to Christianity if he is to have her completely; until then she refuses to flirt with him. Yasha vacillates between these different directions, metaphorically speaking, as well as between Judaism and Christianity. Because of Emilia's presence in his life he is forced to choose between Esther, the good, pure woman who represents Jewish orthodoxy, and Magda, the Christian peasant woman who serves as his apprentice and mistress. He is also forced to make a choice between her and Zeftel, the sinful woman leading a free and promiscuous life, the deserted wife of an escaped thief from Piask. With Zeftel he allows himself to be frank and candid. He is physically very much attracted to her:

> . . . what was he looking for on this dung-heap? He had repeatedly decided to break off, but whenever he came to Piask he was again drawn to her. He now ran towards the house with the fear and anticipation of a school boy about to go to bed with his first woman. (Ibid., p. 38)

Despite Zeftel's promiscuity, she possesses practical wisdom and is psychologically savvy in matters of relations between the sexes. She is the only person in whom he confides. At Zeftel's he encounters and is attracted to Piask's Jewish underworld. His attraction to Piask's thieves and criminals is something his personality requires and he shows himself capable of adapting himself to radically different situations, people and circumstances. The women adore and admire him. Magda and Zeftel worship him blindly, almost uncritically. Esther is aware of his weaknesses but still loves only him:

> Esther looked at her husband as she ate. Who was he? Why did she love him? She knew he led a wicked life . . . Everyone vilified him and pitied her but she preferred him above any man, no matter how exalted – even a rabbi. (Ibid., p. 23)

She appreciates his skills as magician and craftsman: "She had long since come to the conclusion that she would never be able to understand all his complexities. He possessed hidden powers, had more secrets than the blessed Rosh Hashonah pomegranate has seeds" (ibid., p. 12). Although Esther is a believer who tries to maintain a traditional Jewish home, and although she is not the ideal representative of erotic love, there is a mutual attraction between the two: ". . . he always returned to her and always with some gift in his hand. The eagerness with which he kissed and embraced her suggested that he had been living the life of a saint during his absence" (ibid., p. 11). They retain the magic of a young married couple, perhaps due to his frequent absences from home: "He embraced her and she blushed like a bride. The long periods of separation had preserved in them the eagerness of newlyweds" (ibid., p. 22). But the Orthodox Jews in the synagogue Esther attends reject him.

The traditional brand of Orthodox Judaism represented by Esther cannot accept him, firstly because he does not observe the commandments of his faith, nor does

he live in accordance with the traditional way of life, and secondly because of his profession. Artistry was not acceptable to the Jews of those days. It seems to him that Judaism is at war with art and the joyous life. In contrast, the bourgeois Christian Polish society of the late nineteenth century was much more accommodating and welcoming. But he hesitates, for he is aware of the disparity between how the Jewish and Christian faiths regard sin and crime.

Later on, the protagonist concludes that he must completely and unambiguously return to his religious origins. Even during his earlier times of doubt when he was conflicted between the aesthetic and the moral life, the world of Judaism never ceased to be important to him. Despite his permissive lifestyle, he still feels part of his people, remembering his parents, who occasionally appear to him in his dreams and strengthen this aspect of his personality. The synagogue and *Beth Hamidrash* are the representative focal points of Judaism and Jewish life. Yasha is not 'fluent' in this world. One example which shows both his ties to his religion and his estrangement from it is the scene in which he peeks through the open door of the *Beth Hamidrash* in Lublin. He feels alienated but at the same time perceives the spirituality and completeness the Jews possess because of their faith, customs and the familiar ambience which unite them. Ironically, and perhaps somewhat cynically, on another occasion it is the synagogue that reminds Yasha, once more, of his heritage. On one of his trips to Warsaw together with Magda, they are caught in a fierce storm. Forced to leave the wagon, they seek shelter from the downpour in a building that happens to be the Makov Synagogue, which now provides him not only with physical shelter but spiritual sanctuary as well:

> God in Heaven, how long was it since he, Yasha, had been in the holy temple? Everything seemed new to him: the way the Jews recited their introductory prayers, how they donned the prayer shawls, kissed the fringed garment, wound the phylacteries, unrolled the thongs. It was all strangely foreign to him, yet familiar. Magda had gone back to the wagon, as if fearful of all this intense Jewishness. He chose to remain a moment longer. He was part of this community. Its roots were his roots. He bore its mark upon his flesh. He understood the prayers. (Ibid., p. 58)

The third time that a synagogue brings Yasha back to his history, or at least closer to it, is the most unlikely of all. He is about to commit a break-in so as to obtain enough money to marry Emilia. But this time the master of the high wire fails at descending from a balcony and the wizard of lock-picking suddenly finds himself unable to unlock the safe! It refuses to yield. It is ironic that this act of theft, which is symbolic because of its relation to religious conversion and the severing of his last ties with Judaism, is what finally subdues him. This acrobat and renowned juggler fails – succeeding only in breaking his leg! Now in his distress, as he flees fear, failure and the law, he heads for a synagogue: ". . . he saw the courtyard of a synagogue. The gate was open. An elderly Jew entered, prayer-shawl bag under his arm. Yasha darted inside. Here they will not search" (ibid., p. 121).

He goes to the synagogue again seeking physical safety. But instead, he experiences an epiphany and suddenly comprehends the significance of the deed he was

about to commit. He understands that the Christian world is not his world; he realises that Emilia's world, its faith, symbols and culture are not his. It dawns on him that Divine Providence stopped him in time and that his failure was a heavenly sign: "Only now did he realise what he had attempted and how Heaven had thwarted him. It came over him like a revelation" (ibid., p. 122). "At that very moment it occurred to Yasha what sort of lock was on Zaruski's safe and how it could be opened" (ibid., p. 121). He remains seated in the synagogue, overcome by lethargy, emotionally and mentally drained, until he is handed a prayer shawl and phylacteries by an old man. After fumbling with the laying of the phylacteries – he who manages all locks so deftly – and feeling the subsequent humiliation, he feels a profound connection to his religion for the first time in a long while:

> And the same group of Jews, who but a moment before watched him with the sort of adult derision, now looked at him with curiosity, respect and affection. Yasha distinctly sensed the love which flowed from their persons to him. 'They are Jews, my brethren', he said to himself. 'They know that I am a sinner, yet they forgive me . . . After all, I am descended from generations of God-fearing Jews . . .' He remembered his father who, on his deathbed, summoned Yasha to his side and said: 'Promise me that you will remain a Jew'. (Ibid., p. 125)

Formerly alienated from God, he returns unequivocally to Him, as well as to his fellow Jews and to a sense of oneness. Having said his farewells to Emilia and all that she represents, he re-enters the *Beth Hamidrash*. Yasha perceives this physical punishment to be something much more profound than just an accident (Emilia's interpretation) which keeps him temporarily away from his profession, from Emilia, from her world and all it entails. He is at the advanced stages of enlightenment, seeing the significance of this heavenly 'chastisement'. He believes this to be a sign recalling him to his faith, since Heaven saved him from the consequences of his compromising impulses. The difference in how these two people view the event clearly illustrates the different worlds they represent.

Yasha breaks off all his ties with Emilia. Magda disappears from his life by committing suicide and Zeftel becomes romantically involved with Herman the pimp. In his own words:

> . . . He had looked on the faces of death and lechery and had seen that they were the same. And even as he stood there staring, he knew that he was undergoing some sort of transformation, that he would never again be the Yasha he had been . . . He had seen the hand of God. He had reached the end of his road. (Ibid., p. 181)

Thus comes to an end this lengthy chapter in his life and the events which led him back to his first and true world – Judaism.

Dilemmas and deliberations have always been part of the human condition, and even more so in the modern era. Modern man is known for his scepticism[12] and for his agonising over existential questions, as well as issues relating to faith, belief, ethics, morality, etc. The main character is presented as a Jew whose deeds and

reflections are connected to the Jewish experience. Being conflicted between two worlds, the question of whether there is a transcendental reality beyond the physical, visible existence, and having to choose between honesty or deception as a way of life, are issues common to all religious, national and racial identities. For this reason anyone can identify with Singer's protagonist, who represents both a man of the past and, even more so, Modern Man. Consequently, although *The Magician of Lublin* is actually set in pre-modern times, the hero is a modern figure seeking answers, an inquisitive character who refuses to accept things at face value.[13]

The perception of the magician as a modern figure states that the hero's inner struggles are typical of a modern man, who lives in a world in which the Creator lets His creatures suffer alone. Yasha, therefore, agonises between two polarities: he yearns for absolute perfect freedom but it complicates his life. It is no coincidence that the author assigned this character the profession of tightrope walker. Up there, supposedly free, he realises a highly individualistic aspiration – being an acrobat who relies solely upon himself. However, this is also a very dangerous and demanding occupation, one that requires extreme precision, one that can easily cause his downfall or even death. To these necessary skills one may add Yasha's desire to fly like a bird. In his dream he also sees himself flying: "Now with a pair of artificial wings he flew over the capitals of the world. Multitudes of people ran through the streets pointing, shouting . . . as he flew, he received messages by carrier-pigeon – invitations from rulers, princes, cardinals" (ibid., p. 54). Again: "Yasha dozed off and dreamt that he was flying. He rose above the ground and soared, soared. He wondered why he had not tried it before – it was so easy, so easy. He dreamt this almost every night . . ." (ibid., p. 34). These dreams express a distinct wish for physical, artistic and spiritual freedom. He wishes to be unbridled and uninhibited by the demands of morality, society, religion or any other commitment. Such a dream can be dreamt by any man or artist but Yasha follows in the footsteps of Icarus; he designs wings whereby he will be able to fly. These imaginary wings are real to him in his relations with women, and his ties to them are described in metaphors taken from the world of flight.

Yasha's actions cause him the same kind of grief one finds in the fate of the Greek tragic hero who brings catastrophe upon himself: "And as he planned new stunts, he was plagued by the fear that the old ones were beyond his powers and would cause him an untimely death" (ibid., p. 83). He realises quite well that his womanising will eventually prove his downfall: "They are all the same, each one of them a spider" (ibid., p. 83). He must mend his ways if he is to avoid this fate and prevail. In other words, the author has created a complete, multi-faceted figure, rich in psychological insights, which is typical of modern man and of modern protagonists. Yasha does not attribute his fate to some external force; he is fully aware of the fact that it is his own decisions and way of life that will to a large extent determine his destiny, rather than any supreme power outside himself.

Structurally, too, the book is like a modern novel. It is divided into three parts, each with its own format and writing technique.

In Part One, chapters I–V, the author's style is realistic, with symbolic elements. The narrator provides a realistic description of the trip from Lublin to Warsaw. He mentions actual names and places and offers a detailed account of the character's

mundane activities, as well as some of his inner conflicts. However, within this description some symbolic 'seeds' are sown, as, for example, in the description of the horses Kara and Shiva.

Part Two, chapters VI–VIII, is written in a surrealistic style. It spans a brief forty-eight-hour period in which many significant events occur, including the hero's complete transformation: this magician, acrobat, almost thief – a Jew who nearly converted for the sake of a woman – now returns to the bosom of Judaism, to his people and his faith.

Events in this part of the story – such as Magda's suicide and Zeftel's move to South America – happen unexpectedly. This is the essence of Surrealism, where details have meaning and make sense but cease to do so when connected. This, however, is true only superficially because, in fact, there is a connection between all these events. It is Yasha himself. All these surrealistic elements highlight the tremendous transformation he undergoes. Therefore, although the time period is a mere forty-eight hours, the events described in that time take up a considerable part of the novel.

In Part Three, the Epilogue, Yasha implements the decision he made at the end of Part Two, when he already felt the impending change:

> . . . he would never again be who and how he had been. The last twenty-four hours were unlike any previous day he had experienced. They summed up all his previous existence, and in summing it up had put a seal upon it. He had seen the hand of God. He had reached the end of the road. (Ibid., p. 181)

However extreme or even insane his act may seem, it would indeed appear that the ground for it had already been laid. The author could well have ended the novel at this point but he chooses to add an epilogue:[14]

> A picture after the end of the drama: the chapter following the novel's end, the epilogue, is not directly connected to the story; its plot goes beyond the plot of the latter. It is the direct spokesman of the author's truths.

Bashevis-Singer presents his main character's occupation as magician; this creates a link of sorts between himself and Yasha. Both are artists, born into the Jewish world but wandering and evolving towards other worlds: faith and a Jewish education on the one hand, heresy on the other. In this the two are very much alike. It would thus seem that the epilogue is significant.[15]

All the styles the author uses in this novel lead to Metarealism, which unifies the book and lends it coherence. The epilogue describes Yasha as he isolates himself within four walls, secluding himself from the external world and its temptations. The descriptions of his physical pain, his emotional agony and his dilemmas are very realistic. But alongside these, there is his involvement with prayer, with his faith in the Creator, with the blessings he gives to those who seek him in their hour of need. He undergoes a complete transformation when he becomes a devout, righteous man, fully repentant, one who has moved from wantonness to piety, from debauchery to asceticism and then to becoming a 'saint':

> . . . It was as if he had become again a foetus in his mother's womb, and once more the light referred to in the *Talmud* shone from his head, the while an angel taught him the *Torah*. He was free of all needs. (Ibid., p. 186)

The Realism, the surrealistic elements and the epilogue all fall under the metarealistic 'umbrella', since in this novel: "the real and the ethereal dwell side by side in perfect harmony."[16]

This very unusual, wondrous character, who is a typical metarealistic figure representing the archetypal Jewish pattern, is initially the Jewish artist, pondering as he painfully vacillates between the Jewish and Gentile worlds, coping with the former while confronting the latter's reaction to him. He then becomes the archetypal saint who goes from one extreme to another, from a tightrope walker to an ascetic incarcerated in a doorless cell.

All this belongs to the world of 'above and beyond'.

## *Self-portrait with Seven Fingers*

Chagall painted many self-portraits. He appears in several variations in many of his works – at different ages – although he always preferred to depict himself as a handsome man. As one would expect of a good self-portrait, Chagall documents both external and internal features, his appearance, and his sensitivity and innermost thoughts.

In this particular self-portrait,[17] Chagall depicts himself in one of the most crucial phases of both his personal and professional life: his transition from Vitebsk in White Russia to Paris[18] – then the art centre of the world. He presents himself against the backdrop of a town and a city, two cultures, two very different lifestyles that together constitute the core of his existence both as a man and as an artist.[19] Despite the painting's apparent verisimilitude, it does not constitute an accurate reflection of objective reality like a photograph; it is rather an image, an imaginary self-portrait, surrounded by memories and visions, that lies somewhere between fact and fantasy, of a sophisticated, elegant modern painter, a cubist with all the distortions inherent in that style, as that is how he wished to be perceived. The year is 1912, one of the most decisive years for the cubist movement that so influenced Chagall. One might even say that Chagall was inebriated with Cubism and that is why he chose to present himself in this fashion. In this painting he is a young man of twenty-five who has been in Paris for two years (he first came to Paris in 1910 and stayed until 1914). The artistic events and developments of the period, his acquaintance with artists such as Cendrars, Apollinaire, Léger and others in Paris, his exposure to new styles, have all affected his own.

The figure in the painting has been distorted through the use of the modern currents of Cubism, Expressionism and Surrealism. In relation to the height of the painting, the length of the body is exaggerated and disproportional to its other parts. Thus, Chagall stresses his own importance as man and artist: he constitutes the centre of the painting and of the world he is presenting. But he goes even further:

the body parts that directly affect his artistic creation – the head from whence his ideas spring and the hands where the visible expression of those ideas is generated – are enlarged. A further gesture: he adds two extra fingers to his left hand, in order to indicate its importance as the deliverer of the special skill and abundant talent possessed only by a creative artist, who differs from ordinary mortals in this respect. This is Chagall's perception.[20] It is worth noting that the number seven has a special significance in the Jewish tradition and in the Bible. The hand is emphasised by its brightness and light colour. To make it more prominent, the knee below, painted as a bright triangle, is pointing to the hand, and beneath the knee, a kind of coloured triangular arrow is again pointing at the hand, all in order to draw attention to the painting on the easel, and to the painter's extraordinary seven-fingered hand.[21] Other body parts are also distorted in the painting. The painter's eyes are misshapen, large and expressive, with a bow-shaped right eyebrow suggesting energy, strength, dynamism and vision. His nose is sharply chiselled to convey determination, as is his mouth and the sculpted, geometrically-shaped cheek with a dark space at its centre. The locks of his curly hair are clearly formed, some round, soft and lyrical, while others are stormy and pointed. His other facial features are light-coloured and express thoughtfulness, as does his gaze, which is not focused on any particular object but is rather solemn, reflective, as if looking at something invisible and distant, evoking nostalgia. The painter is pensive, perhaps thinking about his life, his art or even about the painting he has just completed – the one on the easel, which is a reduced variation of a larger one he had produced earlier, *To Russia, Asses and Others* (1913–1914).[22] He does not show himself actually painting but seated in his atelier with palette, brushes, easel and painting, with his seven-fingered hand seemingly protecting and sheltering the painting on the easel. The use of the cubistic-analytical technique of dividing the cheek into geometrical shapes limits the use of colouring for the face to dark and light shades of gray, stressing the darker and brighter sides of his personality, and the emotional and the possible psychological and physical stress of the moment, as he finds himself at a crossroads. The darker colour in the sunken cheek and in his eyes, especially the larger right one, emphasises mystery and the depth of a creator's feelings and imagination. Similarly, the large eye with a small pupil – surrounded by black and dark red in the right eye, and a kind of blue in the left – indicate turmoil that is dramatic and highly complex, both internally and externally.

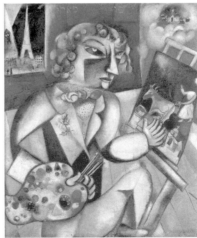

**10** *Autoportrait aux sept doigts* (Self-portrait with Seven Fingers), Marc Chagall, 1912, oil on canvas (128 × 107 cm). Stedelijk Museum, Amsterdam, BI, ADAGP, Paris/Scala, Florence © ADAGP, Paris and DACS, London 2009.

Chagall portrays himself as a modern man and artist, in an elegant suit, cubist style, with carefully tended hair, a somewhat exaggerated bow tie, a flower in his lapel and a polka-dot shirt underneath his jacket. He looks like a twentieth-century man who belongs in Paris. Below the picture of Paris there is some sort of a table on which one can faintly see a book. But behind him, on either side of his head, two Yiddish words are written in Hebrew script: 'Russia' and 'Paris', the two poles of his personal and artistic life. Next to the word 'Paris' is a picture, perhaps a painting, or a view through a window, showing the city's best known symbol – the Eiffel Tower – large, stretched upwards, illuminated. Next to it, a parachutist is caught in a beam of light from above – this is Paris of the night, a city of freedom and enlightenment. Next to the word 'Russia' is a Russian church and some village houses, symbolising Vitebsk. The space the Vitebsk image fills is greater than that filled by the Paris image. It differs from Paris not only in its landscape but also in how it is portrayed. It is painted on a red background, suggesting a storm, drama, a complicated situation. In the centre of the red lies the village, enveloped by soft, round clouds that buffer it, creating a dreamy, lyrical impression, despite the storminess suggested by the red colour. Paris, on the other hand, is clearer, linear, with cubist geometrical shapes – the mystery and elegance that are characteristic of the city alongside the greenery, houses and people strolling along or riding in a carriage. Vitebsk looks like a dream sprouting directly out of Chagall's imagination or vision, and the smaller of the painter's two eyes, which has some blue in it, is closer in colouring to the town. Next to it, between the eye and the lock of falling hair parallel to his nose, begins a circular shape, a rounded spot that is repeated with greater illumination in the shapes of the clouds surrounding Vitebsk in the painting behind him.[23] This parallelism creates a closeness between the artist and his town. Next to the end of the lock of hair and bordering on the dark red begins the light red colour of Vitebsk. Even the blurred, blue, dome-like shape adds to the dream-like atmosphere. In Chagall's dream, in his memory, the town is poetic, magical, enchanted, an island protected from the complexities of daily life. This is nostalgic, while the true state of affairs on the easel is quite different: a topsy-turvy world that is complex and disjointed: in a night fantasy a headless woman hovers in the dark sky; above her, light is emerging and beneath her feet there is red. A luminous red cow stands on the roof of a house that is smaller than itself, while beneath, two abstractly-shaped green figures suckle from it. It is only in the original picture, *To Russia, Asses and Others*, that one can tell that these are actually a calf and a child. The small painting differs in many respects from the original; for example, the suckling is larger than the child. The picture simultaneously describes Vitebsk realistically and symbolically, revealing a state of dramatic disharmony. In terms of his position in the painting, the artist is closer to Paris but the angle he sits in, the way he turns his body, the hand, the knee underneath it, the brushes in his hands pointing towards the easel – all demonstrate his love for Vitebsk and what occupies his thoughts. Physically he is in Paris but at the same time his entire being is preoccupied with Vitebsk, etched in his heart. His palette, which is his entire physical, mental and spiritual world, has all the colours in the painting; this is indicative of the fact that he is undergoing the same drama experienced by Vitebsk. His head is in the centre of the drama, within the stormy red area, which symbolically expresses the painter's condition at this stage of his life.

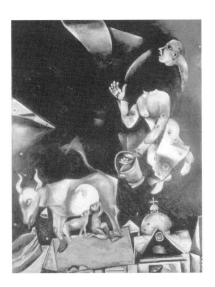

**11**   *Á la Russie, aux ânes et aux autres* (To Russia, Asses and Others), Marc Chagall, 1911, oil on canvas (157 × 122 cm). Musée National d'Art Moderne – Centre Pompidou, Paris, BI, ADAGP, Paris/Scala, Florence © ADAGP, Paris and DACS, London 2009.

Blending his personal and artistic life is a common feature in Chagall's work. At this particular point, he finds himself in a predicament, having to decide between provincial Vitebsk, the soil that had nourished his art, and the grandeur of Paris, which was the fountain that nurtured it; between Paris, its influences and the modern styles he has absorbed there, and Vitebsk, his hometown, to which all his memories, his childhood and his entire spiritual life are connected. Chagall tries to revive a world that is no more: "Cities, houses, families vanished like smoke and I tried to bring back their images on my canvases."[24] He employs the technique of distortion to represent a Jewish artist, conflicted and torn between two worlds.

It is no coincidence that he writes the two words 'Russia' and 'Paris' in Yiddish, for these two words alone suffice to disperse all doubts as to his heritage. These two locations are the focal points of the painting, which help position him in the modern world while remaining tied to his Jewish roots, despite all the temptations and all the ideological and stylistic influences.

## COMPARATIVE ANALYSIS
### *The Magician of Lublin* and *Self-portrait with Seven Fingers*

At the core of the comparison lie the artist and art in general and the Jewish artist and his art in particular – their doubts, deliberations, dilemmas. Neither work is an accurate reflection of objective reality but each oscillates between fact and fantasy. The novel is not an autobiography, though it is evident that it contains matters the author is drawn to or identifies with. The protagonist resembles the novelist in many of the things he does, says, thinks or is preoccupied with, and the reader senses the novelist's sympathy and empathy towards him. In the self-portrait, Chagall's auto-biographical elements are obvious and explicit. He presents himself as he wishes to be perceived.

Yasha Mazur is an acrobat, a juggler, a master lock picker, a tightrope walker and above all, an abundantly talented magician; a master of deception. Chagall's image

is that of an especially gifted painter, conveyed symbolically by the two extra fingers, hinting at his ability to perform artistic magic – beyond the capabilities of mere mortals. Both artists live in a non-Jewish environment and have a desire to fit in with their surroundings, be cosmopolitan and enjoy international renown. They are highly creative and skilled and neither looks like or is perceived as Jewish: Yasha because of his uncommon and untypically Jewish occupation, requiring frequent travelling for his performances in the circus and mingling with the Gentile Polish society; he is, therefore, not well received by the Jewish community. Chagall's revolutionary appearance is that of a modern, sophisticated, cubist artist with elegant clothes and a special hairstyle.

The two figures are characteristic of the modern hero. Chagall's cubist distortions contribute to his image as a man of the twentieth century, with the city of Paris and the Eiffel Tower behind him, though for all his exposure to Modernism, he still dreams of the *shtetl* and its culture – the creative starting point from which he sprang. Yasha, who lives at the end of the nineteenth century, is on the brink of Modernism, and is the figure of the modern anti-hero: inquisitive, sceptic, beset with doubts, hesitations and indecisions. The central issue of both works is that of a crisis of great magnitude. Their conflicts are of such proportions that both agonise over having to choose between two polarities, two cultures and two lifestyles.

Yasha is at a crossroads. Though a great womaniser, his primary struggle concerns Emilia and Esther, who represent the two religions – Christianity and Judaism. Chagall is confronting a choice between two locations: the town of his past – Vitebsk – and the city of his present – Paris.

Yasha's inner struggle is the conflict between the familiar and the foreign. He no longer observes the commandments of his faith, nor does he live in accordance with the Orthodox Jewish way of life. He finds the bourgeois Christian Polish society more attractive, accommodating and welcoming as he feels his alienation from his faith growing stronger. Yasha goes through emotional agony as he approaches the idea of conversion to Christianity. It is only after seeking physical shelter from a fierce storm, and finding it in a synagogue, that he realises it is spiritual as well. The epiphany he experiences in that familiar ambience reveals to him that it was God who thwarted his committing the crime of breaking into a safe, by making him break a leg in the process. He reaches the overwhelming and profound understanding that Divine Providence loves him, watches over him and saved him from the consequences of his impulses, that he is descended from generations of God-fearing Jews and that he is being called back home; he is determined to return unequivocally to his religious origins, knowing full well that he will have to make great sacrifices – one of which will be letting go of his desire for absolute freedom.

The symbol of such complete freedom is his being up in the air, totally unattached, on the high wire. But in actuality, he is only supposedly free, since stringent rules of precision have to be adhered to in order to maintain his balance, or else this demanding occupation might end up in his downfall or death. His desire to be free physically, spiritually and artistically appears in his dreams as well, as he soars and flies like a bird. Consequently, in order to be embraced again by the Jewish community and atone for his deeds, he gives up the rootlessness of his travels and permissive lifestyle, isolating himself from the temptations of the external world. His

transformation from wantonness to piety, from debauchery to asceticism, to becoming a righteous, devout and pious man, is complete. He becomes a repentant saint. Being a man of extremes, this man, who aspires to be unfettered on many levels is incarcerated, ultimately of his own volition, in a doorless prison.

Chagall's internal discords, as a modern twentieth-century painter and a Jewish artist torn between two worlds, are expressed in the exaggerated and disproportional facial features. The focus of the painter's inner turmoil is the choice he has to make between the past and the present. Vitebsk, with which the painter's entire being is preoccupied, is etched in his heart. It is his memories, his childhood, the place to which his entire inner spiritual life is connected. 'Speaking' to his Vitebsk he says: "On your soil I left . . . my soul . . . I did not have one single painting that didn't breathe with your spirit and reflection."[25] Vitebsk is the emotional and inspirational source of his work, whereas Paris means the most to him physically and professionally. For all his exposure to modernist influences, one cannot help but sense his nostalgic yearning for his past. As in Yasha's case, Chagall reveals what is most important to him – his origins. He is facing Vitebsk in the small image above and to the right of his head – enveloped by clouds – and he presents it on a canvas on the easel as well: a quotation from his *To Russia, Asses and Others*. The words 'Paris' and 'Russia' appear on either side of him in Hebrew script. It is obvious that while relating to his town, he retains the image of the surrounding Gentile world, and yet the Yiddish words dispel all doubts as to which direction he is leaning. Therefore, it is of no consequence at all where Chagall is, geographically speaking. Both Yasha and Chagall then eventually return and remain tied to their Jewish sources, despite external ideological and stylistic attractions.

Being a magician, Yasha lives in a world where deception mixes with honesty, fake mixes with real. This leads to his conflict about whether there is a transcendental, supernatural reality beyond the physical, visible existence. Yasha is presented as "no ordinary man", "a special wondrous character", immersed in the spiritual world of prayers, preoccupied with the mysterious world of the occult, experiencing an epiphany in the synagogue – all pointing to the Metarealism in the novel.

In the painter's self-portrait the Metarealism appears both in the distorted portrayal of his face and in his adding two fingers – representing the artist's soul – to the painter's hand, indicating the artist's unique talent and capabilities.

Stylistically, the novel is written mainly realistically, with symbolic and surrealistic elements. The starting point of the painting is realistic, with fauvist, cubist and surrealist elements. The two works share the umbrella of the metarealistic style.

Both heroes are seen as they experience revolutionary changes. As the narrator, Singer describes Yasha's from the start to the radical conclusion, step by step. Chagall depicts himself in the midst of a crisis or conflict and from there, leads the viewer to the past.

This comparison clearly reflects that literature is the art of time, while painting is the art of place.

# Notes

1   Isaac Bashevis-Singer, *I.B.S. Collected Stories: A Friend of Kafka to Passions*, The Library of America, N.Y., 2004, p. 363.

2   See: Irving H. Buchen, *Isaac Bashevis-Singer and the Eternal Past*, N.Y. University Press, N.Y., 1968, p. 204: "Singer's skepticism works both ways. He looks at the past with a modern eye at the same time that he adopts traditional optics to scrutinize modernity."

3   See: Richard Burgin, *Conversations with Isaac Bashevis-Singer*, Doubleday & Company Inc., Garden City, N.Y., 1985, p. 20.

4   See: Isaac Bashevis-Singer, *People in My Way*, Sifriat Poalim, Tel Aviv, 1999.

5   Ibid.

6   Isaac Bashevis-Singer, *I.B.S. Collected Stories: a Friend of Kafka to Passions*, Library of America, 2004, p. 610.

7   See: Marc Chagall, *L'Art de la Peinture*, P. Seghers (ed.), Seghers, Paris, 1957, pp. 651–656.

8   See: Marc Chagall, *My Life*, Translation: Dorothy Williams, Peter Owen, London, 1965, p. 84.

9   See: Isaac Bashevis-Singer, *The Magician of Lublin*, Penguin Books, 1960, p. 21.

10   See: Jule Chametzky, "History in I. B. Singer's Novels", in *Critical Views of I. B. Singer*, Irving Malin (ed.), New York University Press, N.Y., 1969, p. 172: "The story is at once a parable of the artist and of modern man . . ."

11   See: I. H. Bilezki, *God, Jew, Satan in Works of Isaac Bashevis-Singer*, Sifriat Poalim, Tel Aviv, 1979, p. 122.

12   See: J. S. Wolkenfeld, "I. B. Singer: The Faith of His Devils and Magicians", in *Critical Views of I. B. Singer*, Irving Malin (ed.), New York University Press, 1969, p. 94: "Its discussion of faith leads more directly, though not more pertinently, into the modern situation. It shows us two connected dilemmas – one, that freedom ultimately becomes a trap like any other and two, that all human actions lead eventually to death and to evil."

13   See: Ben Siegel, *Isaac Bashevis-Singer*, Minneapolis, University of Minnesota Press, 1969, p. 6.

14   See: Azriel Uchmani, *Contents and Forms*, Part 1, Sifriat Poalim, Tel Aviv, 1976, p. 78.

15   See: Ruth R. Wisse, "Singer's Paradoxical Progress", in *Critical Essays on I.B. Singer*, Grace Farrell (ed.), G.K. Hall & Co., N.Y., 1996, p. 110: "Finally, to escape the world he both loves and fears he returns home and walls himself up in penitential solitude. The choice between licentiousness and asceticism is made absolute, as if the only escape from the one were to the other."

16   See: Hillel Barzel, *Metarealistic Hebrew Prose*, Masada, Ramat Gan, 1974, Introduction.

17   This painting also has a preparation, like other works by Chagall.

18   See: Franz Mayer, *Chagall*, Thames and Hudson, London, 1964, p. 167: "Far from being a naturalistic study, it is a complex metaphor for Chagall's peculiar position as man and artist at that time."

19   Ziva Amishai-Meisels mentions this fact in the book: *Russian Jewish Artists in a Century of Change 1890–1990*, "The Jewish Awakening: A Search for National Identity", Prestel, Munich–New York, 1990, p. 55: "Chagall went to Paris in August 1910, absorbing fauve color and cubist faceting into his 'folk' style. He redid his major Russian Jewish works in his new French style . . . He expressed his multifaceted identity in 'Self-portrait with Seven Fingers' . . . in this painting he encapsulated the identity crisis many newly emancipated Jewish artists expressed in their works."

20   See: Jacob Baal-Teshuva, *Chagall*, Taschen, Köln, 2000, p. 68: In this book, Baal-Teshuva claims that the number 7 held a special significance for Chagall, one of magic and mysticism, also because Chagall himself was born on the seventh day of the seventh month in the year 1887.

21   See: Michel Makarius, *Chagall*, Hazan, Paris, 1987, p. 62: "The Self-portrait with Seven Fingers affirms the artist's ability to transfigure reality: a transfiguration that firstly touches the actual hand of the artist whose powers seem thus multiplied."

22   See: Aleksander Kamensky, *Chagall – The Russian Years 1907-1922*, Thames & Hudson Ltd., London, 1989, p. 104: "This work is a milestone in Chagall's creative work, it is the first of his works in which the cosmos becomes the setting for the action . . . it opens a new dimension . . . none of Chagall's previous works so closely combined both the every day and the fantastic."

23   See: Mira Friedman, "The Paintings of Chagall – Sources and Development", The Tel Aviv Museum, 1987, p. 167: "The artist distinguishes between three levels of reality in the painting. . . . "true" reality: the world which can be glimpsed through the window – where the city of Paris is depicted . . . The second level of reality is embodied in . . . the remembered image of Vitebsk, rising up in his mind's eye . . . depicted here enveloped in clouds and floating in space. The third reality is manifested in the painting resting on the easel . . . in the artist's imagination and is given concrete expression in his artistic creation . . ."

24   See: Marc Chagall, "Art and Life", University of Chicago committee on social thought, typescript, Feb. / Mar., 1958, p. 2.

25   *Marc Chagall on Art and Culture*, Benjamin Harshav (ed.), Stanford University Press, California, 2003, p. 92.

Chapter **THREE**

# Love and Lovers

The motif of love and lovers is central to the works of both artists who relate to three different kinds of love:

    A.  Spiritual – within the framework of Orthodox Judaism

    B.  Sentimental / nostalgic – associated with the experience of the *shtetl*, the Yiddish language and its culture

    C.  Physical / sensual – depicted quite openly in the spirit of the times.

Bashevis-Singer tends to keep these three kinds of love distinct.

An excellent testimony of deep affection within the Orthodox way of life is provided by *The Penitent*. The protagonist, Shapira, has a long history of romantic involvements, starting with the marriage to his wife, continuing through adultery (chance encounters) but ending in his choosing (through matchmaking) a rabbi's daughter from the ultra-Orthodox Me'ah She'arim quarter in Jerusalem.

In *The Magician of Lublin*, Yasha Mazur is physically drawn to several women about whom he cares deeply: Emilia, Magda, Zeftel, but the most ideal and winning love in Bashevis-Singer's view is that represented by Yasha's wife Esther, since hers is anchored in the Orthodox way of life.

Bashevis-Singer appreciates and misses nostalgic love, while he scorns the 'capitalist' kind he finds in America. He does not hold back when it comes to his contemptuous criticism of relationships between men and women that are based on interests, money, power and exploitation.

Love of the nostalgic variety, associated with the Jewish culture and milieu, is frequently found in Bashevis-Singer's writing. An obvious example is the novel *Shosha*, in which Aaron Greidinger, filled with yearning for lost dreams, returns to his childhood sweetheart, a girl who is mildly retarded but who brings with her the memories of and associations to the 'aromas' of Yiddish and its culture that are no more.

In fact, there is a certain connection between Bashevis-Singer's personal life and his love stories, although they are not exactly autobiographical. The attraction most commonly found in his writing is of the physical and sensual kind, which he describes quite explicitly, as was the practice of some of his contemporaries. Bashevis-Singer is very much aware of the issues of sexual desire and lust, and includes many such rapturous encounters in his works.

Herman's physical attraction to Masha, the Holocaust survivor, is described in *Enemies, A Love Story* as somewhat complex-ridden. Although Herman realises that

such strong emotions are destructive, they prove stronger than he is, and he continues to meet with the attractive woman.

In many stories there are women who make a brief appearance and with whom the narrator has an affair or a flirtatious episode, such as in "The Briefcase", where he has a chance encounter with Rosalie Kaddish, following one of his lectures.

Perhaps the work that most perfectly embodies the combination of true sensual and spiritual affection is his novel *The Slave*, which describes the love of Jacob the captive and Wanda-Sarah, the convert to Judaism.

For Chagall, a lyrical artist and poet, love is one of his favoured subjects. The three kinds of love in his works are united into a single essence. His attitudes towards women, his muse, his female angel, his beloved Bella as fiancée and wife, reappear in different formats throughout the entire span of his artistic career. Even after the death of Bella, who had been his inspiration and played such a significant role in both his personal and artistic life, Chagall continued to 'court' love with the same vigorous spirit, albeit with a certain acceptance of the changes due to advancing age.

Unity of body and soul, as in physical-sensual alongside spiritual-poetic love – all fusing into a single entity – is maintained. He transforms his deep closeness to Bella into an ideal emotional state. For him, the very delicate sensitivity is also connected to the past, to Vitebsk, to the Jewish *shtetl*, to the yearning for what used to be. In the years 1910–1922, the blossoming bliss between Chagall and Bella provided the main motif in a series of works. Thanks to his creativity and fertile imagination, his paintings transformed their private and personal happiness into universal images of true union between man and woman.

Chagall painted his *Lovers in Black* sometime after 1910. The stylised manner and use of black-and-white in this portrayal of a pair of young lovers within an oval framework create a dramatic theatrical effect. Although the figures are reminiscent of Chagall and Bella, this is not an actual self-portrait. In this early painting it is clear how the artist strives for both physical and emotional perfection, a prominent motif in many of his works dealing with the subject. The oval shape provides a sense of completeness and harmony, even though the couple neither smiles nor looks optimistic. Despite the contrasts between them, there is also a feeling of unity and intimacy achieved by their physical resemblance, and by the fact that Chagall uses rounded expressive lines which repeat the oval shape. Both figures are in black-and-white with a dramatic expression on their faces, especially the man's. Both are young and are positioned so closely together that their faces almost form a single portrait – eye to eye, nose to nose, and mouths almost united into one. This motif will become even more pronounced in later works.

Another step is taken in the direction of the perfection of mutual fascination in *Lovers in Blue* (1914). Here the two lovers are shown more fully than before. Their mouths truly unite into one, bringing them together in physical and emotional intimacy. Her hand covers his body, its caress further bringing them together. The dominant blue hues in the painting add a poetic and dream-like element, while the green suggests an association with nature and reality. Here, too, there is a theatrical note, reminding one of a circus or clowns – in the woman's dress, the bejewelled

glove, as well as in their collars. Through colour and composition, Chagall enables the couple to express a delicate and highly emotional sensitivity.

In *Lovers in Green* (1914–1915) Chagall reveals an even greater physical intimacy; however, there is less emotion here despite the parallel points between the two. Their heads are nearly aligned and united underneath a curved line, creating a kind of circle around them over the entire painting. Stylistically, Chagall uses more cubist forms than before: in their hats, their profiles, their lapels, especially that of the woman, and the geometrical shapes inside and outside the circle. Although their faces are of unequal size and height, Chagall still manages to convey the feeling of two-in-one. Green is the dominant colour, symbolising reality, nature and the dominance of the cosmos. In addition to the realistic aspect of the couple's attachment to each other, the atmosphere of the soft and subdued blue and purple add a sense of poetic reverie and revelation to the entire scene.

*Birthday* (1915–1923) is one of the first examples of Chagall's well-known floating motif, which he uses in the context of this favoured subject showing the natural blending of fact and the fantastic. There is an explosion of his feelings for Bella in a most original manner. He comes hovering through space behind and above her and surprises both her and the viewer with a kiss and a bouquet of flowers. The surrealist elements of soaring help Chagall make this scene of the beauty of intense love unforgettable.

In *The Promenade* (1917) Chagall himself is standing on the ground while a weightless Bella floats in the air drawing him up towards her; he expresses in a poetic and original manner the great happiness and excitement he is obviously feeling. He is the more prosaic of the two while Bella – overhead, dressed in an elegant purple garment – is trying to lift him up to the transcendental spheres beyond the cubist reality of the town.

In *Double Portrait with Wineglass* (1917) Chagall is riding on Bella's shoulder, raising his glass to toast their joy. The whole world – the sun and stars – participates in their celebration. Usually Chagall is the one with feet planted firmly on the ground, but in this case he is the one hovering above and it is she who is the anchor. His weight seems to press on her and thus one of her eyes is covered while the other is wide open, expressing her intense happiness, vitality and the inspiration she receives through the purple angel above them.

Multicoloured flowers of unusual sizes and shapes symbolise the great fascination Chagall and Bella have for each other. He expresses his joy in the form of the huge garlands he paints, with lovers inside.

At times the couple appear even though their mutual affection for each other is not the central topic of the painting. For example, in *Time is a River without Banks* (1930–1939), with the pair on the river bank, it is suggested that it might be possible to cope with the passage of Infinite Time which is the determining factor in the flow of life through fondness and overpower it by the strength of art and creative imagination.

A gesture to both physical-sensual attraction and pious devotion anchored in the Orthodox Jewish tradition is presented in *A Ma Femme* (1933–1944), which shows a couple under the bridal canopy. The woman, who strongly resembles Bella, is on a red bed and Vitebsk appears in the background within a kind of circle,

hinting at something remembered. A colourful flowery spot inside the circle expresses poetry and happiness. The two are surrounded by motifs often used to express romantic attachments: a fish, a chicken, a winged clock.

Later, Chagall paints his second wife Valentina in *Portrait of Vava* (1966), though one cannot identify her image as clearly as in Bella's case. Towards the end of his life, Chagall makes the subject of amorous attractions more abstract and symbolic as figures that are less clearly identifiable, although his approach to the subject is still as enthusiastic.

## "Sam Palka and David Vishkover"

"Sam Palka and David Vishkover"[1] is simultaneously realistic and incredible. In many ways it is typical of Bashevis-Singer's writing, although it is one of his more surprising works. There are two original combinations in the story: that of the Old and the New Worlds, pertaining to the main character, Channah Basha, and that of love that is pure and sensual, even crude – within a single figure – Sam Palka, who is also David Vishkover.

The story is based on contradictions: between the characters, between Sam Palka and David Vishkover; between Bessy, the terrible 'witch', and the naïve Channah Basha. There is also a sharp contradiction between the old, poor, shut-in world of the *shtetl*, which Channah Basha brings with her and zealously preserves for decades, and that of Manhattan outside Brownsville, where she lives. Almost all of Bashevis-Singer's stories contain an element of surprise, some completely unexpected 'punch-lines', usually saved for the end. But here the plot is full of surprises, wonderment and a mysteriousness which is not clarified even at the end. The reader is led by the protagonist's first person narrative from one extremely unlikely situation to another, which places a great deal of strain on the reader's credulity.

Bashevis-Singer opens with a very realistic background description of how Sam Palka tells the narrator his stories and asks him to edit them. This provides a realistic facet to the tale but also touches on one of Singer's favourite topics concerning authors, readers, works of literature, Yiddish-language journals in America, and the problematic nature of the bond between author and reader. Through Sam Palka, he takes the opportunity to attack modern literature and its writers. The author hides behind the narrator and shows just how inept and boring such writers are. Through the events recounted, one learns of life in America before and after World War II, up to the late 1950s, and hears passing mention of the establishment of the State of Israel.

The author severely criticises America through the descriptions of Jewish institutions, Yiddish writers and American literature, as represented by Sam Palka and his physical appearance. Nevertheless, it is Love which reigns supreme in the story. This is Palka's romantic, true caring for Channah Basha, alongside the cruder, more sensual kind of relationship: "Why should I deny it? I was not faithful to her all these years . . . I like to play also with others. As long as I did not have true love I spat on frivolous women, but now that I had a true love it suited me to play around with others too" (ibid., p. 682).

However, in this work such chance encounters, such supreme, forbidden pleasures, serve only to illuminate the true, innocent sentiment around which the plot revolves.

Channah Basha's character, her modesty, her humble way of life and feelings for David Vishkover are what transform a sensational tale into one of a purer, truer connection between a Jewish man and woman. In order to strengthen this image, Biblical allusions and Biblical parallels are used in the descriptions of emotional involvement in general and of Channah Basha in particular. This is characteristic of Singer's writing and of his symbol-centred pattern of composition found in other works as well. He begins with a Biblical allusion to love – that between Rachel and Jacob – and then goes on to mention some less pure ones – those of King David and Bathsheba, and King Solomon and the Queen of Sheba. Thus he prepares the background for the story with its double focus on the subject: sensual, and even cheap, versus pure.

Using this technique, he compares the female protagonist to Esther, the perfect queen. The author describes her as a unique, nearly legendary or fairy-like figure: ". . . this girl was white, with blue eyes and golden hair – a beauty . . ." (ibid., p. 677). The narrator describes not only her physical looks as perfection incarnate, but also her inner being – she was innocent, honest and incapable of lying, a romantic awaiting the true love of her life: "They offered me many matches but I refused to marry through a matchmaker. I have to be in love" (ibid., p. 678). Her beauty, purity and piety are all connected to the past, to the Jewish world of bygone days and to the *shtetl.* Even her apartment reflected this: ". . . and I saw a room that looked exactly like one in the old country. If I hadn't known that I was in Brownsville, I would have thought that I was in Konskowola" (ibid., p. 677). She dressed like they did in the Old World, cooked as they did, read only in Yiddish, rarely went out of the house and had never visited Manhattan. She busied herself with charities, wept and fasted for the Jewish victims of the Holocaust and contributed money to Israel.

Here Bashevis-Singer has designed a figure of perfection refusing to accept money or the luxuries of the surrounding materialistic world. The narrator never ceases to admire her and her innocence, and neither does the reader. Indeed, the inner world built by the protagonist and his feelings is unbelievable. He continues to visit her in a neighbourhood inhabited mostly by blacks and Puerto-Ricans, in a dilapidated house, eating the old-style cooking, having the same kinds of conversations and treating each other as was customary in the past.

This is the symbol-centric pattern which turns the relationship between David Vishkover and Channah Basha into a Jewish intimacy filled with sensuous and aesthetic pleasure; the narrator claims at the end that such a deeply meaningful union between two people cannot survive unless it is protected and preserved within the framework of the Old World. In fact, the main character does not reveal to his beloved that his wife Bessy passed away long ago and that he could in fact marry her, for the simple reason that he fears it will destroy the illusion David Vishkover built for the two of them:

> But this meant killing David Vishkover. Don't laugh – he is a real
> person to me. I have lived with him so long that he is closer to me

than Sam Palka. Who is Sam Palka? An old lecher who has made a fortune and doesn't know what to do with it. David Vishkover is a man like my father, peace be with him. (Ibid., p. 684)

The issue addressed here is: what is truth? Is it permissible to lie, to deceive, to cheat, to distort reality in order to attain the absolute truth and the truest of emotions?

The narrator understands that everything connected to his true identity has to do with America, the New World and its materialism, and that such genuine closeness as exists between him and Channah Basha can only do so inside the 'bubble' which she built together with him: "No one spoke a word of Yiddish in my crowd. How could I bring Channah Basha into this Gentile-like world? With whom would she be able to talk?" (ibid., p. 682). A possible solution would be to move with her to the Land of Israel, but World War II foils that plan. This suggests that such a blissful unity of hearts can last only in a spiritual context – the Holy Land. Here Bashevis-Singer states quite explicitly that a bond of this nature is nothing short of a miracle – related to time and place, related to the *shtetl* and related to the bond with the 'land of milk and honey'. The author creates a parallelism between the real and the imaginary, between the actual and the poetic.

## Lovers over the Town

This painting is one of the high points in Chagall's expressions of perfect, lyrical, physical and spiritual love.

In keeping with his custom in those years, a man and a woman, reminiscent of Chagall and Bella in real life are floating above a typical Chagall-style town. Chagall commented once that his paintings were his autobiography.[2]

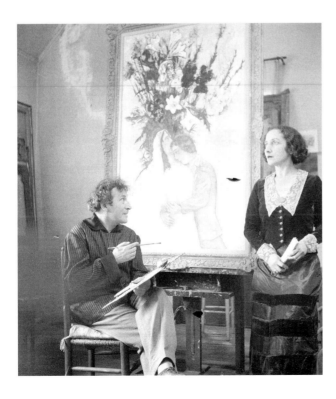

**12** A photograph of Chagall painting Bella in the Studio 1934. Getty Images/Roger Viollet.

The figures resemble those in a number of other works of his in the same period. There is a parallel between the couple and the town, while at the same time there is a significant contrast between them and the Jewish *shtetl*, accentuating the meaning of the Pale of Settlement to which the authorities limited the presence of Jews. The depiction is more of a village than a town because of the desire to stress its Jewish aspect and the connection which he and Bella share with their birthplace. For this reason the houses are small, low and sloped, so as to give them movement and expression; they are crooked, fragile and look like unplanned extensions. The greater part of the village, and especially the fence surrounding it, are presented in a cold, geometric cubist style, mostly in hues of gray and black. Six segments of a geometrically-shaped fence surround the town.

However, Chagall takes steps to alleviate the 'coldness' of the cubist rendition of the houses by placing them very close together. Some of them have chimneys, which are suggestive of home and warmth. He also highlights the open windows through the use of red, pink and yellow colours, which add comfort and expressiveness to the scene. However, the overall impression is still one of an angular grayness and loneliness. The village is almost completely empty: there are no people or animals except for the small goat in the background and the small human figure relieving itself outside the fence, both of which emphasise the down-to-earth nature of life, in contrast to the idyllic perfection of the couple above. The fences bind and close in, whereas the couple is very free, as if sailing in the open sky.

Beside the typical *shtetl* houses, there are also some buildings representing the Gentile establishment, as found in other paintings by Chagall, reflecting the reality that can be seen in the actual photograph of the town. A white church with blue-green domes is visible in the distant background, positioned almost in the centre of the painting. Next to it, a small building recalls Vitebsk Town Hall. Nearby, there is a pink-red building with two chimneys, comprising the colourful focus in the painting, located very near its centre as Chagall's knee and his left hand point to it.

Further to the right on the skyline there is a white house with a blue roof, reminiscent of a neo-classical structure. Chagall's right shoe points to it and gives it emphasis. Towards the lower right there is another cubist-shaped house that is softened by its colours, with a more cheerful and vital look than the others around it.

The spots of colour Chagall adds to some of the houses, the green area signifying vegetation and nature, and the bluish spot near the neo-classical building, indicating the sky, all soften the gray cubist reality and connect to the couple up above, who look rounded and lyrical in comparison with the geometrical village below.[3]

The couple is quite out of proportion to the size of the town, taking up nearly the entire width of the painting, hovering above in a protective manner. To emphasise the expression of the great affection between the two and the rapturous spirit, Chagall uses his famous and unusual soaring motif, his metaphoric way of expressing elation and freedom rather than something banal, exaggerated or melodramatic. Chagall succeeds in placing this concept at the centre, focusing attention on a love unbridled, unfettered, that is at the same time realistic and symbolic – physical and spiritual.

While these figures appear autobiographical, Chagall turns them into universal symbols of lovers by means of the stylised cubist design and gray colouring, and into Jewish lovers through their profound bond with the village, though they lack the

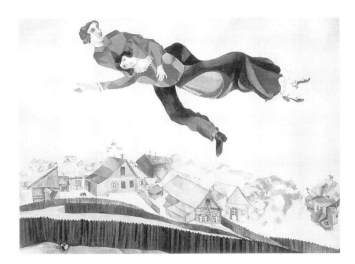

**13**   *Lovers over the Town* (Over the Town), Marc Chagall, 1914–1918, oil on canvas (198 × 141 cm). © ADAGP, Paris and DACS, London 2009.

appearance of Orthodox Jews.[4] While each of the two figures is separate, they almost blend into a single body – like a musical instrument reminiscent of a cello: Chagall's head and upper torso serve also as Bella's body, and Bella's lower torso serves as Chagall's. His left arm is on her and her right arm is stretched up in the air, protecting her hometown, sheltering it and so they seem as two arms of one person. Her two legs are balanced in the air and fuse with his left leg, while his right leg sticks out, more closely connected to the town, and can be perceived as the couple's second leg.

Certainly, there are differences between the masculine and the feminine figures in the painting. Chagall is more angular, Bella rounder and softer. The composition is one of balance and harmony, and physical and emotional perfection. Their expressions are similar and a certain physiognomic resemblance can be discerned. Thanks to Bella, he is able to rise above reality and float, experiencing both metaphorically and realistically a true spiritual and poetic unity. His leg is the anchor and balance for life and the 'lever' holding them airborne. Therefore, it has the various gray colours of reality, as well as dark and light blues – related to the sky, to spirituality. He has shades of green as well, linking him to nature and the more poetic aspects of reality. Bella is more spiritual, lyrical and airy. Chagall is more down-to-earth, though his head nearly touches the top of the picture – the sky.

The green-blue spot near the lower right-hand corner and the green-blue of the church and its surroundings are hues that also appear in the couple's clothing, accentuating the link between the real and the ethereal, the metarealistic. All this is achieved through a portrayal of love that is at once realistic, symbolic, universal and Jewish.

COMPARATIVE ANALYSIS
## "Sam Palka and David Vishkover" and *Lovers over the Town*

Both works present love as the central theme. The artists succeed in taking a topic that could easily be something of a cliché, and turning it into something unique,

imaginative, a combination of reality and surprise. In these compositions one finds two private 'universes' of special interpersonal communication. In the first, Sam / David and Channah's, it is more shell-like, impenetrable, while Chagall and Bella's – though as private – is less secluded insofar as the outside world is concerned. The distinction between the two creations, dealing with the attainment of the supremely felicitous state, lies in the means towards the achievement of that end. In the former, the tool to attain such absolute bliss is based on falsehood, while in the latter both the goal and the route towards it are based on inventiveness and imagination, but most importantly trust and fidelity.

For Chagall, the originality of his wild imagination turns the joining of heart and mind into a sphere in which the physical and the metaphysical come together. The metaphorical floating and defiance of gravity turn Chagall and Bella's oneness into a suggestion of freedom and joy.

Bashevis-Singer, too, used his fertile imagination to turn the incredible into the nearly believable. Through his use of the element of the unexpected, and by constructing the story on contrasts and opposites, he succeeds in creating emotions that are real but imaginary at the same time, physical as well as spiritual, which become an indication of perfect universal and Jewish love.

The realistic kind of relationship which both describe belongs to a specific time and place in relation to a town – Brownsville or Vitebsk. The extensive verbal and visual portrayals of both artists indicate the extent to which the lovers are part of the town and its life. The difference is that in Chagall's painting, everything – even the town – is more lyrical, more poetic, whereas Bashevis-Singer's story contains criticism of the Jews in America, the lifestyle, the state of the Yiddish language, its culture, its writers and readers. What is surprising is that although Bashevis-Singer is generally speaking more sharp-tongued, critical and even overly cynical, in this case he describes a complete, harmonious, physical and spiritual unity, as does Chagall. In Chagall's painting, the relationship is based on the real-life, truly remarkable bond between the couple, while Singer invents the fraud of the main character's double identity in order to create an exceptionally intimate sensitivity. In both works the particular relationships – between Bella and Chagall, and between Channah Basha and David Vishkover – are turned into a representation of universal-Jewish harmony. By means of the link between the realistic and the metarealistic, the protagonist in the story possesses two separate identities, which later merge into one. In the painting, the figure of Chagall floating over his village represents both the real and the metareal.

The artists connect their fervour, enthusiasm and mutual joy to the home, the Jewish village and to Yiddish. Chagall has deep ties to his hometown, Vitebsk, and Bashevis-Singer brings the *shtetl*, which he misses and appreciates more than ever now, to New York. Home has a special significance and serves as an anchor for each relationship and strengthens it, in a physical as well as a metaphorical context. Chagall depicts Vitebsk in a cold cubist style, but with spots of colour. He shows universal and Christian elements, such as the Town Hall and the church, and at the same time he paints the small clusters of houses of the Jewish part of the town.

Bashevis-Singer describes the corruption in New York, where the relations between the sexes are hypocritical, and where money is the 'idol' of desire. In

contrast, there is Channah Basha's modest home, which enables the narrator to imagine he is back in Konskawola. Channah Basha maintains all the Jewish customs in the Gentile city of New York: "I pushed the latch, the door opened, and I saw a room that looked exactly like one in the old country" (ibid., p. 677). The foods, the Yiddish plays she sees, the books she reads, her never having visited Manhattan, her entire personality and appearance are products of the culture of the past.

The Jewish motif appears alongside the universal one in both cases. The difference between the two works in this respect lies in the fact that Chagall only hints at criticism, by marking the ghetto boundaries and showing the man relieving himself, whereas Bashevis-Singer levels very sharp criticism against the materialistic American way of life, to which the Jewish home provides the contrast of authenticity and honesty.

Eternity is part of love and the ideal kind has to do with absolute time, but it is also vulnerable and fragile. Chagall depicts an impossible situation: a couple floating in the sky, defying the laws of gravity, and yet the artist succeeds in convincing the viewer of the veracity of the joyful experience, though logically the situation is fragile, as the couple could fall down at any moment and their feelings could come crashing down with them. In Bashevis-Singer's story, love's fragility is even greater. Sam Palka's lie may be exposed any day. David Vishkover is 'playing with fire', so to speak, and the game may destroy this perfection: "Besides, to find out that I had been lying to her all these years might be a shock that would tear our love apart like a spider web" (ibid., p. 682).

Emotional euphoria manages to elevate a person above reality: Sam Palka rises above all the corruption around him and overcomes all hurdles obstructing the path to his emotional 'bubble'. The same is true of the painting: Chagall and Bella are floating in the free and open air. The two couples are protected by their enclosed, sheltering personal space – the freedom in the open air and sky, and the collapsing but still surviving house in Brownsville.

Despite these similarities it must be noted that the story is more critical and realistic, and by definition more detailed – for it speaks of a process from youth to old age. Sam Palka does what he can to enter a secluded 'bubble' which will grant him true happiness with the naïve Channah Basha, who does not change even as she ages. But the situation does: "We are both on diets. She now cooks with vegetable oil instead of butter. I am afraid to eat a piece of babka – cholesterol" (ibid., p. 684). Bashevis-Singer is very sober-minded; even when relating to the absolute state of exaltation he remains critical, but with a wink.

Chagall, on the other hand, depicts lovers, in this as in other paintings, as young people who are more beautiful, optimistic and lyrical and less aware of life's hardships. Even in his old age Chagall remained faithful to this approach of poetic idealism.

As a result of these two approaches, and perhaps due to differences in the artists' personalities and the circumstances of their lives, there are distinctions in the types of couples described. The general concept is the same: that of the universal yet Jewish archetype. In the painting, each of the two romantically involved souls is independent, and only subsequently do they become one. Bella is a liberated woman whom Chagall turns into a modern woman through her independence and

her being equal to him, and also by means of the modern and daring cubist style he uses to shape her image.

Channah Basha is somewhat childlike and naïve, still living in the old world and incredibly dependent on Sam Palka physically, mentally and emotionally: "Channah Basha. She was always the same. In all those years she learnt only a few words of English" (ibid., p. 681).

Both works present the ideal, personal, Jewish and universal love.

## Shosha

At the core of the novel *Shosha*[5] lies the extraordinary and impossible love of the narrator, Yiddish writer Aaron Greidinger, for his childhood sweetheart, Shosha, who lives at 10 Krochmalna Street, Warsaw.

From the outset, the reader moves between the novel's two poles of real and metareal. The latter consists of details so fantastically fictional as to defy credibility. As is his custom, Bashevis-Singer mentions actual places, well-known historical events and precise dates in order to give a realistic basis to the composition. "It was summer 1914. A month later a Serb assassin shot the Austrian Crown Prince and his wife" (ibid., p. 16). Later he describes the period preceding World War II and its aftermath, clearly delineating the hardships of physical survival in the shadow of war.

It is against this background that the author tells of the narrator's unlikely relationship and marriage to Shosha, a girl bordering on the retarded, both physically and mentally:

> Shosha made silly mistakes in her Yiddish; she began a sentence and rarely finished it. When she was sent to the grocery store to buy food, she lost the money. Besheleh's neighbours told her she ought to take her daughter to a doctor because her brain did not seem to be developing but Besheleh had neither time nor money for doctors. And how could they help? Besheleh herself was as naïve as a child. . . . at nine she spoke like a child of six. (Ibid., pp. 9–10)

In her studies and her development she lagged behind, and even when the narrator meets her again many years later, he notes that she has not changed. Bashevis-Singer criticises society and its ignorance in matters concerning women and relations between the sexes. Using Shosha's real innocence and her arrested development as a backdrop, he stresses people's cruelty, ignorance and prejudices: ". . . I did not know there were still such fanatics in Warsaw" (ibid., p. 102).

Even after she grows up, Shosha remains as she was – a unique type of person, a kind of 'exhibit' in the centre of the novel: "Shosha had neither grown nor aged. I gaped at this mystery" (ibid., p. 74). Although the narrator is aware of it all, he is still attracted to her: "Her figure had remained childlike, although I detected signs of breasts" (ibid., pp. 74–75).

He is quite aware that his emotional involvement makes no sense. Shosha does not live in a realistic world; certainly not in his. But against all odds he *does* marry

her because she represents purity, naïveté, beauty and truth. She evokes in him memories of his childhood and of the Jewish street as he remembers it with its sights, sounds and scents, recreating a world that is no more.

It is quite difficult to imagine a close bond between two people who are so different. From the novel's very beginning the polarity is striking: a rabbi's son, scion of a learned family with a distinguished lineage, and a mildly retarded person from an uneducated family. Their homes were also very different, which can perhaps explain why Aaron the child was attracted to his friend. Aaron's was quite ascetic. Everything there was forbidden; hers, on the other hand, was a warm place, full of furniture, utensils, the aromas of good cooking – a kind of refuge from the cruel world outside. Whatever Aaron was not allowed to do in his own strictly Orthodox home, he was permitted to do in her house.

In her company Aaron feels important, developing his imagination, inventing and weaving stories for her, passing on to her his knowledge of logic, atomic theory and various foreign terms. Shosha avidly takes in all that Aaron offers and he finds himself infatuated with her, as when they were still children.

These memories, this innocence, these pure feelings, become sweet reminiscences and dreams for which the narrator yearns, though he is not even certain of their meaning: ". . . I did not know it, just as I didn't know that my friendship with Shosha, the daughter of our neighbour Besheleh and her husband Zelig, had anything to do with love" (ibid., p. 9). Still, throughout the years of adulthood he continues to long for that childhood experience which remains engraved in his heart.

The narrator grows up to be an author and playwright. He has relations with a number of women, three of whom play a role in the novel. All three are very different from Shosha: Dora is a communist revolutionary; Celia is a married woman from a good family and Betty Slonim is a theatre actress from America, for whom the narrator is supposed to write a play. Quite possibly it is the tremendous dissimilarity between Shosha and these three which so draws him to her. After their marriage, Shosha, who did not make a good partner for conversation, *does* change and develop. Strangely but also understandably, memories and longings turn into a real and growing fondness. Even within the sphere of their physical relationship, unexpected things happen. At first Shosha is even embarrassed to give Aaron an innocent kiss. He is physically attracted: "I was cold, too, yet at the same time I was overcome by a desire different from any I had felt before" (ibid., p. 198). Subsequently their desire for each other grows stronger yet.

The novelist is very critical throughout the book. At first he criticises the classroom (*cheder*) in which Aaron studied as a child, where no secular subjects were taught but only 'dead' languages – Yiddish, Hebrew and Aramaic that are of no use. Yiddish, recognised only by a small group, was frowned upon by those religious sectors when used to write about secular subjects, and then was in danger of vanishing altogether. He criticises the ascetic religious life at home, where Judaism to him was a world of deprivations, restrictions, prohibitions and variations of 'Thou shall not'. The narrator attacks the injustice and inequality between 'haves' and 'have nots', especially in time of war. Nothing worthy of criticism escapes his notice. He describes corruption, prostitution, crime and injustice on the Jewish street.

The echoes of war, fear of Stalin and the even greater fear of Hitler provide muted but dissonant background music to the story's events. The dangers which Jews face are explicitly expressed by Betty, the actress. The narrator's concern for Shosha is strong, as is his emotional and moral commitment, so much so that he rejects Betty's offer to travel with her to America and save his life. His relationship with Shosha ties him to the past, to the *shtetl*: "Although I had turned away from the Jewish path, I carried the Diaspora upon me" (ibid., p. 223). When Betty inquires about his strange marriage, his answer is: "I really don't know, but I'll tell you, anyway. She's the only woman I can trust" (ibid., p. 231).

Perhaps Shosha's link to the metarealistic is also part of her charm. She dreams, sees the dead resurrected and imagines demons and spirits, which she fears. Despite her childishness she possesses sharp senses, which connect to the supernatural, especially to anything having to do with death in general and her own in particular. One example is the appearance of her sister Yppe in a dream:

> . . . Suddenly Yppe was there. How could she do it? She spoke to me like one sister to another . . . then that day before Yom Kippur I saw her in the chicken soup. She had a wreath of flowers on her head, like a Gentile bride, and I knew that something was going to happen. (Ibid., p. 206)

Reality and metareality are cleverly, gently but tightly interwoven throughout the novel, creating a fantastical setting for the symbol-centric exhibit of a love that is personal, universal and Jewish all at once.

To a certain extent, Shosha may be said to help the narrator in his writing and in developing his talent, serving as a kind of muse.[6] She brings him luck in his writing; in her way she stops the advance of time, denying death, since she embodies Krochmalna Street and its dead as they were twenty years earlier. And after all, what does literature do if not stop time and preserve it? Consequently, both she and literature extend time; they move the past to the present with perhaps a hint at the future.

The heroine evolves to become Aaron's literary and social companion, with whom he shares thoughts and discusses ideas, including those about the pieces he is writing. Her innocence allows him to feel liberated in her company.

Shosha's external appearance, like her behaviour, improves, and twice in the course of the novel she mentions her desire (which remains unfulfilled) to bear children. Aaron considers his wife also to be his child; When Betty tries to convince him to flee to the United States because of Hitler, he says: "I can't kill a child. I cannot break my promise either" (ibid., p. 230).

In order to come full circle from Aaron Greidinger's perspective, and perhaps to end the novel, which is somewhat like a fairy tale, the author adds an epilogue: Shosha's death and the atrocities of the Holocaust. This is the same literary device used in *The Magician of Lublin*. In the Epilogue the author describes the end of love vaguely and indirectly. He comes full circle through his visit to the Land of Israel and his emotional meeting with Haiml Chentshiner, who reminds him of things forgotten – introducing into the novel subdued echoes of the unspeakable brutality and ruthlessness endured.

## *Between Darkness and Light*

The retrospective painting *Between Darkness and Light*[7] (1938–1943) is a self-portrait with Bella, painted partly during the war years and partly when they were already in America.

This self-portrait is an expression of Chagall's great appreciation of and intimate attachment to Bella, as muse and woman, who complements him and gives him personal and artistic hope. Chagall depicts himself as a painter with palette and brushes, next to an easel. Much of the painting is dominated by the scene behind him of his town Vitebsk, covered in snow in the harsh cold of winter – a symbol of life's hardships. Chagall in fact depicts himself surrounded by the cares of his world – the Jewish *shtetl* in the background with its familiar, small, tightly packed houses. The black windows seem to 'speak' sadness. A sled hitched to a draft animal carries passengers trying to escape the cold and other afflictions.

On the road above there is a male figure in the shape of a street lamp; this might be an allusion to his father. Below, in the left-hand corner, a woman with a chicken's head is holding a baby in her lap. This is one of Chagall's symbols of motherhood (perhaps his own mother). The style is daring and original, creating more universal interest than if he had painted a typical image of a woman and mother.

The chicken has a human expression in its large eye, its beak and its crest, which resembles a feminine hairdo. Her expression is worried, sad, as is the baby's, and she is cut off at the side and below. The baby is held by a hand that is half wing, with feathers for fingertips, and another which is human. By means of the embrace of the wing, the two are joined into one in a symbol of perfect motherhood.

The artist is standing next to his easel with a sombre expression on his face. On either side of his shoulders are wing-like shapes; an association reinforced by the previously mentioned earlier painting: *Auto-Portrait with Wings*. To his right is the shape of a path – originally a wing – and to the left is the colourful red shape from which Bella emerges. These two shapes define a triangle into which the *shtetl* above fits.

In the treatment of the subject, there is something metaphysical about the village. The artist looks like an angel with superhuman traits. Here Chagall mitigates this aspect and turns the wing-like shapes into a means to link him with the town, with his past and with Bella, who is his present and future.

Bella bursts in from outside the picture, the wind blowing in her hair. She moves in and connects to Chagall's face, above and along his left arm. Their two faces unite into one. Bella is the artist's beloved and his inspirational muse. Chagall's face is mostly a darkish blue, suggesting concern. Bella has a white face, suggesting hope. Around her neck is a red scarf which could allude to the sunset with its fiery red and to the three colours, blue, white and red, forming the French *tricolor*. In other words, the colours symbolise the flag of France, the land of liberty, equality and brother-hood, extending him a professional invitation. This is another example of the combination of reality and metareality, as is Bella's floating and the fusion of faces and bodies into a single figure. Thus, this very particular couple takes on a more universal significance: the artist and his inspiration, the artist and his beloved, the

**14** *Entre chien et loup* (Between Dog and Wolf; also indexed as Between *Darkness and Light* (Twilight)), Marc Chagall, 1938–1943, oil on canvas (100 × 73 cm). Private Collection, BI, ADAGP, Paris/Scala, Florence © ADAGP, Paris and DACS, London 2009.

Jewish couple, and the link to the *shtetl*. In fact, the couple is standing here at an emotional and professional crossroads – having to choose between Vitebsk and Paris. His left arm, his thumb and his brushes are turned towards the easel, indicating his intention to go to France, whence Bella comes and points to. Bella gives him 'air', vision and daring.

## Comparative Analysis
## *Shosha* and *Between Darkness and Light*

These two works focus on the topic of the various aspects of ideal love – physical, spiritual and artistic – each placing the artist at the centre of their portrayals.

The protagonist of *Shosha* is author Aaron Greidinger, while Chagall himself is at the centre of his painting. In describing the course of Aaron Greidinger's life and how he deals with the difficulties of writing, Bashevis-Singer presents the problems which he himself faced as a writer, and specifically as a Jewish one. So does Chagall vis-à-vis painting, when he positions the artist and his beloved at a crossroads between Vitebsk and Paris, with the former in the background and his easel in the forefront.

The autobiographical or semi-autobiographical[8] nature of these compositions is one of the key points of similarity. In Bashevis-Singer's own words: ". . . *Shosha* is the only novel I wrote in the first person. Almost like memoirs"[9] (ibid., p. 87). Krochmalna Street and Warsaw set the scene for Aaron Greidinger, who in many respects is reminiscent of Isaac Bashevis-Singer as a child, young man and author whose background was one of deprivation in Warsaw's Jewish quarter. Aaron is a lively and inquisitive child who displays a great thirst for knowledge. Religious and secular Jewish life in the *shtetl* is vividly related, spanning childhood, youth and adulthood, and into the couple's unexpectedly successful marriage.

Chagall and Bella resemble themselves; they are depicted against the background of the Jewish village in Vitebsk. Bella emerges from outside the picture, from the open air, and represents the artist's love and muse, his inspiration as artist and man.

Both works are based on a nostalgic yearning for a bygone dream; such longing evokes a desire to preserve it as it used to be.

The two works look back in time. Just as Singer wrote the novel in America, Chagall painted the picture when he was no longer in Vitebsk, but in Paris. They observe themselves, their towns, families and the existential state of the Jewish people from a perspective of gentle longing, from a distance of time passed; in the painting this is all shown by means of the gazing expressions, which are not at all focused and seem to be imagining, perhaps dreaming; directed to vistas beyond time and the viewer.

The artists present themselves against a background of issues of personal and national consequence, such as the rise of Hitler and the outbreak of World War II. The novel begins during World War I. It provides a very authentic description of the hunger and shortages during that period. As time goes on, the increasing power of the Nazis underlies the plot. Fear is never far from the surface. Betty understands this more than anyone: "The Jews here are all going to perish. You'll sit with that Shosha until Hitler marches in" (ibid., p. 229). In the epilogue, when Aaron Greidinger meets Haiml Chentshiner in Tel Aviv, Greidinger hears what befell him and millions of other Jews whose fate was worse by far: "A hundred times I virtually looked the Angel of Death in the eye, but when you're fated to stay alive miracles occur" (ibid., p. 239).

Chagall, too, depicts a time of danger and impending destruction, manifested by the ominously dark skies in sharp contrast to the whiteness of the snow; a mother fears for her child's fate, people are fleeing in a sled, and even the houses appear 'frightened'. The painting was created during the period 1938–1943, the war years, allowing for the red colour of Bella's shawl to be associated with blood.

Another point the two works have in common is the fact that against this shared backdrop of the times, the artists present an ideal love, which is also linked to art. The women act as muses, providing inspiration: Bella in her 'flight' brings imagination to the art; it is as if she emerges from the painter's easel. It is Bella, too, who contains within herself two of the three colours of the French flag, red and white, which together with Chagall's blue face comprise the colours of the flag of the country of freedom and artistic opportunity.

Shosha, too, arouses inspiration in the artist, for her interest in Aaron's writing has increased and deepened. Consequently his writing improves after the marriage; the novel is much better than the play he intended to write.

But the two kinds of inspiration are dissimilar: Bella is independent, dynamic, self-assured, and is given room to manoeuvre freely whereas Shosha is childish, dependent and under-developed, though surprisingly this is to Aaron's liking.

Both bonds are based on surprise and fragility on the one hand, and on honesty, candour, trust and a strong emotional attachment on the other. Bella's bodiless figure bursts into the picture dynamically. The intimate relationship in the novel, too, is fragile, due to the polaric differences between Aaron and Shosha, and the

severity of the oppressive times, which might cause their union to dissolve. Against all odds, both unions survive intact.

Stylistically there is some parallelism between the two works, for in both there is a metarealistic element, which turns them into universal works in spite of their very particular nature.

As for the link between the real and the metareal, both compositions are anchored in a specifically defined time and place. Reality envelops the lovers in every detail, but still a metaphysical component manages to present itself. In the novel, Shosha conducts a dialogue with the dead and with death, and is shown to have a strong intuition about her own demise. She dreams of the dead being resurrected and imagines demons and ghosts, such as the appearance of her dead sister in the chicken soup – a foreboding sight. In the painting, the metarealistic facet is manifested in the way Bella bursts into the picture and combines with Chagall to unite into a single figure. Chagall is standing in the forefront with two triangular surfaces in the shape of wings (based on Figure 608 in Franz Meyer's catalogue). Associatively this is the metaphysical element indicating how the artist envisions himself as a painter – as an angel with superhuman qualities; all this with the quintessential *shtetl* in the background constituting the essence of the Jewish ghetto even though it is not an actual one.[10]

Both couples exhibit an archetypal symbol-centric model, representing complete love associated with the muse, with art and the Jewish world, fearing the worst while surrounded by a hostile Gentile environment that is part of the Jewish ethos.

# Notes

1   See: Isaac Bashevis-Singer, *Passions and Other Stories*, Farrar, Straus & Giroux, N.Y., 1975.
2   See: Sidney Alexander, *Chagall*, Translation: Shlomit Kedem, Ladori, Tel Aviv, 1990, Vol. 2, p. 495.
3   See: Michel Makarius, *Chagall*, Hazan, Paris, 1987, p. 90: "This constant desire to place himself in relation to Vitebsk makes the latter a realistic counterweight to his roaming imagination."
4   See: Aleksander Kamensky, *Chagall: The Russian Years, 1907–1922*, Thames & Hudson, London, 1989, p. 224: "The couples are both individualized and archetypal: one occasionally recognizes the faces of Chagall and Bella and sometimes only their general outlines appear."
5   See: Isaac Bashevis-Singer, *Shosha*, Penguin Books, 1979.
6   See: Hana Wirth-Nesher, Isaac Bashevis-Singer as translator: "Apprenticing in the Kitchen of Literature", in *Recovering the Canon*, David Neal Miller (ed.), Brill, Leiden, 1986, p. 41. Shosha is termed an undeveloped woman-child and Jewish muse.
7   Based on an earlier painting by Chagall – *Self-portrait with Seven Fingers*; item 608 in the catalogue list of reproductions, at the end of Franz Meyer's book. A similar painting with modifications: in the original, Chagall appears more prosaic, realistic and mature. He is without Bella, without hope, only with the hardship behind him.
8   See: Frances Vagas Gibbons, "Trangression and Self Punishment", in *Isaac Bashevis-Singer's Searches*, Peter Lang, N.Y., 1995, p. 75: "Shosha is a semi autobiographical novel of Poland, in which the author rewrites his life."
9   See: Richard Burgin, *Conversations with Isaac Bashevis-Singer*, Doubleday & Company Inc., Garden City, N.Y., 1985, p. 139.
10  See: Hana Wirth-Nesher, "Orphaned Fiction", in: *Recovering the Canon*, David Neal Miller (ed.), Brill, Leiden, 1986, p. 49: In *Shosha*: ". . . The world is almost entirely telescoped into Krochmalna Street, the Jewish ghetto."

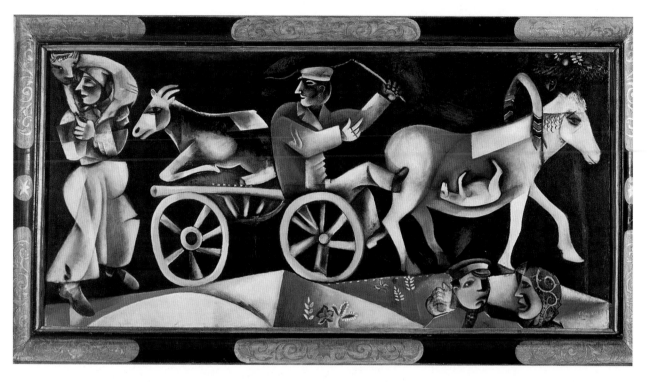

**1** *The Cattle Dealer*, Marc Chagall, 1912, oil on canvas (200 × 96 cm), Kunsthalle, Basel. Photo Scala, Florence © ADAGP, Paris and DACS, London 2009.

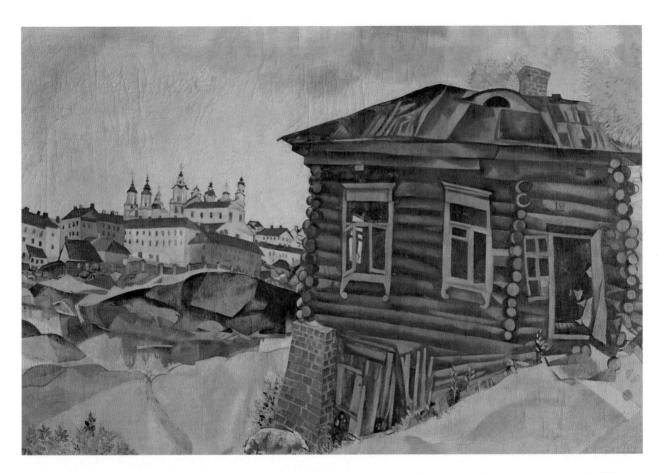

**2** *La maison bleue* (The Blue House), Marc Chagall, 1917. Oil on canvas (97 × 66 cm). Musée des Beaux Arts, Liège, © ADAGP, Paris and DACS, London 2009.

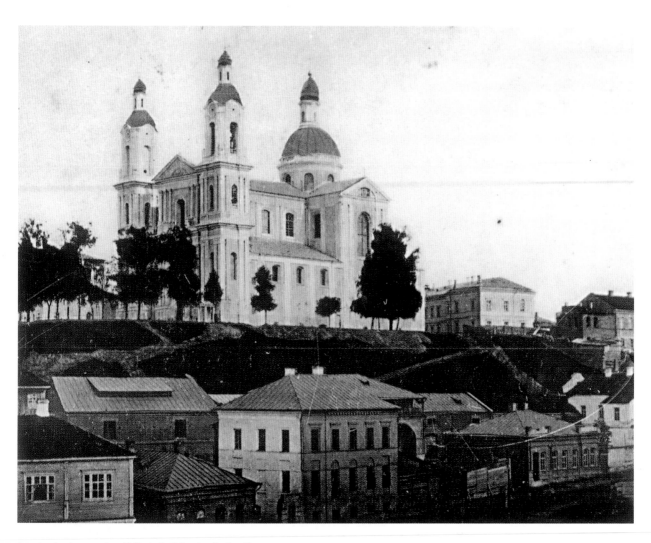

**3**  A photograph of Vitebsk. Private Collection.

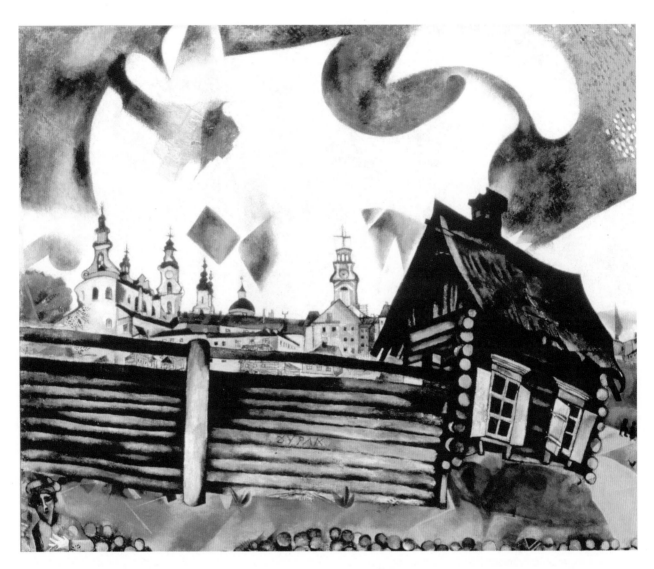

**4** *La maison grise* (The Gray House), Marc Chagall, 1917, oil on canvas (74 × 68 cm), Thyssen-Bornemisza Museum, Madrid, BI, ADAGP, Paris/Scala, Florence © ADAGP, Paris and DACS, London 2009.

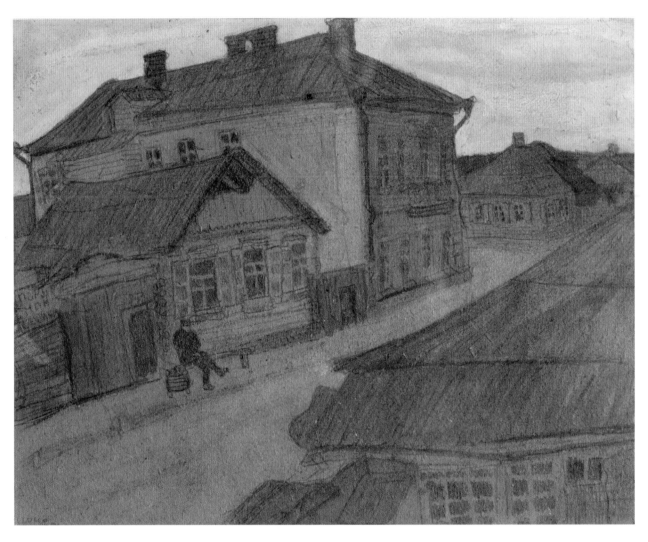

**5** *Village Street*, Marc Chagall, 1909 (38 × 28.8 cm). Corbis/Araldo de Luca © ADAGP, Paris and DACS, London 2009.

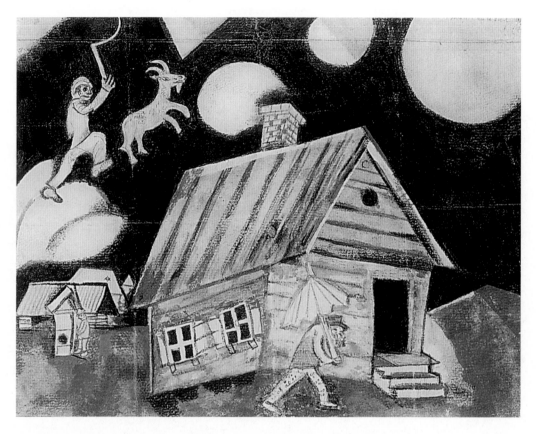

**6** *Etude pour 'La Pluie'*, Marc Chagall, 1911, pencil and gouache
(31 × 23.7 cm). Galerie Tretiakov, Moscow © ADAGP, Paris and DACS, London 2009.

**7**  *Vitebsk*, Marc Chagall, *c.*1914, gouache and Indian ink (24.8 × 19.2 cm). Private Collection, © ADAGP, Paris and DACS, London 2009.

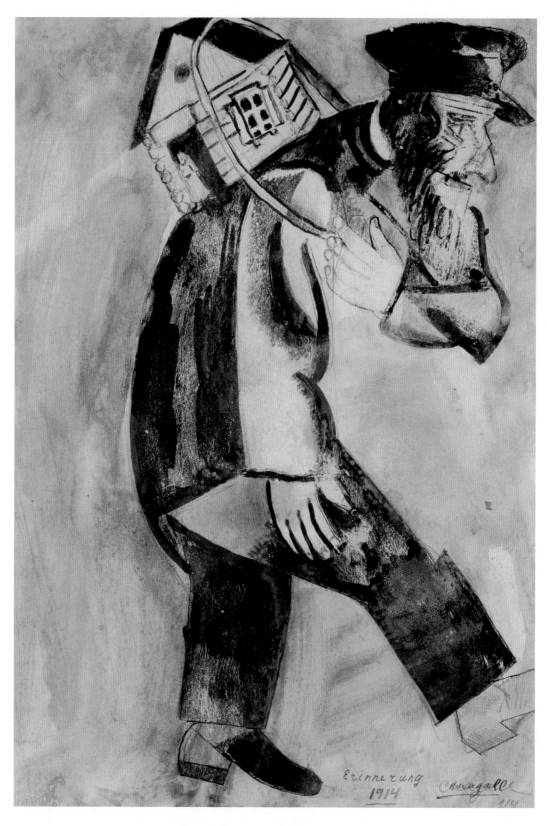

**8** *Remembrance* (Souvenir), Marc Chagall, 1914, pencil and gouache (31.8 × 22.2 cm).
Corbis/Araldo de Luca © ADAGP, Paris and DACS, London 2009.

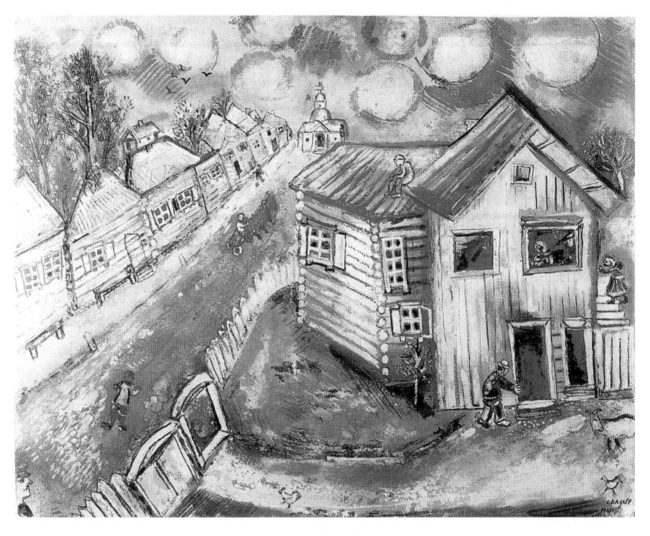

**9** *My Village*, Marc Chagall, 1923–1924, gouache (62 × 49 cm). Collection Catz, Milwaukee, © ADAGP, Paris and DACS, London 2009.

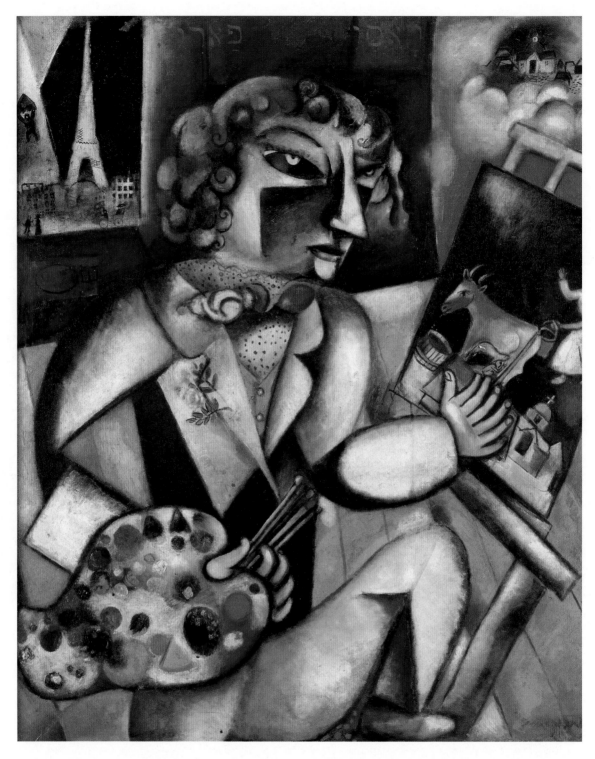

**10**  *Autoportrait aux sept doigts* (Self-portrait with Seven Fingers), Marc Chagall, 1912, oil on canvas (128 × 107 cm). Stedelijk Museum, Amsterdam, BI, ADAGP, Paris/Scala, Florence © ADAGP, Paris and DACS, London 2009.

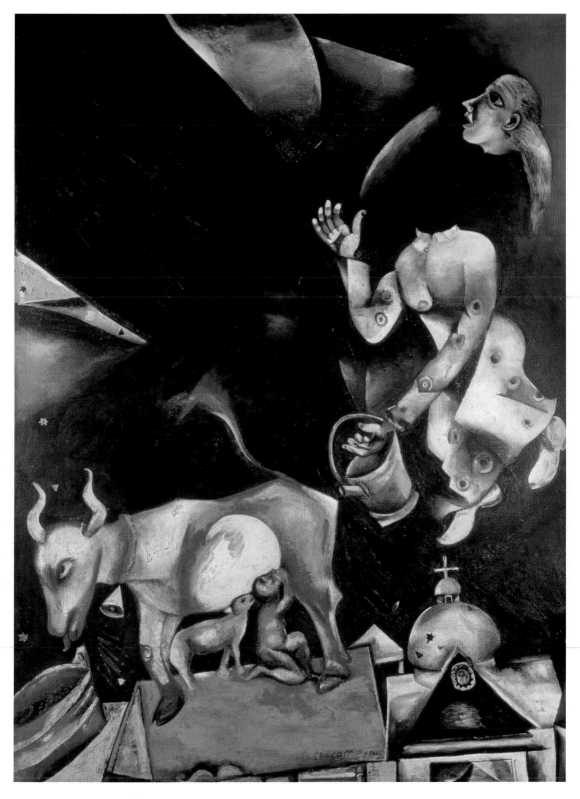

**11**  *Á la Russie, aux ânes et aux autres* (To Russia, Asses and Others), Marc Chagall, 1911, oil on canvas
(157 × 122 cm). Musée National d'Art Moderne – Centre Pompidou, Paris, BI, ADAGP, Paris/Scala,
Florence © ADAGP, Paris and DACS, London 2009.

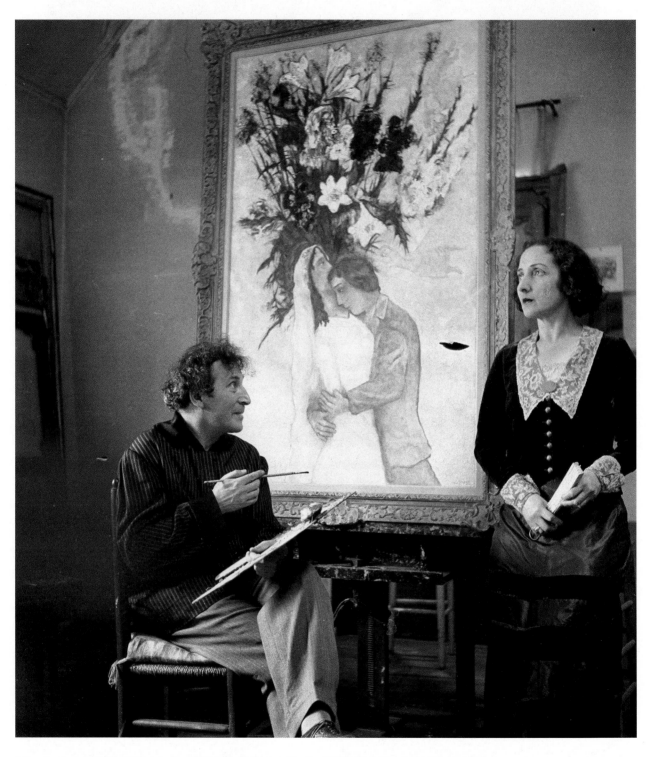

**12** A photograph of Chagall painting Bella in the Studio 1934. Getty Images/Roger Viollet.

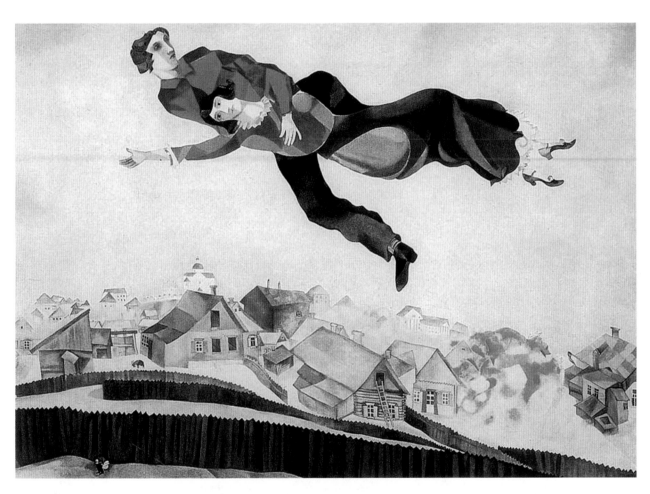

**13** *Lovers over the Town* (Over the Town), Marc Chagall, 1914–1918, oil on canvas (198 × 141 cm). © ADAGP, Paris and DACS, London 2009.

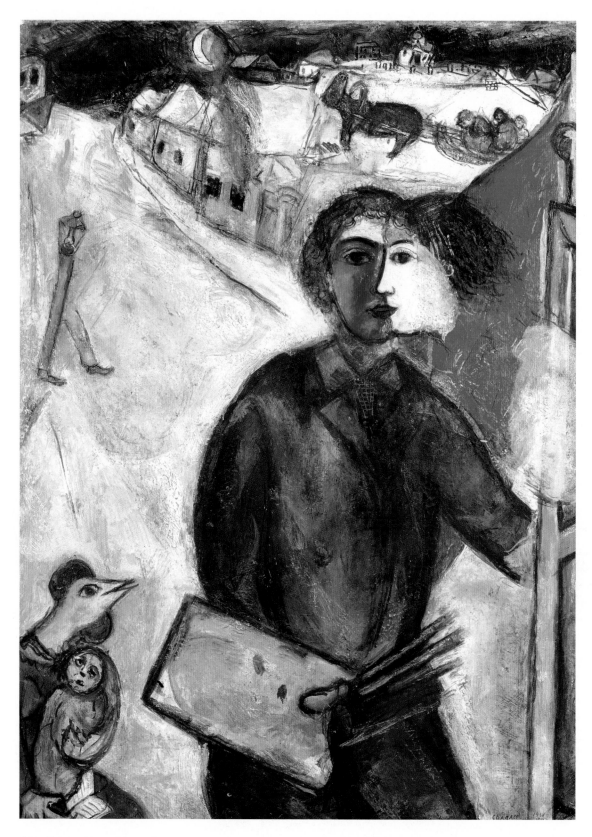

**14** *Entre chien et loup* (Between Dog and Wolf; also indexed as *Between Darkness and Light* (Twilight)), Marc Chagall, 1938–1943, oil on canvas (100 × 73 cm). Private Collection, Bl, ADAGP, Paris/Scala, Florence © ADAGP, Paris and DACS, London 2009.

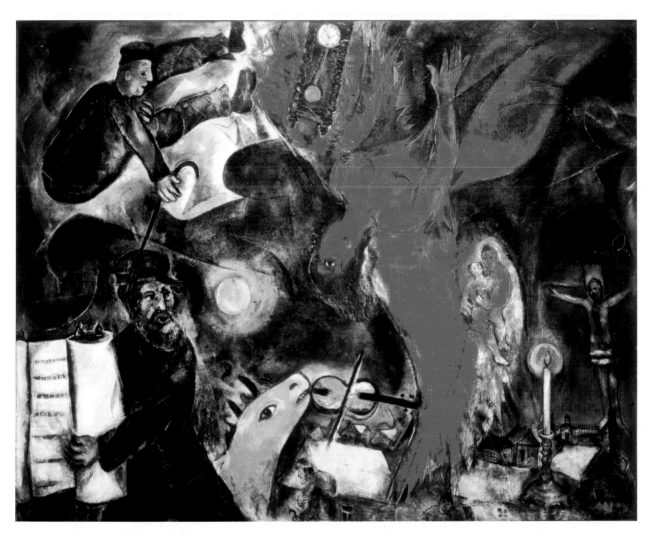

**15**  *La chute de l'ange Allegorie representant la perte de l'ange de son statut divin* (The Falling Angel), Marc Chagall, 1923–1933–1947, oil on canvas (189 × 148 cm). Musée des Beaux-Arts, Basel; White Images/Scala, Florence © ADAGP, Paris and DACS, London 2009.

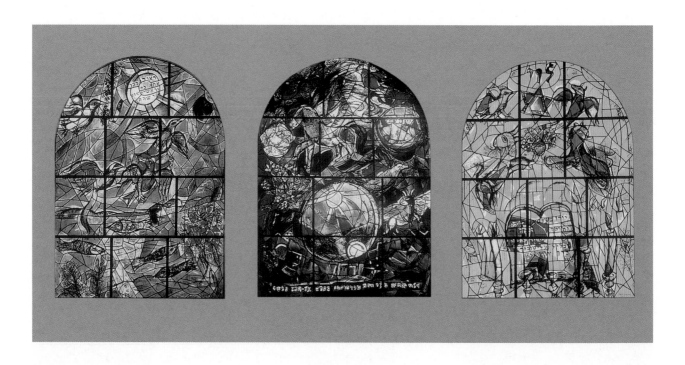

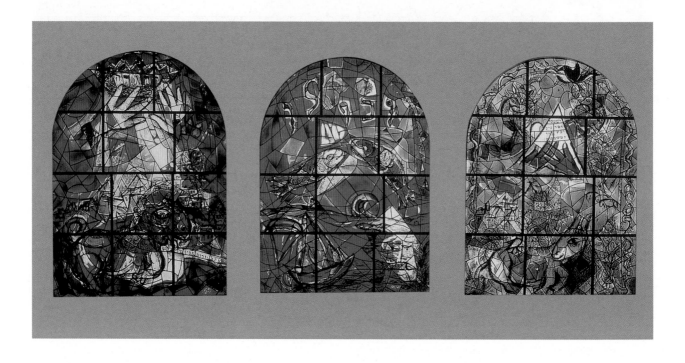

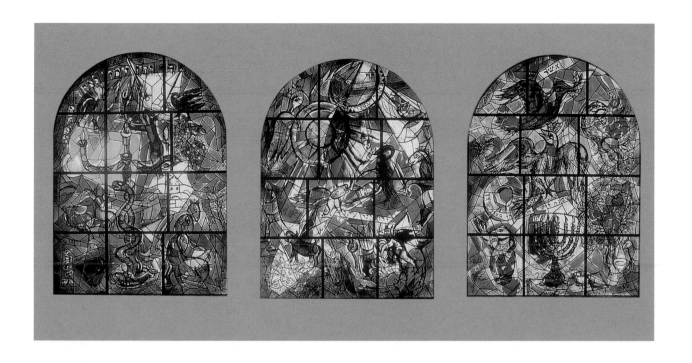

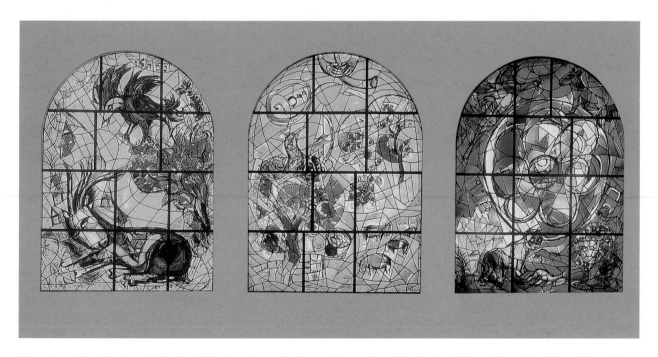

**16**  Jerusalem Hadassah Medical Centre, stained glass windows from the twelve tribes of Israel by Marc Chagall
© ADAGP, Paris and DACS, London 2009.

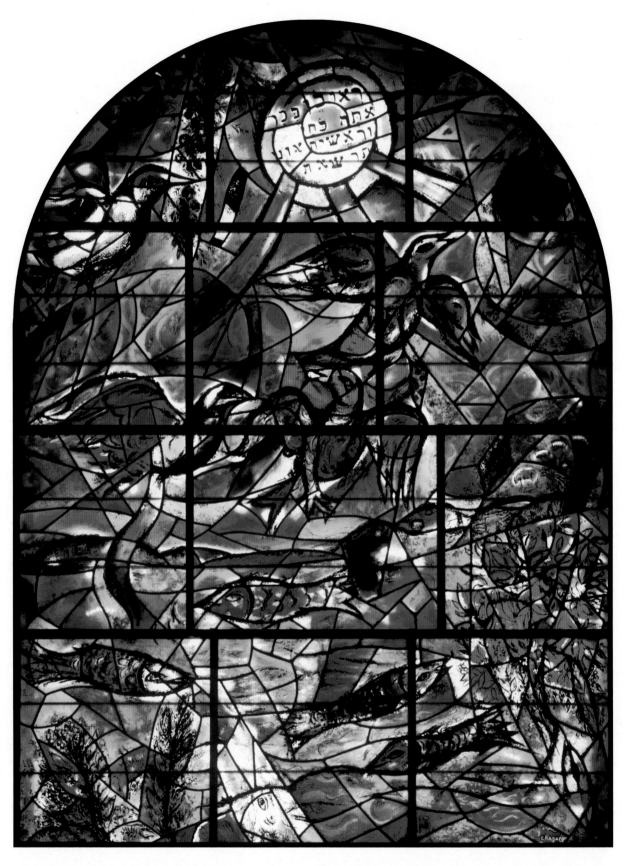

**17**  Jerusalem Hadassah Medical Centre, stained glass window of Reuben from the twelve tribes of Israel by Marc Chagall. Sonia Halliday Photographs © ADAGP, Paris and DACS, London 2009.

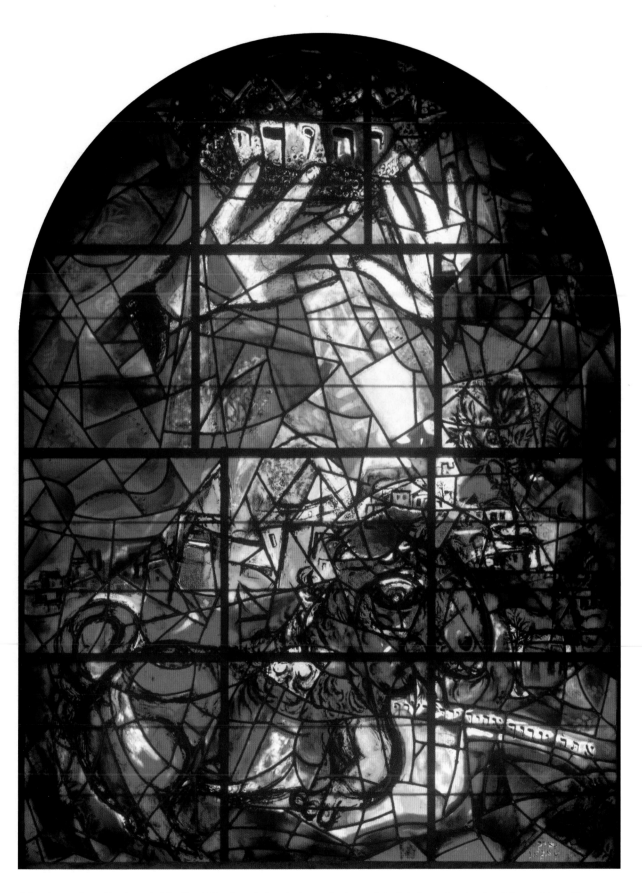

**18** Jerusalem Hadassah Medical Centre, stained glass window of Judah from the twelve tribes of Israel by Marc Chagall. Sonia Halliday Photographs © ADAGP, Paris and DACS, London 2009.

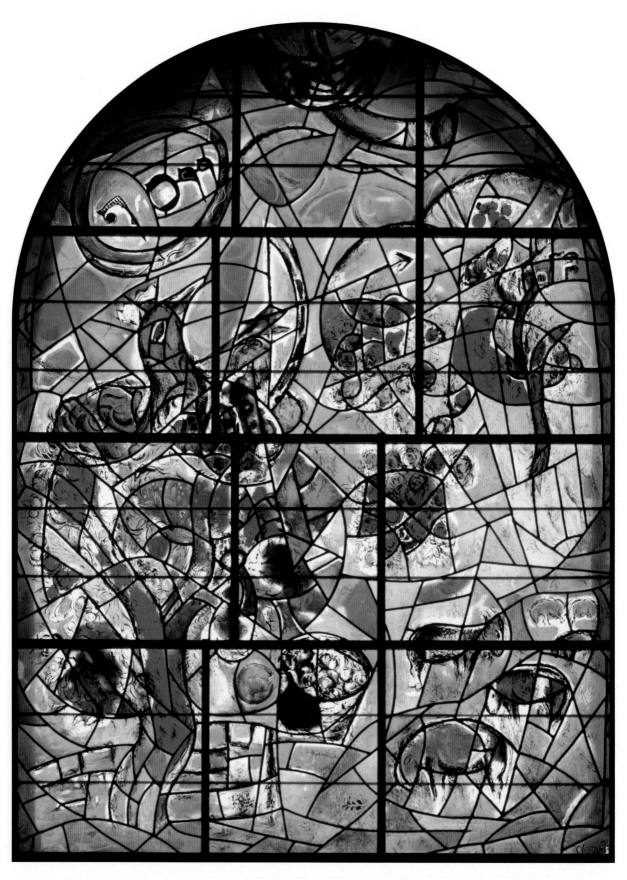

**19** Jerusalem Hadassah Medical Centre, stained glass window of Joseph from the twelve tribes of Israel by Marc Chagall. Sonia Halliday Photographs © ADAGP, Paris and DACS, London 2009.

# The Holocaust (*Shoah*) and War

The Holocaust and World War II are a common element in the works of the two artists with descriptions of the horrors and atrocities, and the implications thereof.

Bashevis-Singer treats the subject from a perspective of deep emotional involvement and great empathy, at times by way of general accounts of events, and sometimes by delving into minute details. It is a recurring theme in his works mainly because it was the most traumatic event in the long history of persecutions and *pogroms*, deportations and ethnic purges the Jewish people have undergone, and because the author lost part of his own immediate family and many close friends in this unspeakable tragedy. This horrific period constitutes a significant turning point in his work, with respect to records of pre-Holocaust Jewish life, especially in Warsaw and other parts of Poland, and subsequent descriptions of survivors, particularly in America.

In some of his works Bashevis-Singer evokes the winds of war; in others, he conveys the horrors of the Holocaust itself, while in yet others he focuses on the aftermath. He deals with the physical, mental and psychological implications and raises theological and ethical questions, which are left unanswered. The greater part of the novel *Shosha* takes place before the crisis of civilization began, though the motif of the tragedy engulfing Europe is present throughout. Bashevis-Singer verbally paints the Jewish ghetto in the pre-war ambience of uncertainty. Betty Slonim, the American actress who wants to save Aaron Greidinger by bringing him to America, frequently mentions the total devastation: "The Jews here are all going to perish . . . There is even a chance that this might happen" (ibid., pp. 229–230).

The character Sam Dreiman also predicts the imminent disaster when trying to convince the narrator to marry Betty. Out of concern for her he says: "Things will not end well in Poland. The beast Hitler will soon come with his Nazis" (ibid., p. 144).

The threat of dark days ahead is echoed throughout the novel and the love story unfolds in the shadow of severe famine. The fears from World War I and the bleakness of World War II, already on Europe's threshold, accompany the story to its tragic end – and into the epilogue, where the narrator learns of man's inhumanity towards man during his visit to Tel Aviv in the 1950s, when he meets Haiml Chentshiner. During their encounter he learns of the personal tragedies and of the scope of the catastrophe that befell the Jewish people. He sees people with tattooed numbers on their arms, and Haiml tells about his own struggle for survival in occupied Warsaw, and about friends and relatives who perished. The deaths of Shosha, her mother, the narrator's mother and brothers are all recounted. Bashevis-Singer says that in *Shosha*

he worked differently: "In *Shosha* I do the opposite. The Hitler tragedy is a mountain that cannot be seen as it was. It has to be reduced to a small number of episodes."[1]

In *The Slave*, too, there are premonitions of events to come. The novel itself is an historical love story, taking place in seventeenth-century Poland. However, the *pogroms* and attacks on Jews, especially those in 1648–1649, led by Bogdan Chmielnicki, are mentioned and characterised in a way which is very reminiscent of the *Shoah*. The novelist uses these reports to echo the chaos and atrocities of World War II. He does this because these *pogroms* typify Jewish agony wherever and whenever it occurred. At Josefov and in "other regions the Cossacks had beheaded, hanged, garrotted, and impaled many honest Jews. Chaste women had been raped and disembowelled" (ibid., p. 11).

Everyday life – continuing as if nothing had happened – reminds one of life in the ghetto, where the survivors tried to stay alive and continued to trade and even to amuse themselves. The impressions from *The Slave* are similar: "Despite the upheaval, Poland's commerce remained in the hands of the Jews. They even dealt in church decorations, although this trade was forbidden them by law" (ibid., p. 106). He does not withhold his criticism of Jewish life under these circumstances: "Stranger than this, however, was the attitude of the Jews who, having just survived their greatest calamity, behaved as if they no longer remembered . . . The rabbis and elders were again quarrelling over money and power" (ibid., p. 108). The author even goes so far as to use the word 'holocaust'. Certainly one may use this term for other catastrophes as well, but his use of the concept in this particular context arouses clear associations with *the Holocaust*.

In his short stories, too, Bashevis-Singer deals quite frequently with the subject: "Sam Palka and David Vishkover" indirectly raises the issue of Nazi savagery and its implications. Among the special character traits of Channah Basha, the story's heroine, the narrator mentions her kindness in a related context: "Now that there was war and she heard how the Jews were tortured in Europe, she began to cry . . . Some organisation advertised that they mailed packages to Russia, and every cent that I gave her Channah Basha sent there" (ibid., p. 683).

In many of the post-war stories in America, the Holocaust is mentioned *en passant*. Refugees are mentioned, who are still mercilessly affected by the unfathomable suffering, and the bestiality and barbarism – the magnitude of which no mind could grasp. In "The Briefcase" he describes the complex figure of Reizel, constantly beset by the anxieties she has carried with her from the ghetto, such as her obsession for food, and fear and screaming.

In "The Little Shoemakers" Abba Shuster manages to flee the terrors of the approaching calamity almost at the last moment. Bashevis-Singer mentions the beginning of the period when the Nazis arrive in town. Here the author links the present Abba to the one mentioned in the massacres of 1648–1649, who he thinks might be his original forefather. This is one example of how Bashevis-Singer makes an explicit connection between the *pogroms* of the seventeenth century and the *Shoah*.

In "A Day in Coney Island" the narrator is trying to escape from the fighting raging through Europe by attempting to obtain an American visa. It is a tragi-comic situation and typical of many Jews who succeeded in escaping the war but experienced trouble getting the longed-for visa.

Chagall, too, expresses the same motif, although it would appear to have had a lesser influence on his life, his art and in particular the figures he painted. In a number of works the brutal and violent period is to be found only in the background. However, in *The Revolution* (1937) he portrays the Communist Revolution in Russia. It was painted when he had already become a French citizen and could afford to look back critically at the events of October 1917. On a table in the centre of the painting there is an upside-down 'clown'. This is Lenin performing what looks like an acrobatic trick. Lenin's world is shown overturned, with the red flag falling down. Other people in the vicinity, including the artist and his family, are situated on the roof of what looks like a typical *shtetl* house; they observe events in fear and wonderment but go on with their lives. Another Jew takes to the road with his bundle and stick. A third is sitting by Lenin, holding a *Torah* scroll and praying for better days. Soldiers on the painting's right side check and aim their weapons. The entire picture conveys an atmosphere of aggression, violence, confusion and anarchy.

*Fire in the Town* (1940) expresses the horrendous experiences of fighting and casualties, and the frightful life of the Jews in the Diaspora. This is a most dramatic composition, infused with red as a sign of the fire raging through the town. A Jewish couple and their child are trying to flee the fire, which is spreading through the houses of the *shtetl*; in the background, domestic animals are doing the same.

Not only does the painting symbolise the anti-Semitism so many Jews have experienced throughout history, but also the discrimination Chagall himself experienced. Chagall's mother had to bribe one of his teachers so that he would be allowed to attend school in Vitebsk. Later on he needed a special permit in order to study painting in St. Petersburg. These experiences were not forgotten by the painter, who reminds himself and his audience of the petty restrictions endured by Jews.

Similar feelings of terror are expressed by the woman and her child in *Fire in the Snow* (1940). The houses are going up in flames and she and her baby flee, frightened, through the snow. During the 1940s, when Chagall was living safe and secure in the United States, he painted a series of works exposing acts of persecution; hostilities, death and the tragedy are prevalent themes.

The paintings of the crucifixion, which aroused bitter disputes in Jewish circles, show the plight of the Jews and everyone else in those dismal days of belligerency.

*War* (1943) shows the shock and panic of the times by means of two carts or sleds, which seem to be floating in the air. The horse pulling the carriage is scared, its legs raised in the air. An expressive red fills the painting's lower part, together with a wandering Jew on the road. A dead man lies in the middle of the street and the *shtetl* houses are upside down. Above them a mother with flame-like hair is escaping with her baby.

## *Enemies, A Love Story*

In this novel the Holocaust plays a more central role than in any other work.[2] Bashevis-Singer describes neither the magnitude of the genocide nor the uniqueness and consequences of its evil explicitly. He depicts neither the unprecedented

annihilation of a people whose only crime was that of being born, nor the course of its events. He chooses to describe life after, but not in the European arena where the unimaginably appalling liquidation of the Jews took place; but rather in America. Still, this entire book – the main characters, the events and their implications – are all directly or indirectly influenced by the barbaric behaviour of the Nazis. Although the story takes place in America, it also describes the past vividly and convincingly.[3] The entire story is a direct continuation and consequence of the violent and inhuman behaviour of the Nazis in Europe.

The novel's main character, Herman Broder, was saved by a peasant woman, Yadwiga, who hid him in her parents' hayloft in the town of Lipsk in Poland for three years. Out of gratitude he marries her and lives with her in Brooklyn. It is to be expected that from that point on events would develop in the direction of a new life in America, but this is not the case: Herman does not lead a liberated, free life in the land of opportunity. Rather, he continues to live under the influence of those suffocating years, which follow him in his daily life and in his nightmares, practically, symbolically and metaphorically. The novel begins with a dream in which the real and the imaginary intermingle, hanging like a cloud over his life:

> In his dreamy state, he wondered whether he was in America, in Tzivkev, or in a German camp. He even imagined himself hiding in the hayloft in Lipsk. Occasionally all these places fused in his mind. He knew he was in Brooklyn but he heard Nazis shouting. They were jabbing with their bayonets, trying to flush him out, while he pressed deeper and deeper into the hay. The blade of a bayonet touched his head. (Ibid., p. 8)

These dreams and hallucinations haunt Herman throughout the novel. When he walks the streets of New York, he searches for places that will shelter him from the Germans, preparing hiding places in case the Germans start bombing: "As Herman walked along, his eye sought hiding places in case the Nazis were to come to New York. Could a bunker be dug somewhere nearby? Could he hide himself in the steeple of the Catholic church? He had never been a partisan, but now he often thought of positions from which it would be possible to shoot" (ibid., p. 20).

Herman, who continues to be a victim, in fact lives as a prisoner in the free city of New York. Such is his physical existence because of persisting anxieties, memories and the inability to liberate himself from the sights of the past. Part of his state of mind is a result of his weak, irresolute and impractical character. But to the same degree, it is a product of his cruel and bitter fate. A case in point is his simultaneous entanglements with three different women: Yadwiga, the Polish peasant woman; his beautiful and attractive mistress, Masha; and his first wife Tamara, mother of his two children, from whom he separated before the war. She had long been presumed dead but is resurrected quite suddenly, some time after the war had ended. With each of these women he has a complex relationship, based on intimacy and attraction, yet leading at times to alienation and even hatred. He becomes inextricably embroiled with each of them and with all three together, a fact which sometimes comes across as extremely exaggerated and fictional.[4] Herman's life, his personality and the fate of the women in his life appear to surpass reality.

The women are the strange 'exhibit', the impossible marvel at the heart of this novel, in which reality and metareality are closely intertwined. On the one hand, as is common in his writings, the details are accurate: Polish and American place names, dates and facts are given with such convincing authenticity that they seem completely realistic and true. On the other hand, there is the story itself: Tamara's return from the dead, Masha's travails and the presence of supernatural forces, mostly related to the world of those killed during 1939–1945: "'Tamara alive!' He said the words out loud . . . had risen from the dead. He wanted to laugh. His metaphysical joker had played him a fatal trick" (ibid., p. 61).

Elsewhere one can also see how the real and the metareal coexist convincingly:

> The waves surged toward the shore, hissing and foaming, receding
> again as they always had – barking packs of dogs, powerless to bite.
> In the distance, a ship with a grey sail rocked on the water. Like the
> ocean itself, it both moved and remained stationary – a shrouded
> corpse walking upon the water. (Ibid., p. 143)

Situations such as these are the constant experience of the novel's protagonist, as a direct or indirect result of a catastrophe beyond contemplation.

The fates of the three women are also a direct result of what transpired in Europe, although in each case personal character and choice are involved. True, Yadwiga follows Herman to America, leaving her family and faith behind, converting to Judaism out of her own free will; had it not been for the widespread colossal devastation in her home country she would never have come to marry Herman.

Masha is the *femme fatale* – beautiful, attractive, a head-turner, even after the inferno she has been through. She is the subject of Herman's erotic passion; he is totally captivated. Masha is selfish, childish, capricious, daring and at the same time dependent, exploiting and rebellious where all religious and social conventions are concerned.

Nearly every fairy tale has a destructive force of some kind, often in the form of a witch. Here it is Masha, the temptress who destroys herself as well as those around her. She becomes the reason for Herman's downfall and that of the other women in his life. Living through the years of "hell on earth" is the major influencing factor in her life, moulding and reinforcing her destructive characteristics, and it is precisely this combination which binds her and Herman together.

Tamara, Herman's only legal wife, is also affected by the same monstrosities. Their dismal marriage had already faltered before the outbreak of hostilities in Europe. Herman abandoned her and their children and sought to divorce her. After Herman had been informed that she had perished, her return complicates his life. She is a mixture of a zealous communist and a Zionist, adopting ideologies and slogans, feminism and femininity; she protests, signs petitions, and constantly celebrates in raising funds; Tamara saves Herman, in a sense, when at one stage, she 'takes command' of his life, becoming his boss. Her bursting into his life in Brighton Beach brings unbearable memories back into his new home.

Yadwiga, ironically, becomes the anchor of a Jewish home. She is kind and behaves in the traditional Jewish fashion, preserving the ritual practices of Herman's childhood home as best she can. The clean house in Brighton Beach, with the

fragrances of the past, constitutes a kind of 'bubble' for Herman; though protective, it is also a prison cell, isolating him from himself, society and life around him. He sinks into a life of deception: he becomes Rabbi Lampert's ghost-writer, writing about religion, although he himself is a non-believer. He tells lies to Yadwiga. She is completely dependent on him since she speaks no English – she neither reads nor writes, does not work and rarely leaves her home. He is husband, brother and father to her. But when bored he seeks other stimuli in order to infuse more life into his imaginary-closed world which, to some extent, is like a fairy tale.

The end is typically Jewish: despite the tragic ending of the death of Masha, and Herman's disappearance, which was possibly a suicide, Masha, a baby girl, is born to Yadwiga, keeping Herman's lineage alive. The message is clear: out of the ruins and the ashes, the Jewish seed will be perpetuated.

Tamara continues to search for Herman in the 'lost relatives' section of the classified ads. Perhaps he is no longer among the living, but then again, he may still be hiding in some barn, in an American "haystack". He represents the World War refugee, a Jew who survives but cannot cope with reality. Still, the novel ends on an optimistic note, for the fact that Yadwiga gives birth on the eve of the Jewish Pentecost is symbolic, hinting at Biblical Ruth the Moabite, one of whose descendants was King David. Hope springs from Yadwiga, hinting at future salvation. Tamara, who is like Naomi, Ruth's mother-in-law, raises little Masha as a Jewess in her own home, with Yadwiga, who converted out of conviction and love. In this way Tamara compensates for her own children, who were *Shoah* victims. Ironically then, it is she who helps Herman's lineage survive. Out of ruin comes redemption; out of ashes comes salvation; out of despair comes the victory of body and soul. It is the willpower and the vitality of Jewry in the free land of America that make the spirit triumph.[5]

## *The Falling Angel*

This work, which constitutes a concise, concentrated representation of the motif of the unfathomable catastrophe during the war and the Holocaust, was painted in three stages, in each of which Chagall made changes and added elements. In the first version, painted in 1923,[6] there is considerably less detail than in the final version, but the main subject is already evident – a figure in a sudden fall from above, and next to it the figure of a Jew, who is fleeing while holding a *Torah* scroll. The other parts of the painting, and especially the background, are abstract.

In the 1933 version, Chagall added certain details: the suckling in the middle between the Jew and the falling angel; the violin, the clock and the candlestick; the youth who seems to have been bounced upwards; the village in the background; this time the angel is more clearly depicted and has a stronger presence.

The final version of 1947[7] becomes even more striking: Chagall added the crucifix and the mother and child. The background is now very dark and foreboding. The village houses behind the fence in the second version, which were relatively spacious and straight, now become crowded and crooked, reminiscent of the houses of a *shtetl* in the snow, as depicted in his other works. In this last version, Chagall may

be said to have combined all the elements indicative of armed confrontations and the inferno in general, and specifically with reference to the Jewish world and the *shtetl*.

There are motifs from Chagall's familiar repertoire: the fleeing Jew protecting the *Torah* scroll, the suckling with the violin, the Jew with a parcel on his back at the base of the picture, mother and child, the crucifixion, the village houses and figures floating in the air. Into this familiar and recognisable world, a combination of raging fury, menacing wrath and forces of anger – Jewish and universal[8] – erupts in the figure of a fiery angel. Chagall includes both Jewish and Christian motifs – another well-known aspect of his artistic language. It is all sudden and forceful. The red angel takes the form of a voluptuous woman. It falls into the picture from above, passively, in shock, just like the shock it arouses in others. The angel is pushed down in a kind of reverse float, seemingly having no control over the situation. The billowing wild hair covers the right eye, while the left one is very frightened, wide open, and the mouth expresses surprise. The cubist shapes on the angel's torso and wings add to the dynamism of its unexpected fall into earthly reality. The bright red colour suggests a flame, which threatens to engulf and consume all. But still, there is no annihilation; there is most certainly mayhem and a severe blow, but other factors present help one cope. One of these is the Jew whose face is blue, the colour of spirituality, who protects the *Torah* scroll with great determination, in contrast to the youth, who does not look Jewish and who is floating above him. The youth's face is green, indicative of earthliness. He is bounced upwards, knowing neither the reason nor the purpose of it all. He appears surprised, confused, searching for a way out. The mother and child, located at the edge of the wing, may survive, even though they are in the fire. The candle gives off light and may continue to do so, like the celestial bodies which will continue to provide illumination.

The catastrophe 'free falls' into the real world, penetrating it, while man has no control whatsoever over this unstoppable force. It is the intervention of the metaphysical, something from 'beyond', which intrudes upon this everyday reality. This event, coming down in the form of an angel, like a force from above imposing itself on the physical world with no apparent rhyme or reason, is what makes the composition metaphysical. The world as constructed by Chagall consists of largely Jewish features, with some Christian allusions, as one sees to the right of the angel's wing, near the lower right-hand corner. Chagall also includes certain Christian subjects known from his other works: next to the low, distorted houses with their dominant gray-black colours, evoking physical and metaphorical decay and sadness, Chagall has placed an official, straight, geometrical structure reminiscent of the Town Hall or other official buildings of the establishment of Christian Vitebsk.

Close to this building, as if rising from it, is Jesus on the cross, whose lower body is covered with a loin cloth resembling a Jewish prayer shawl, representing both Christian and Jewish pain. His expression is calm and tranquil relative to the situation at hand, as a halo of fire surrounds his head. Such a combination of Christian and Jewish elements also appears elsewhere in Chagall's works.[9] The mother and the child are a reminder of Mary and Jesus, but again evoke an association of the Jewish mother, with the bright, illuminated aura around her head and body. The candle, too, reminds the viewer both of church and of Sabbath candles,

which signify the spirituality, Jewish or Christian, that will last forever, just like the sun and the moon. These sources of light are positioned nearly opposite each other on either side of the angel's wing, reaching down to the ground; the three have round forms to indicate perfection, and the colours consist of various hues of yellow, the colour of human spirituality, with a touch of green as a reminder of reality.

Chagall, who lived his whole life among Gentiles, felt quite comfortable in their midst and thus easily interwove aspects from that world into the Jewish one. The calamity of cosmic proportions is worldwide but clearly he puts more stress on the Jewish Holocaust at the centre of the painting. The colossal adversity comes in the form of an angel, but this is not an angel of religion. The artist shows that this is an overwhelmingly supernatural force creating total chaos in the world below. Chagall turns the angel, precisely because of its feminine secular nature, into a symbol of devastation that befalls the world violently, unexpectedly and inexplicably.

The world survives. The Jew escapes with the white *Torah* scroll, symbol of absolute spirituality; it is open because it is not a museum exhibit but a living, breathing, practical facet of Jewish life.[10] The yellow suckling also survives; it is placed in the centre of the picture between the Jew, the fiddle and the angel's wing; it is a symbol of femininity, motherhood, gentleness and humanity, large and yellow, with a large open eye and an expressive human mouth. The suckling is on the other side of the mother and child; there is yearning on its upward-pointing face. It rises, so it seems, out of the village houses as if to shield the wandering Jew, the white roof and the other village houses with the bow of the violin. The blue violin is a colourful parallel to the Jew's face – a sign of spiritual uplifting and elation by means of music – another well-known motif in Chagall's works.

There are dark shapes spread along the entire width of the centre of the painting, over the houses, as if pressing or pushing the destructive wing's internal contour line. The Jewish spirit indicated by the fiddle, a typically Jewish instrument expressing emotion,[11] distress and misery, will overcome all the affliction and misfortune. The bow lies diagonally as if just waiting for someone to pick it up and use it. The Jew with the parcel on his back, brown-hued and realistic, turns towards the Jew with the *Torah* scroll; the latter will live through any crisis due to his inner strength,

**15** *La chute de l'ange Allegorie representant la perte de l'ange de son statut divin* (The Falling Angel), Marc Chagall, 1923–1933–1947, oil on canvas (189 × 148 cm). Musée des Beaux-Arts, Basel; White Images/Scala, Florence © ADAGP, Paris and DACS, London 2009.

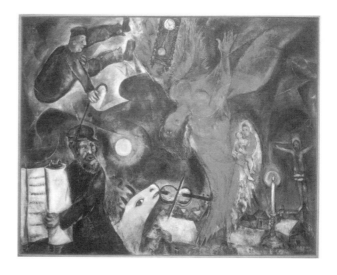

holding on to and protecting the *Torah* and absorbing from it the inner fortitude he needs in order to prevail.

Chagall has presented here a complex situation, both Jewish and Christian, from the most incomprehensibly evil period in world history. The clock, which appears to be falling diagonally in the upper wing, anchors everything into a specific, real time: war breaks out on a certain day at a certain hour in a certain place. But the adversity is also metatemporal. It supersedes time. The angel who drops in from above has not yet completely entered the picture; neither has the clock. There are more existential threats ahead, but the clock in the upper wing falls into the centre, inside the temporal dimension. The angel, too, falls diagonally, into the centre, from the top right corner towards the Jew with the *Torah* scroll. The raised hand, the hair and the pointed tips of the angel's wing enhance the dynamism and force. The angel brings with it turbulent and tumultuous times.

## COMPARATIVE ANALYSIS
### *Enemies, A Love Story* and *The Falling Angel*

The novel and the painting both deal with the Holocaust and the ravages of war. The artists adopt an original design for their work. While it is common to treat the war itself or the ruin in its wake, here both choose to focus on less common perspectives and analyse the subject from unusual angles.

Bashevis-Singer presents the main character, Herman Broder, after 1945. He reveals what befalls him as a direct consequence of the inhumanity, torture and torment rather than describing the events themselves – as any mention of the war is retrospective, since the plot unfolds in New York City. He becomes entangled in simultaneous relationships with three women. What these women go through is also a direct consequence of that awful period of 1939–1945. The aftermath of World War II is the central axis around which the entire novel revolves.

Chagall's painting, too, reveals the result of *the* crisis of colossal proportions that descends upon the world. The infamous events themselves are not portrayed; just the angel, falling down uncontrollably into the picture, with the strong red colour arousing associations of fire and flame. There are, however, no depictions of torture, combat or any real destruction. Furthermore, Chagall hints at survival within the feeling of a general catastrophe. There is no actual physical disaster. Certainly there are distortions, a great fright, wandering, sadness, a longing for humanity, but there is also a spark of hope for continuity: the Jew fleeing with the *Torah* scroll, the suckling and the fiddle, the mother and child, the burning candle, and the sun and the moon illuminating the surrounding darkness.

In other words, both artists deal with the war's outcome rather than the events themselves. Bashevis-Singer describes the actual post-conflict and confrontational situation while Chagall, though he *does* paint a calamity, dwells on its effects. Alongside the trauma for the Jewish world, which was so physically, psychologically and socially devastated, neither artist ignores the Gentile Christian world, which was also brutally affected.

In *Enemies, A Love Story* it is mainly Yadwiga who represents the suffering of the Gentile world – leaving her home, her native tongue, becoming totally dependent on someone else; and more than anything, risking her life for Herman while saving his from the Nazi beast:

> For three years Herman had depended on her utterly. She had brought food and water to him in the loft and carried out his waste . . . During the summer . . . Yadwiga hid him in the potato cellar. She put her mother and sister in constant jeopardy . . . (Ibid., p. 11)

The widespread destruction which befell the Gentile world is expressed in Chagall's composition, where Jew and Gentile mingle more than in the novel. He paints the crucified figure as Christ, but girds him in a cloth reminiscent of a Jewish prayer shawl. Behind the *shtetl* houses rises an official building in the neo-classical style. There, too, is fire and ruin. The candle could be seen as both a church candle and a Sabbath candle – it 'flickers' but will not yield. The mother and child, reminiscent of the Virgin and Baby Jesus, are inside the fire, within the angel's destructive wing, but they, too, will not succumb. Devastation is not only the lot of the Jews. The Gentile youth who has been tossed upwards does not understand what has happened nor why, where he is headed or what his role in the world is; he, too, is affected by the viciousness of the events.

Women play a crucial role in both works. In the novel there are the three women in Herman's life, each representing a different aspect of womanhood, and all three are closely associated with the *Shoah*. They are also responsible, to a great extent, for the entire chain of dramatic events Herman undergoes. True, some of what happens to him can be attributed to his weak and irresolute personality but much is due to his ties with the three women.

The figure with a strong presence – in the form of a red, female angel – introduces an atmosphere of fire and infernal drama. In both cases the women play a role in the introduction of doom into everyday reality.

The figure of the Jew at the centre of both compositions is conceptually similar. The major Jewish character in Chagall's painting is the man protecting the *Torah* scroll, trying to hold it as far forward as possible, away from the catastrophe. This is an Orthodox man with the beard and sidelocks, hat and coat of a traditional, pious Jew. His face is somewhat distorted, reflecting his fear of what is to come. At the same time his face is blue, a colour related to spirituality. Even more significant is the white of the scroll. It is open, as if the Jew had grabbed it in the middle of his studying and started running so as to save it. The *Torah* is not a museum piece; rather, one is meant to live in accordance with its teachings; its white colour signifies absolute spirituality, touching upon supreme spheres of sanctity. The Jew and the *Torah* will be saved because of his faith and trust in and his attachment to it.

Bashevis-Singer's protagonist devotes time to studying the Holy Scriptures. True, he is not an observant Jew like Chagall's figure; in fact, he does not obey the commandments at all and observes neither the New Year customs nor the Day of Atonement, the holiest of days in the Jewish calendar. But he comes from an Orthodox home. His father, Shmuel-Leib Broder, was a disciple of the rabbi of

Hosatin and he, Herman, received a Jewish education at the hands of a tutor his father had hired for him. Herman is a thinker interested in the spiritual; an intellectual with many fields of interest.

Many existential and complex questions common to both compositions, with respect to the future of the Jew in the painting and the future of little Masha, daughter of Herman and Yadwiga, remain unanswered. What kind of world will they live in? What awaits them? Does man have freedom of choice? Can man escape his destiny? Why did such a disaster and the ensuing devastation descend upon humanity? Why is there no control over this tragic situation? Clearly, the Jewish presence and values will continue to exist. Masha expresses it well:

> Papa always said that everything comes from God. You say it, too, Mama. But if God could allow the Jews of Europe to be killed, what reason is there to think He would prevent the extermination of Jews of America? God doesn't care. (Ibid., p. 39)

In both compositions the penetration of the supernatural and the metaphysical into the physical is striking. In the work of Bashevis-Singer, the realistic dimension is dominant in his detailed 'drawing' of figures, situations, place names, concepts and current events. Chagall also presents a true-to-fact background: the *shtetl*, the figures and the basic point of origin planted amidst wars and world revolutions. But these two factual depictions are lit by a wonderous burst of the 'beyond', providing them both with a metarealistic facet: the feminine red angel falling into reality without any ability to control or manoeuvre itself, and in the novel, the discourse with the occult. In Tamara's physical appearance there was something of mysticism in general: "During the years he believed Tamara dead ... She had loved him. Essentially she was a spiritual person. He had often spoken to her soul, begged her forgiveness" (ibid., p. 62).

Jewish existence in both works endures and triumphs: in Chagall's, thanks to the *Torah* – the religious, ethical, ideological and practical aspects of it save the Jew both symbolically and realistically; in Bashevis-Singer's, it is thanks to the birth of little Masha, who continues Herman's lineage and the Jewish legacy.

The idea of the Jewish faith unyielding and overcoming all ills is aptly expressed in Herman's thoughts, when he tries to sever all contact with the *Torah* and its commandments:

> He stopped at the Botanical Gardens to look at the flowers, the palms . . . grown in the synthetic climate of hothouses. The thought occurred to Herman that Jewry was a hothouse growth – it was kept thriving in an alien environment nourished by the belief in the Messiah, the hope of justice to come, the promises of the Bible – the Book that had hypnotised them forever. (Ibid., p. 53)

The connection to the spiritual, the Divine promise and the *Torah* in the painting, and the continuation of the Jewish people in the shape of little Masha in the novel, express a common theme: the archetypal Jew, conquering universal anarchy while harbouring hope for the perpetuation of His People.

# Notes

1   See: Richard Burgin, *Conversations with Isaac Bashevis-Singer*, Doubleday & Company Inc., Garden City, Inc., N.Y., 1985, p. 139.

2   See: Isaac Bashevis-Singer, *Enemies, A Love Story*, Fawcett Crest, New York, 1972.

3   See: Irving Howe, "I. B. Singer", in *Critical Views of I.B. Singer*, Irving Malin (ed.), New York University Press, N.Y., 1969, p. 101: ". . . Here is a man living in New York city, a sophisticated and clever writer, who composes stories about places like Frampol, Bilgoray, Kreshev, as if they were still here."

4   See: Charles A. Madisson, *Yiddish Literature: Its Scope and Major Writers*, N.Y., Schocken Books, 1968, p. 482: "I.B.S. tends to overstress the traits and egocentricities of his characters."

5   Sarah Blacher Cohen, "From Hens To Roosters", in *Recovering The Canon*, David Neal Miller (ed.), Brill, Leiden, 1986, p. 81: "As women who survive with dignity and purpose, they not only provide a sanctuary for an errant husband, but they reflect Singer's hope that a meaningful existence is still possible after the Holocaust."

6   See: Franz Meyer, *Chagall*, Thames and Hudson, London, 1964, Classified Catalogue, 369.

7   Ibid., 613.

8   See: Franz Meyer, *Chagall*, Thames and Hudson, London, 1964, p. 489: "While Chagall was working over the picture, his experience of all the world-shattering events since 1933 heightened the expression of the picture and gave it a different meaning. One is probably not mistaken in seeing a parallel between the cosmic catastrophe of the angel's fall and the course of recent history. The angel is fire from heaven, a burning brand, an insatiable flame that threatens the sane forces of life."

9   Like similar characters in other works by Chagall such as *I and the Village, Joy in the Village* and *The Cattle Dealer*.

10  See: Mira Friedman, "Marc Chagall's portrayal of the Prophet Jeremiah", in *ZEITSCHRIFT FÜR KUNSTGESCHICHTE*, 47 Band, 1984, Heft III, Sonderdruck, Paris and Cosmo Press, Geneva, 1984, p. 382: "The representation of a Jew holding a Torah scroll is usually associated in Chagall with war and *pogroms* and the Holocaust of the Second World War."

11  See: *The Green Fiddler*, 1923.

# Religion and Mysticism

Jewish religious motifs such as prayer, holidays, the *Torah* and other holy books, Jewish mysticism, *Kabbalah* and supernatural figures and scenes play an important role in the works of both Bashevis-Singer and Marc Chagall.

The novelist shows an affinity for the *Kabbalistic* theories of Rabbi Yitzhak Lurie[1] and has a tendency towards sensational contents and demonological motifs, which create tension and add strength to his compositions. Our terrestrial world is imperfect in comparison to the spiritual upper spheres. According to the *Kabbalah*, God limited Himself during the act of creation. As a result of this limitation, known as 'reduction' (*tsimtsum*), numerous external 'husks' were created which comprise much of our environment, together with Divine 'sparks', the meaning of which is difficult to grasp. At the same time, forces of evil were also released and these, together with the material obstacles posed by the 'husks', prevent a human being from attaining perfection and reaching happiness or unification with Divine forces.

Bashevis-Singer came from a family of *Hassidic* rabbis. This explains his predilection for the *Kabbalistic* world: "My origin is from generations of *Hassidic* rabbis and *Kabbalists* . . . in our home there was Judaism which contained all tastes . . . and all of the mysticism of faith."[2]

Many of his books deal with the occult, with faith, with the search for absolute intimacy with God, with the search for and discovery of the transcendental. 'Black magic', demons, spirits and superstitions also appear in many of his works.[3]

Singer was greatly influenced by writer, poet and thinker Aaron Zeitlin, particularly in the realm of the supernatural. It is no coincidence that he chose to write the introduction to Zeitlin's book, *The Other Reality*, which deals with inexplicable or incomprehensible facts and events as witnessed by well-known people, and with the research of para-psychological phenomena. This field was very close to Bashevis-Singer's heart and is widely referred to in his own works.

It would thus seem that he was drawn to a deep aspect of mysticism or the occult relating to the positive mysticism known as 'white mysticism', which contributes to the construction of the profound meaning of a work of art. He believed that literature should educate and entertain, as can be seen in one of his conversations with Richard Burgin: "In a previous conversation with me you pointed out that in your opinion the main purpose of literature is some kind of entertainment . . ."[4] It is for this reason, so he explains, that he deals with 'black mysticism' as well, the sensational kind touching upon the mysterious and the irrational.

Singer's special interest in demonology also led him to the folkloristic aspects of *Kabbalah*. He added secular or scientific sources to create something new from the *Kabbalistic* foundations he utilised. The author's first encounter with this world was

through his father (*In My Father's Court*[5]). From then on, he turned to the world of the occult for answers to various existential questions that puzzled him, and for the enrichment of his fertile imagination.

> My father started with moral sayings and suddenly began to speak about the *Kabbalah*. 'Things are not simple. Things are not simple,' he said. 'Everything is a secret within secrets. According to the *Kabbalah* everything is according to law. In everything there is a secret. Mysteries within mysteries . . .'. [6]

In his autobiography *Lost in America*[7] Bashevis-Singer speaks of the attraction the world of the *Kabbalah* held for him. In the introduction to Part One, "A young boy in search of God", he distinguishes between mysticism and religion. He claims that both come from one and the same source – the human soul, which senses that the world is not accidental, that the Divine Spirit pervades it. The distinction lies in the fact that religion is a public experience, whereas mysticism is something felt by the individual. His purpose in this essay is to recount the experiences of a man who considers himself a bit of a mystic in his life and in his literary work.

In this part of his autobiography, Bashevis-Singer provides the reader with his religious creed, claiming that the Jews whose religious affiliations were not strong enough fell by the wayside and became assimilated into other nations. The only people who remained part of the Jewish nation were Jews who took their faith seriously, and gave their children a comprehensive religious education. Jews in the Diaspora adhered to their one hope, that the Messiah would eventually come.

At the end of the novel *The Magician of Lublin* one reads of the closeness to the world of Judaism and the occult. Yasha, detached from the world, from reality and from all that surrounds him, tries to come closer to God. The wonder of Creation, God's power in the world, reward and punishment, as well as ethical and other existential issues, fill Yasha's mind and thoughts. The end of the novel shows a connection with the 'beyond', in the affinity Yasha feels towards the world of the dead. The hero, and perhaps the author too, choose to be closer to God as a solution to a life which may seem lively and complete but is in fact hollow and devoid of meaning.

In *The Penitent*, too, the main character chooses the path of religious orthodoxy. To a considerable extent this again reflects the author's choice in life. In fact, in the Introduction to the book, he apologises for the two opposing tendencies in it: the secular, anti-religious tendency, about which he spoke at the Nobel Prize ceremony, and the inclination towards orthodoxy. This perhaps has to do with his fear of assimilation – a noticeable trend in the America of the 1960s and 1970s among progressive secular Jews.[8]

In many of his short stories, Bashevis-Singer touches on the world of mystery and the occult. In "Sabbath in Portugal", the mysterious spirit of generations of "*conversos*" (forced converts – *Anusim*) hovers over Señor da Alvira and his wife, who in the narrator's imagination was transformed into Esther, his girlfriend prior to the Holocaust. A connection to the heavenly worlds, to forces beyond our ken, to a sense of irrational mystery, also appears in stories such as "The Chimney Sweep", "The Parrot", "The Jew from Babylon" and The "Kabbalist of East Broadway".

"The Yearning Heifer"[9] provides a good demonstration of Bashevis-Singer's mystical approach to life, nature and the universe. The personification of a heifer yearning for its mother and sisters in the cowshed from which it was taken, testifies to the author's solid belief in a world of irrational mystery. The animal is endowed with human traits such as the emotion of painful longing, and with a human appearance of large ears and giant eyes; it is given wisdom which only animals possess. Here the author demonstrates his love towards the heifer, his warmth and deep, mystical understanding. All of nature senses and feels. In this story Bashevis-Singer weaves mysticism into reality by treating the 'mooing' as a mystery not of this world; he imagines a heavenly heifer in a far-away constellation that has awakened, and begun a mourning that will not cease until all life in the cosmos is resurrected.

Only a sensitive ear such as Singer's, and his observant eye, can hear the 'mooing', the yearning sound for its mother, and see the universe's expectation of revival. By means of his inexhaustible resourcefulness, his belief in the occult and his affinity for the world 'beyond', Bashevis-Singer succeeds in creating an enchanted world, an imaginative and meaningful mystery, a gateway into the irrational world of the occult. In the author's words:

> . . . "The Yearning Cow" is a very special story . . . I once saw a heifer scream like this and a man told me that it had been taken out from a stable where there were other cows and the heifer was missing either its mother or its home. . . . You cannot try to write another story about a screaming heifer.[10]

Chagall, too, is close to the world of the occult, to mysticism and to the mysteries of life. He perceives a unity between man, nature, the world and beasts, all of which are a part of Creation. For him mysticism is a broad concept.[11]

Chagall believes in a spiritual love that fills the world. Angels[12] and people connect mystically through a union of humans and animals, as if an internal secret language links them together. The presence of some animals that float, or others that play the fiddle, and the presence of angels among people, all constantly point towards a transcendental and supernatural reality. His bond with the Land of Israel, the Bible and the Jewish faith was deeply important to him. The Jewish-*Hassidic* background of his childhood and youth had a lasting influence on his choice of motifs. Of all the well-known Jewish painters of the twentieth century such as Pissarro, Soutine and Modigliani, Chagall was the only one who drew inspiration from the Jewish world; it is inconceivable to think of his art without its Jewish aspect.

Chagall considered himself and wanted to be perceived as an artist of the world at large. As such, he painted various crucifixion scenes, a fact which aroused disputes and debates among his Jewish admirers. His ties to Israel also brought him closer to Judaism, although it must be said that his relations with the State of Israel were ambivalent and problematic. For the Knesset building in Jerusalem he created three wall carpets and fifteen mosaics. He also made the famous stained-glass windows of the synagogue at the Hadassah Medical Centre in Ein Karem, Jerusalem. He contributed paintings to museums in Israel, but maintained a reserved attitude,

although he knew that despite all his successes, he would always be considered a Jewish artist.

In 1931 he painted *Rebecca at the Well*, a work in which he tried to capture the atmosphere of the Orient through the camel and the bright colours. *The Shepherd Joseph*, painted that same year, depicts him as an exotic youth with beautiful eyes.

*Interior of a Synagogue in Safed* (1931) conveys the poetic oriental spirit and ancient Middle Eastern architecture, which is light and hospitable, in bright colours. He also painted Abraham greeting the angels, the sacrifice of Isaac, Rachel's tomb, King David and more.

Angels are a frequent motif in Chagall's works. In *L'Apparition de la Famille de l'Artiste* (1935–1947) his family appears to be resurrected; accompanied by some animals, they float in space over the town, while it is not clear whether they are living people or spirits. Above them there is a feminine angel-like figure. The artist, as if enveloped in a dream, sits in front of his easel and paints them in the abstract. In *The Bridal Pair with the Eiffel Tower* (1928) an angel-woman comes through the window and presents the couple with a bridal bouquet as a sign of the great joy sent to them from above.

Animals are an integral part of Chagall's compositions.[13] In *The Stable* (1917) the head of a suckling appears to grow out of and parallel to the stable. Its almost-human eyes express deep yearning, suffering and longing. Together with the upward-pointing mouth, it gives the impression of being part of the household, of the village, of life.

In *Between Darkness and Light* (1938–1943) the chicken below is an indication of femininity and motherhood. In *I and the Village* (1911) the cow is standing in front of the artist, making eye contact with him. It, too, is a symbol of femininity, motherhood, warmth and humanity. Complete harmony exists between humans and animals.

## *The Slave*

At the centre of *The Slave*[14] one finds the wonderful love between Jacob the captive and Wanda, the daughter of the Pole Jan Bzik, Jacob's owner. In this, as in other novels, Bashevis-Singer combines the real with the metareal, facts with the fantastic. Jacob and Wanda's highly unlikely relationship takes place in the seventeenth century, against the background of the *pogroms* headed by Bogdan Chmielnicki, who destroyed Jewish families and entire communities: "In other regions the Cossacks had beheaded, hanged, garrotted, and impaled many honest Jews. Chaste women had been raped and disembowelled" (ibid., p. 11). Although the possession of slaves was illegal in Poland at the time, Jacob arrives as a slave in a remote village where paganism, ignorance, superstitions, even incest and, of course, a deep-rooted hatred of Jews, coexist. This darkness is lit up by the character of Wanda, who is beautiful, healthy, wise and kind, in complete contrast to her surroundings. It is in this setting that a unique story of idyllic intimacy unfolds.

The hero is firmly connected to reality, as well as to religion and the Jewish tradition. The novel is saturated with motifs taken from that tradition, and in particular

from the Bible: it is based on the Biblical story of Jacob, who journeys to Haran, falls in love with Rachel and works for seven years, and then for another seven, in order to win her as his wife. There are many points of similarity between the Biblical Jacob and Rachel and this Jacob and Wanda, who converts and takes the name Sarah. In both cases Jacob is far from home, family and fellow Jews. In Haran, as well as in the remote Polish village, people engage in pagan rituals and witchcraft. True, Jacob went to his uncle Laban of his own free will, but the additional seven years he had to stay there were because of Laban's trickery. This was a kind of slavery, too. In the novel, the hero is taken against his will, ending up with Jan Bzik by chance. The times are different but the similarities are clear. Both heroes are scholars but also shepherds, people who learnt to manage well in the countryside. The Patriarch tended Laban's flocks with great success, as recounted in the story of the speckled and spotted sheep. The slave tends Jan Bzik's cows with such success that the simple peasants suspect witchcraft is involved. Although agriculture and cattle raising were not common occupations among seventeenth-century Jews, the novelist chooses to place Jacob in the countryside, surrounded by beautiful landscapes and mountain views.

In fact, his occupation enables him to observe the commandments of the *Torah* better than any other would have:

> He scampered over the rocks with the agility of a monkey, mindful of which herbs and grasses were good for the cattle and which harmful. All those things which are required of a cow-herd he could do: light a fire by rubbing wood against wood, milk the cows, deliver a calf. For himself he picked mushrooms, wild strawberries, blueberries, whatever the earth produced . . . (Ibid., p. 13)

He becomes adept at agricultural work and adapts well to life in the countryside, where he appreciates the great miracle of Creation:

> As he drowsed, he heard pine cones falling and the coo of a cuckoo in the distance. He opened his eyes. The web of branches and pine needles strained the sunlight like a sieve, and the reflected light became a rainbow-coloured mesh. (Ibid., p. 16)

He even has a dog[15] which he does not like at the start and symbolically names him Balaam, alluding to Judaism's dislike of dogs. It takes some time, but Jacob eventually gets used to its barking and licking. In the *Kabbalah*, a dog is considered a defiled animal – part of the demonic forces. In the *shtetl* it would be nearly impossible to find a Jewish dog owner. But this dog watches over Jacob and his herd and like the Biblical Balaam, turns out to be a blessing rather than a curse. His greatest success is with the cows, that produce more milk and look healthier than those of the other peasants. Jacob feels affection towards the cows and even speaks to them: ". . . 'Good morning, Kaviatola!' Jacob spoke to her. 'You had a good sleep, didn't you?' He had become accustomed to speak to the cows . . ." (ibid., p. 9). Such a relationship with nature and animals is not characteristic of Jews; quite the contrary. That is what makes this Jew and the novel so unique.

Jacob may well be considered Bashevis-Singer's Jewish hero who is the most at peace with his faith and his God, making repeated attempts to maintain both his

humanity and Jewish identity. Yasha Mazur, in *The Magician of Lublin*, attains perfection only at the end of the novel, and the faith of the penitent Joseph Shapira also evolves over time. Bashevis-Singer's other characters abandon their Judaism and go through a heretical phase. Herman Broder in *Enemies, A Love Story* and Aaron Greidinger in *Shosha* are good examples. Jacob, on the other hand, has complete trust in God, almost never wavers and has no conflicts when facing his hard life.

Even when torn between his faith and his desire for Wanda, Jacob tries to convince himself to remain a dedicated Jew, pleading with God to relieve him of this world's temptations so that he should not sin before Him. In his prayers he talks of his soul that is weary of wandering among Gentiles, murderers and idol worshippers, and begs God to take him back to his origins. He avoids non-kosher food and tries to live in accordance with the Jewish calendar: "Rosh Hashana, Yom Kippur and Succoth, according to Jacob's calendar had passed" (ibid., p. 63). On Passover he makes an effort not to eat leavened bread; in fact, he tries to observe all the commandments properly, from sunrise to sunset. In the morning he washes his hands and then says the morning prayers; in all his actions he tries to remain an observant Jew. Jacob is well versed in Jewish traditional literature. Before he is taken prisoner, and also after his return to Josefov, he is admired for his learning; he tries, though, to hide the extent of his knowledge so as to minimise inquisitive inquiries about his and Wanda's families.

What is surprising about this novel is that the hero, unlike others, almost never questions his religion, nor entertains the kind of doubts which may lead to heresy, and altogether to an abandonment of its teachings: "Jacob of Josefov took the privations Providence had sent him without rancour" (ibid., p. 11). His steadfastness was not the result of inculcated habit; Bashevis-Singer presents his protagonist as someone who thinks, observes, knows and doubts, and yet adheres to the God of Israel and His ways.

Trying to cope with the situation by means of his intellect, his emotions and his devoutness, Jacob tries to clarify to himself his own attitude towards God:

> I have no doubt that *You* are the Almighty, and that whatever *You* do is for the best, but it is impossible for me to obey the commandment 'Thou Shalt Love Thy God'. No, I cannot, Father, not in this life. (Ibid., p. 91)

Here is a hero who inquires into his own relation to religion, beliefs and connection to Judaism, yet despite problematic issues, remains a believing Jew. Despite his intimacy with Wanda, and after he goes back to living among Jews, Jacob is a solitary and reflective figure. The physical and spiritual trials he experiences remind one of the Patriarch, who was also basically " a quiet man, staying among the tents . . ." (Genesis 25:27). Wanda-Sarah's death in childbirth as a young woman, and her husband's longing for her, are definitely reminiscent of the Biblical figures.

There is another allusion to a Biblical figure, that of Moses: Jacob engraves the six hundred and thirteen commandments of the *Torah* on stone, in an act not unlike that of Moses and the stone tablets.

Wanda's figure is based largely on a Biblical precedent, primarily that of Sarah the Matriarch. Like Sarah, she comes from a pagan family. She is desired by all the

men in the village, reminding the reader of Abimelech and Sarah, and Abraham's fears concerning the matter.

A closer association can be found between Wanda and Ruth the Moabite, and the story of Ruth and Boaz on the threshing floor. Like Ruth, she leaves her family, her village, her people and everything she was familiar with, to follow Jacob. This provides an obvious allusion to the birth of the forefathers of King David and the Messiah. The son to whom Wanda gives birth becomes an outstanding *Torah* scholar, head of a yeshiva in Jerusalem continuing the lineage. Not the Messiah, certainly, but still an unexpectedly fortunate development for the son of a convert who followed Jacob unhesitatingly.

Her character, too, differs from Bashevis-Singer's other female heroines. She possesses beauty, wisdom, physical strength, internal and external purity and a strong erotic appeal. But above all, she possesses an overwhelming desire to understand, internalise, accept and observe the Jewish religion, and not only because of her great love for Jacob.

Esther, Yasha Mazur's wife in *The Magician of Lublin*, possesses some of the same faith, integrity and diligence to be found in Wanda. Masha, in her relationship with Herman in *Enemies, A Love Story*, possesses some of the same bewitching erotic power. Yadwiga, the Polish woman in the same novel, possesses some of the same generous rustic simplicity and diligence as Wanda's; to this, one must add her conversion, and carrying on the lineage through the birth of little Masha. The semi-retarded Shosha possesses some of Wanda's innocence and unconditional love for Aaron. When comparing Singer's characters in the novels mentioned above, some of the differences must certainly be ascribed to the different time periods and locations. Nevertheless, no other character is as complete as Wanda, due to her bond with the novel's hero, and the significance she attributed to their conjugal life. She is willing to learn, adopt the ways of the Jews, and attain the deep understanding of the religion:

> Jacob spoke with her and instructed her in their religion. He had already taught her the prayers and how to write Yiddish and now they studied the Pentateuch, the Books of Samuel and Kings, the Code of the Jewish Law ... Her diligence was amazing, her memory good; many of the questions she asked were the same the commentators had raised. (Ibid., p. 130)

Wanda continues to show real interest, and asks questions to which even Jacob does not always have the answer. When he begins discussing occult matters with her, he thinks of himself as truly witless. He wonders how it is possible for the brain of a Gentile to grasp such deep matters. But from her queries he realises that Wanda understands what he is talking about.

The couple's emotional involvement is intense; it certainly has something to do with her conversion to Judaism, but her growing attachment to the Jewish faith is partly due to her perception of idol worship and life in her village as meaningless. Thus she decides to live her life with her husband and his people, an act demanding great sacrifice on her part. She pretends to be deaf and dumb, hence isolating herself socially and sentencing herself to a life of alienation, loneliness and great

pain, bearing the insults of the Jewish women; here Bashevis-Singer levels sharp criticism at Jewish society, which is very strict in the observance of the Kosher dietary laws but ignores those dealing with interpersonal relationships: "Sarah's presumed deafness left the women free to slander and ridicule her in her presence. She was referred to as a dumb animal, a *golem*, a simpleton, a cabbage head" (ibid., p. 133).

The bond between the two is a perfect fusion of the physical and the spiritual, of very strong, passionate attraction, combined with a mutual romantic sensitivity to each other's finest emotions. The unique tie they share stems from their religion and their observance of the commandments, the social-religious framework – all of which bind them together. Jacob is drawn to Wanda not only because of her attributes but also because she understands his needs as a Jew being a shepherd on the mountain. She agrees to obey the religious instructions out of awareness and spiritual alliance. When they re-enter Jewish society, they draw even closer to each other, since she has to break off all other social ties. Wanda's consolation is their strong mutual affection towards each other, her devotion and her internalising of the values of Judaism.

By using Biblical underpinnings and the archetypal figure of Jacob the Patriarch, Bashevis-Singer turns the story into a metarealistic novel, which ties the pair's reality to the metaphysical, to belief in the Creator. In this way it becomes a universal story of loyalty, trust and fidelity regardless of time and place.

Their special relationship is only partially explained; some parts belong to the occult. The author scatters some hints throughout the book to make the reader feel that their togetherness is preordained by something much stronger than either of them. In the *Kabbalah*, Jacob finds further confirmation of their uncommon closeness, where it indicates that carnal desire has its roots in the upper worlds.

Towards the end of the novel, the reader learns of Jacob's increasing sympathy towards Shabbtai Zevi and his movement; his yearning towards salvation and the coming of the Messiah encourages him to study the occult. His son, Benjamin-Eliezer, whose name reminds one of Biblical Jacob and Rachel's son Benjamin, also becomes interested in mystical studies:

> The *Kabbalists*, to whom he became closer in recent years, claimed that a Jew now had the duty to live in the Land of Israel. The troubles announcing the coming of the Messiah were about to come. There were signs that the war of Gog and Magog was approaching ... The husks were upsetting worlds in order to overcome the balance of grace. (Ibid., p. 237)

The end of the novel reaffirms the closeness to the secret world of the occult: Many years after Wanda-Sarah was buried outside the cemetery, a miracle occurs and the graves of Jacob and Sarah mystically 'gravitate' towards one another: Wanda-Sarah's is miraculously found and she is identified. Jacob is buried at her side:

> They immediately realised that Sarah's grave had been discovered. The community had buried her outside the cemetery but the cemetery approached her and took her inside its wall. The cemetery ruled that Sarah was a Jew and died in purity. (Ibid., p. 253)

The novel raises questions concerning the degree to which a person controls his own destiny, of whether things happen by chance and free will or are predetermined by Divine guidance; and there are issues of reward and punishment. Bashevis-Singer manages to present a composition which is, on the one hand, personally and archetypically Jewish, in that it reflects the Jew and his strong bonds to his origins, making it a work that transcends time and place. He does this by means of its Biblical foundation and links to Judaism, and to the observance of the commandments under nearly impossible conditions; and by means of ties to the mystical world of the occult.

On the other hand, the composition has a universal aspect since it deals with existential matters of general relevance. Singer emphasises the uniqueness of the Jewish people but at the same time sheds light on the more universal aspects of Judaism. It is Jacob who combats idol worship and superstition with his monotheism, who tries to explain, or at least to represent, the faith in one God and its implications in a pagan world of stifling darkness. As such, he becomes the representative of metaphysical truth in the fight against idolatry and ignorance.

## The Stained-glass Windows at the Hadassah Medical Centre, Jerusalem

> I think of Israel as of an Oriental queen. This synagogue should be the queen's crown and I would like my windows to be the jewels of her crown . . . The words in the Bible 'you will be as a crown' came back to me suddenly and I knew I would have God's help.[16]

The idea of receiving inspiration from above, from a Higher Power, an inspiration fused with aesthetic-spiritual beauty, shows how Chagall viewed the windows and their theme. The result is a creation which indeed looks like a glistening gem, shining in bright, mystical and spiritual splendour. The windows are part of a long list of works containing Jewish and Biblical motifs, which appear in different forms throughout Chagall's career; this composition expresses the centrality and importance of Jewish motifs for him and stresses his connection to Jewish tradition, to his roots, to the Bible and even to the Land and State of Israel.

The art of stained-glass window making is unique and quite ancient. Its beginnings date back to the Byzantine period, reaching its zenith in the Gothic cathedrals of Western Europe. Working with stained glass demands special skills over and above those needed in painting. In addition to the significant role played by the artist who prepares the design, the plan, the general layout and the detailed location of each piece of glass, there is an important part played by the craftsman who carries out the artist's plan.

In 1952, Chagall visited the cathedral at Chartres; he was also familiar with Notre Dame de Paris. The colours of the windows, the composition, and especially the atmosphere created by the penetrating light refracted by the glass, all impressed Chagall and inspired him to work with this medium. He began working in glass at quite an advanced age, after he had already had a flourishing career and received

worldwide acclaim. At the time there were other well-known artists, including some of his friends, who worked in glass, among them painters such as Braque, Villon, Léger, and in particular Matisse, who as early as in 1951 made the windows for the Chapel of Our Lady of the Rosary in Vence, where Chagall settled in 1950.

Chagall's works in this medium can be found in numerous places around Europe, in churches, museums and synagogues, just as in his paintings he never hesitated to treat Christian and Jewish motifs together or in juxtaposition. Chagall said of the medium: "There is something very simple about a stained-glass window: just materials and light. Whether it is in a cathedral or a synagogue, it is all the same – something mystical passes through the window."[17] With the Jerusalem creation, he attained one of the high points in his creative career in general and certainly reached his peak in the domain of stained-glass art. At the opening of the Hadassah Medical Centre Synagogue with his windows, in an address Chagall said:

> For me a stained glass window is a transparent partition between my heart and the heart of the world. Stained Glass has to be serious and passionate. It is something elevating and exhilarating. It has to live through the perception of light. To read the Bible is to perceive a certain light, and the window has to make this obvious through its simplicity and grace.[18]

In Jerusalem, Chagall succeeded in uniting the Biblical story with the graphic forms and aesthetic beauty of the colours and light penetrating through them.[19] He worked in cooperation with an outstanding stained-glass craftsman, Charles Marq, who managed the well-known Simon workshop in Reims, France. Chagall was entrusted with decorating a cathedral, a project he considered to be a great honour for a Jew. The first cathedral he designed for was St. Etienne in the city of Metz, where he treated such Biblical motifs as the Creation and the sacrifice of Isaac. He stated that the work was ordered by the French government and not by the Church and therefore refused to accept payment for it.

In 1959, Chagall was requested by the then-President of Hadassah, Dr. Miriam Freund, and the architect of the synagogue, Joseph Neufeld, to create twelve windows for the Medical Centre in Jerusalem, whose theme would be the twelve tribes of Israel. Chagall had to take into consideration the prohibition stated in the Ten Commandments, against the making of any human images, statues or masks for purposes of worship, and sought a way to depict the tribes abstractly. Two Biblical sources,[20] Jacob's deathbed blessings, which he bestowed on his sons (Genesis 49) and Moses' farewell benediction to the tribes of Israel (Deuteronomy 33), were Chagall's primary sources for the project, on which he worked for about two years. Chagall explained his closeness to and fascination with the Bible ever since his youth and how he related to it as the greatest source of poetry of all time, and added: "I have searched for its reflection in life and in art. The Bible is like an echo of nature and this is the secret I have tried to convey."[21]

The result is a dazzling symphony of vivid radiant colour, light, form and content. The physical dimensions of the windows (251 x 338 cm) enable the special, celestial light of Jerusalem to filter through the brilliant colours and illuminate the synagogue's interior.

Through the Biblical text underlying each window and with the help of the light, Chagall succeeded in giving the synagogue a somewhat mystical air[22] and said that his wish was to convey the profound sense of mystery and spirituality that he felt in Israel.

In 1961, before their installation in Jerusalem, the windows were displayed, in a special pavilion built for them near the Louvre, by the French Minister of Culture, André Malraux, who was deeply impressed by them. They were then moved to the Museum of Modern Art in New York whence, in February 1962, they were set in place in Marc Chagall's presence. In the brief speech he delivered on that occasion, he said: "How is it that the air and earth of Vitebsk, my birthplace and of thousands of years of persecution, find themselves mingled in the air and earth of Jerusalem?"

In addition to the two Biblical sources for the iconographical contents, there is another Biblical source he used to determine the colours. These verses deal with the placement and colours of the High Priest's breastplate:

> *And thou shalt make the breastplate of judgment with cunning work; after the work of the ephod thou shalt make it; of gold, of blue, and of purple, and of scarlet, and of fine twined linen, shalt thou make it. Foursquare it shall be being doubled; a span shall be the length thereof, and a span shall be the breadth thereof. And thou shalt set in it settings of stones, even four rows of stones: the first row shall be a sardius, a topaz, and a carbuncle: this shall be the first row. And the second row shall be an emerald, a sapphire, and a diamond. And the third row a ligure, an agate, and an amethyst. And the fourth row a beryl, and an onyx, and a jasper: they shall be set in gold in their inclosing. And the stones shall be with the names of the children of Israel, twelve, according to their names, like the engravings of a signet; every one with his name shall they be according to the twelve tribes.* (Exodus 28:15–21)

The colours are based on the four primary ones: blue, red, yellow, and green. The windows are arranged in groups of three, like the stones in the High Priest's breastplate. The same order was used by Jacob in his blessings to his sons when he called on the names of the tribes:

*On the East wall*:
 Reuben against a marine blue background
 Simeon against a dark blue background
 Levi against a light yellow background.

*On the South wall*:
 Judah against a crimson background
 Zebulun against a red, orange and purple background
 Issachar against a green background.

*On the West wall*:
 Dan against a blue background
 Gad against a dark green background
 Asher against a green background.

*On the North wall*:
Naphtali against a lemon yellow background
Joseph against a yellow, gold and orange background
Benjamin against a light blue background.

Colours have a physical, aesthetic, symbolic and spiritual effect. It was no coincidence that these four basic, predominant colours, which represent the basic colours of the universe, were chosen, thus giving the windows yet a deeper meaning in addition to the meanings related in the Biblical passages.

Chagall prepared each window in five stages:[23]

– Preliminary preparation with pencil, pen and ink: the main outline and the central theme
– Preparatory sketch in ink and watercolours: the basic plan with light and shadow
– First sketch in watercolours and ink: basic colour organisations with preparation of the background colours
– Small gouache and collage model: processing the preceding sketch until the desired result is obtained
– Final gouache and collage model: the final version of the window before the casting of the actual stained glass.

Each window possesses the same basic compositional pattern: all are constructed out of the same number of basic pieces. Just as there is a plan for the overall colour scheme, there is also a similar division within each one, with variations on the geometrical forms – squares, rectangles, etc., and also variations of symmetry and balance within the general composition of each one. Within the general plan, each part is divided into shapes and subparts as appropriate to the theme, colour or reflection of the light – the division contributing to the difference in the overall effect of each 'tribe', which is divided width-wise into four rows, each of which contains three large sections, making twelve sections in all.

This pattern is repeated on each occasion, providing symmetry in the general structure of each window, with a clear connection to the number twelve. Chagall's plan also constitutes a structural echo of the general layout: four walls with three windows on each wall, providing yet another echo of the number of the tribes of Israel. While there are descriptions of all the windows, three are focused on in greater detail: Reuben – the firstborn; Judah – representing monarchy; and Joseph – the symbol of perfection and the link between heaven and earth.

**Reuben**

> *Reuben, thou art my firstborn, my might and the beginning of my strength, the excellence of dignity and the excellence of power.* (Genesis 49:3–4)
> *Let Reuben live, and not die; and let not his men be few.* (Deuteronomy 33:6)

Reuben is the first window in the synagogue, since he was Jacob's firstborn son. Chagall remained fairly faithful to the Biblical framework but allowed himself great

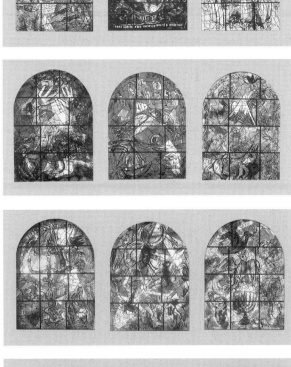

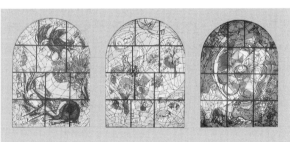

**16** Jerusalem Hadassah Medical Centre, stained glass windows from the twelve tribes of Israel by Marc Chagall © ADAGP, Paris and DACS, London 2009.

freedom as to the contents of each piece. The firstborn's primacy, *"the first sign of my strength"*, prompted Chagall to 'describe' Creation – obviously the beginning. Accordingly he chose the bright blue colour and its various hues against a background of majestic Divine white, which inundates the window at various points of light. The blue together with the white elicit an association of air, water, purity and the lyrical atmosphere of a primeval Biblical space.

In the central section of the top row, a circle evokes the sun with its rays of light. Inside the circle, part of Jacob's blessing appears; here, too, there is the greatest and most significant concentration of white, the colour of purity, Divine sanctity and light – coming in from the 'beyond', from the world of spiritual mysticism which is disseminated in rays, spreading through the universe. This is how Chagall expresses the Divine Presence in the cosmos.

A feeling of movement and flow is generated, distributing the heavenly light around the circle on top by means of internal and external circles. The different rounded glass shapes surrounding the circle and the right-hand rounded beam of

light create a momentum and a feeling of light, expanding from the source towards the universe. Here, Chagall creates a feeling of the beginning of something primeval, through the depicted connection between heaven, water and earth. In the first sketch one can discern the line of the land traversing the third section from above. The same holds true for the other preparatory works. But in the final version it is much less evident and thus the boundary between sky, land and water is invisible. Still, the line of the land appears between hills and in a green spot at the left edge, under a few white sheep drawn in thin, delicate contour lines. The latter make their first appearance in the watercolour preparatory sketch. In the lower middle section there is an area which may be perceived as land, possibly a small bay with a hint of sheep on top, which can also clearly be seen in the final model.

In order to fill the universe and instil a sense of life, vitality and fullness, Chagall places two pairs of birds at the top and two pairs of fish below. Each pair has a different character. The left pair of birds (top and below) is harmonious and calm; the top bird's beak crosses what seems to be an olive branch while the second pair (top and below) is aggressive and disharmonious, especially against the red background. The fish are arranged in reverse symmetry: the right pair is larger, expressive and somewhat aggressive; the left pair is gentle and calm. The different directions of the birds on top and the fish below emphasise the movement and dynamism in the universe, as mentioned in Moses' blessing, speaking of life and the creatures. Thus asymmetry is created above and below – in the numbers of birds and fish, in the directions they face, in the dynamism, the plenty and the feeling of the fullness of the world and of Creation, which comes from above through Divine inspiration. The vegetation, too, shows a parallelism between above and below, between land and water plants. In addition, on the left side there are red plants, which evoke the mandrake fruits that Reuben brought to his mother:

> And Reuben went in the days of wheat harvest, and found mandrakes in
> the field, and brought them unto his mother Leah. Then Rachel said to
> Leah, Give me, I pray thee, of thy son's mandrakes. (Genesis 30:14)

The fruit of the mandrake[24] was considered a symbol of fertility, thus reinforcing Moses' blessing. It was also an object of negotiation between Rachel and Leah – Rachel sold her sister a 'night' with Jacob in return for the mandrakes. The fruit resembles a small apple, perhaps in an indirect allusion to the Original Sin. The red colour introduces a hint of violence and conflict. In parallel to this red there is some red in the two birds in the centre and in the fish below; for balance there are two pinkish-purple spots, one near the top and the other under the water. In all of these there is a balance, in the composition, colour and content, above and below.

Each tribe represents a different character trait of the people of Israel. Reuben possesses strength and power, yet sin and evil; his hasty character is included in the work as well. Through primogeniture, Chagall expresses the primacy of Creation; he expresses the beauty and universality of Creation by incorporating all of it – the sky, the sea, the land, the vegetation below and above the water, fish and birds, movement and calm, clouds and waves. The mystical Divine light that comes from the 'beyond' with its white purity unites the Creation.

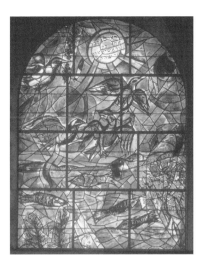

**17**   Jerusalem Hadassah Medical Centre, stained glass window of Reuben from the twelve tribes of Israel by Marc Chagall. Sonia Halliday Photographs © ADAGP, Paris and DACS, London 2009.

### Simeon

Simeon's window stresses the violent, cruel and ugly aspect of the deed committed by Simeon and Levi. They broke the agreement Jacob had reached with Hamor, father of Shechem, and rather brutally avenged the dishonouring of their sister Dinah, who was ravished by Shechem.

The Biblical narrative is depicted by the use of nocturnal dark blue and violent red spots, and more specifically through the red circle around Simeon's name, together with a quote from the verses describing the deed of the two brothers:

> *Simeon and Levi are brethren; instruments of cruelty are in their habitations. O my soul, come not thou into their secret.* (Genesis 49:5–6)

Chagall points to violence, lack of loyalty, violation of agreements and revenge.

### Levi

Although Jacob chooses to associate Levi with Simeon in their deed, Chagall chooses to represent Levi as spiritual, illuminated and illuminating, because he was the forefather of the family of Levites who served in the Tabernacle and the Temple; this was also the tribe that taught the Law to the people. Chagall took a verse from the blessing of Moses, himself a scion of the Levite family:

> *They shall teach Jacob thy judgments, and Israel thy law: they shall put incense before thee, and whole burnt sacrifice upon thine altar. Bless, LORD, his substance, and accept the work of his hands.* (Deuteronomy 33:10–11)

For this reason Chagall chose a very light yellow colour, through which shine spots of white light, symbolising the *Torah* and sanctity; even God's explicit name is written in the quoted verse. It is the ultimate expression of sanctity, the servants of the temple, observance of the commandments, a reminder of the Tablets, the Star of David and other Jewish symbols, which Chagall had absorbed from various sources.[25] In this window Chagall links the most ancient symbols with those of later times: the Tablets and the *Kiddush* Cup or *Havdallah* Cup.

**Judah**

> *Judah, thou art he whom thy brethren shall praise: thy hand shall be in the neck of thine enemies; thy father's children shall bow down before thee. Judah is a lion's whelp: from the prey, my son, thou art gone up: he stooped down, he couched as a lion, and as an old lion; who shall rouse him up? The sceptre shall not depart from Judah, nor a lawgiver from between his feet, until Shiloh come; and unto him shall the gathering of the people be. Binding his foal unto the vine, and his ass's colt unto the choice vine; he washed his garments in wine, and his clothes in the blood of grapes: His eyes shall be red with wine, and his teeth white with milk.* (Genesis 49:8–12)

> *And this is the blessing of Judah: and he said, Hear, LORD, the voice of Judah, and bring him unto his people: let his hands be sufficient for him; and be thou an help to him from his enemies.* (Deuteronomy 7)

This is one of Jacob's longest, most detailed and most generous blessings. In Judah's case, Chagall chose to reflect the entire blessing, adhering to every element mentioned. Judah was accorded this blessing after his three elder brothers had proven unworthy of it.

Judah's is one of the most important windows, due to its strong colours and content, and the comprehensive, multilayered nature of the blessing it contains. Red in at least four different hues dominates here. In the preparatory sketches, however, it was less intense. Red expresses the nature of the tribe of Judah, both in its internal substance as well as symbolically: it is the colour of kingship, heroism and victory over an enemy, of authority and a vital life, of wine and of plenty. There is also some white, signifying a plentiful supply of milk, but even more manifestly the white of heavenly light from above.

The letters of Judah's name appear inside the crown on top.[26] Interestingly, they are quite similar to the letters of God's explicit name (in Hebrew). Out of this crown, a white light – heavenly, pure and mystical – emanates from the 'beyond', seemingly through the allusion to God's name and from the crown's upper edges. The light descends upon the city, the world and the cosmos. Underneath the crown two hands are positioned, as if for the Priest's blessing. Chagall did not depict the hands precisely in the way they are held during the blessing, but the fact that the fingers are spread apart and the right hand shows only four – as the little finger of the left hand is only hinted at – adds to the allusion to the familiar hand gesture of the Priest's blessing.

White light symbolising sanctity, purity and Divine Presence penetrates the world, the Land of Israel and especially Jerusalem, spreading along the width of the third section from the top. Some yellow is added, symbolising a sanctity that is within human reach. There is also some blue – that of the sky. These three colours come down from the crown, through the hands, in broad rays of light. The pieces of glass are large and wide, allowing the light to reach the cubist shapes representing Jerusalem and Shiloh, and on down to the feet of the lion crouching along the window's width below. In the centre of the middle part of the second row there is

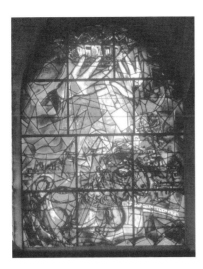

**18** Jerusalem Hadassah Medical Centre, stained glass window of Judah from the twelve tribes of Israel by Marc Chagall. Sonia Halliday Photographs © ADAGP, Paris and DACS, London 2009.

one large and light piece of glass – yellow-beige, which garners the heavenly light over the city.

The window can, in fact, be divided into two nearly symmetrical parts: the top one is dominated by light, indicating sanctity, whereas the lower part represents reality – the city, the lion and part of the opening verse of Jacob's blessing. Behind the lion, which crouches confidently across the width of the window, exuding strength and power, lies Jerusalem, represented by cubist houses with both flat and sloped roofs, suggestive of the houses of both Vitebsk and the Land of Israel.[27] Around the city there is a hint of a wall; this is the Jerusalem of King David, a descendant of Judah who made the city into the capital of the People of Israel. Shiloh can also be identified in this city. It is where the Tabernacle was located, and in it the Holy Ark, which was later moved to the Holy of Holies in Jerusalem. Physically and symbolically, these are two cities in which the Divine Spirit resides, and which are illuminated by the heavenly light. The cities lie between the light and the lion, protected on every side. Perhaps there is a hint of things to come, since according to the *Talmud*, tractate *Sanhedrin*, *Leaf* 98b: "Rabbi Yohanan said: 'What is the Messiah's name?' In the school of Rabbi Imri Sheila they said: 'His name is Shiloh . . . for it is written 'until he comes to Shiloh.' " It is thus possible that Chagall hints not only at Jerusalem and the Shiloh of the past but also at the Messiah, descendant of David, who will come as a bearer of Divine inspiration, redeem the People of Israel and give double meaning to Jacob's blessing to Judah.

This window constitutes a symbolic representation of the tribe chosen for the monarchy, the tribe of King David, to whom were promised power, plentifully flowing wine and milk, the authority of the lawgiver and the judgeship. In the context of Judah, Jerusalem is depicted as filled with heavenly light, which fills the entire universe with white and yellow spots or dots, spread throughout.

### Zebulun

In Moses' blessing, Zebulun and Issachar are mentioned together. Of Zebulun it is said that he should rejoice in his '*comings and goings*', whereas Issachar is blessed in his '*tent*'. The Zebulun window represents the sea, although its colour is not blue, for the tribe was blessed to live along the coast and make a living from the sea. Two

large fish[28] facing each other decorate this window, coloured entirely in the dramatic red of sunrise or sunset. Chagall intended to distinguish the sea here from the sea in the Reuben window – in the former, the sea expresses the primeval nature of Creation, whereas in the latter, it is the everyday sea, of sailors, fish and ships, one of which is capsized, indicating the dangers faced by seafarers. In modern art, a red sea is stylistically more original than a blue one. Chagall has created a very dynamic scene here, with movement above the water as well as moving fish and algae below the surface.

### Issachar

The bright green creates a sense of the crisp, invigorating freshness of fields, plants and the happiness of freedom one experiences in the countryside. Inside the idyllic landscape Issachar's symbol – the ass – lies securely along the lower width, between the two lateral pieces of metal in the lower section, stressing the Biblical words *"between two saddlebags"*. A small bird rests on its back, representing that part of the People of Israel who are assisted by the fruits of Issachar's labour. The presence of the *Torah* learners is represented by the hands, similar to the blessing hands in the Judah window, and by the two rounded shapes behind the white triangle in the upper centre, which are reminiscent of the Tablets. Inside this triangle, Issachar's 'definition' appears just as it does in the blessing identified with him: *". . . a raw-boned ass lying down between two saddlebags."* That is why he is placed between small metal strips, which divide and define each word by itself, like a fence defining the boundaries of the site. It is possible that the white triangle is a reminder of *". . . and Issachar in your tents"* (Deuteronomy 33:18).

These last two tribes represent industry, work and life on land and sea. There are more and less active people; some go out into the wide world, while others remain close to home. This is expressed by Moses' united blessing to these two tribes.

### Dan

Dan was blessed with the authority to judge the people, a characteristic expressed by the three-branched candelabrum located in the centre. At the end of each branch there is a flame. In the right branch the flame comes out of a candle. The two external branches remind one of scales – those of justice. On one side of the candelabrum there is a large yellow spot, representing human justice, for yellow is the colour of human sanctity. On the other side there is a white spot, associated with that at the top which descends onto the city, outlined in the middle section. A sense of absolute Divine justice emanates from the 'beyond', inundating the world.

A *"serpent by the way, an adder in the path"* is wound around the base of the candelabrum; plants and animals surround it. Above, there is a lion springing upwards, in its paw a sword – either of justice or of war. The origin of the figure is the 'lion's cub' in Moses' blessing. The opening verse of Jacob's blessing to Dan, and his definition as a tribe, is written parallel to the arch with the word 'Israel' drawn towards the lower part. Thus, symbolically, Dan's judicial authority originates from above, coming from both a metaphysical and a human power and then spreading to

the People of Israel at large. These two aspects of white and yellow light and their symbolic meanings are also expressed in the verse above, where the letters are surrounded by white and some yellow. Perfect Divine and human justice are both depicted here.

### Gad

The main element in Jacob's blessing to Gad is about war, violence and power. Gad's name is written at the top, surrounded by a circle with the words: *"a troop shall over-come him."* Underneath the circle there is a shield with sharp horns, from which a blood-red colour flows. Arrows and beasts of prey abound, including the head of a majestic eagle. The people of this tribe were reputed to be fearless fighters. The window is an expression of an apocalyptical vision of war, enemies, conquest and violence.

### Asher

Asher is all about tranquillity and prosperity. The name of the tribe in Hebrew is a word associated with happiness and plenty (*Osher*). The window is filled with hues of green, predominantly olive green, as we see in the two olive trees, one above the other. A dove with an olive branch appears at the top as a reminder of the universal peace and harmony which reigned after the Flood.

Below there is a seven-branched candelabrum,[29] whose light derives from the plentiful oil. The crowned bird is a reminder of the anointing of kings. The same is true for the two jars, the larger of which has a bird's head.[30] On a symbolic and mystical level the candelabrum stands for the Divine light, the tree of life and the illumination of the universe. Perhaps Chagall wished to hint at the peace and perfection that will reign with the coming of the Messiah.

### Naphtali

The dominant colour is lemon yellow, with a little gray in it. It differs from the warm yellow of Levi and the bright yellow in Joseph. Below lies a doe which seems to be leaning against a group of houses. Four horns split off from its head, giving a feeling of lightness, movement and speed. The doe is different from the reclining ass in the Issachar window and from the lion in the Judah window. At the side there is a robust tree with a rooster on top, indicating alertness and vitality and reflecting the blessing: *"Naphtali is a hind let loose"* (Genesis 49:21).

### Joseph

> *Joseph is a fruitful bough, even a fruitful bough by a well; whose branches run over the wall: The archers have sorely grieved him, and shot at him, and hated him: But his bow abode in strength, and the arms of his hands were made strong by the hands of the mighty God of Jacob; (from thence is the shepherd, the stone of Israel.) Even by the God of thy father, who shall help thee; and by the Almighty, who shall bless thee with blessings of heaven above, blessings of the deep that lieth under, blessings of the*

*breasts, and of the womb: The blessings of thy father have prevailed above the blessings of my progenitors unto the utmost bound of the everlasting hills: they shall be on the head of Joseph, and on the crown of the head of him that was separate from his brethren.* (Genesis 49:22–26)

*And of Joseph he said, Blessed of the LORD be his land, for the precious things of heaven, for the dew, and for the deep that coucheth beneath, And for the precious fruits brought forth by the sun, and for the precious things put forth by the moon, And for the chief things of the ancient mountains, and for the precious things of the lasting hills, And for the precious things of the earth and fullness thereof, and for the good will of him that dwelt in the bush: let the blessing come upon the head of Joseph, and upon the top of the head of him that was separated from his brethren. His glory is like the firstling of his bullock, and his horns are like the horns of unicorns: with them he shall push the people together to the ends of the earth: and they are the ten thousands of Ephraim, and they are the thousands of Manasseh.* (Deuteronomy 33:13–17)

Joseph's window shines with shades of yellow, orange and gold, expressing a 'round', most perfect and complete blessing. Joseph, Jacob's favourite son, born when his father was an older man, the firstborn son of the preferred wife, Rachel, received a personal blessing from Jacob and was the founder of two tribes, Ephraim and Manasseh. Joseph, whose life was as complicated as it was wonderful, received special treatment from Chagall: eight of his other Biblical illustrations deal with the stories of Joseph. Here his name is arranged in an almost perfect circle at the top; the round shapes are repeated in the letters which make up the name. White and blue light against a yellow background peek out between the letters, hinting at God's blessing descending from heaven, like the white light shining from between the two hands holding a ram's horn at the top. The entire window is studded with spots of white light, disseminating the heavenly blessing onto everything in Joseph's vicinity.

Joseph received the blessings of heaven, the earth and the deep. Three directions come together in his blessing, thus turning his world, life and reality into physical and spiritual perfection. These three domains bring with them different kinds of time and space: that of everyday reality, that of transcendental infinity and that of the deep – both the primeval deep and the depths of water, hinting at plenitude.

Perfection is hinted at repeatedly, in the circular or arc shapes throughout the window: the placement of the hands on top, the hills, part of the rainbow, the fruits, the flowers, the sheep and the fruit basket next to the tree. The greens, blues and reds contribute, since these are the basic colours of the universe.

Some of the difficulties Joseph encountered in his life are also expressed here. For example, on the lower right is a hint of a story – the sheep that symbolise the blessing of the earth are bending down, recalling the brothers who bowed before Joseph, while reminding one of their jealousy and hatred of him because of his dreams and unique traits.

On the left there is a blossoming tree full of fruit, whose branches spread out over the well below; out of the tree rises a crowned bird, symbolising Joseph,

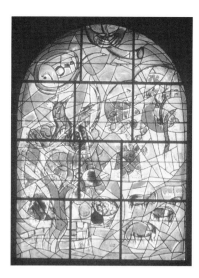

**19**   Jerusalem Hadassah Medical Centre, stained glass window of Joseph from the twelve tribes of Israel by Marc Chagall. Sonia Halliday Photographs © ADAGP, Paris and DACS, London 2009.

holding a bow and an arrow as protection against his enemies, as mentioned in the blessing. The left side, on which the crowned bird appears, symbolises the Kingdom of Israel, while the smaller tree and small houses on the other side are the Kingdom of Judah.

The ram's horns are an indication of several ideas on multiple levels: they remind one of the horns of a wild ox in Moses' blessing. They serve as a reminder of the sacrifice of Isaac – the traumatic experience ending in relief, not unlike Joseph's fate. The ram's horn further reminds people to plead for God's forgiveness during the High Holidays. Above all, it is a symbol of God's blessing, transforming this window into a metarealistic one. The hands, though designed differently, are somewhat reminiscent of the hands in the windows of Judah and Issachar, in that their gesture is also protective; this speaks of sending God's blessing and heavenly plenty from the upper worlds down onto Joseph's almost perfect world, to which the horn symbolising the Messiah is added. The ram's horn stands for the horn of the Messiah. Chagall echoes the tradition concerning the Messiah, son of Joseph,[31] who will precede the Messiah, who was the son of David. In this sophisticated manner, Chagall integrates the hidden and the overt, to create a perfect window.

### Benjamin

Benjamin was Jacob's youngest son, and Rachel's, who died in childbirth. This tribe became known as one of fearless warriors, from whom sprung Ehud Ben Gera – Israel's saviour – and Saul – Israel's very first king. The tribe of Benjamin was also well known for the abduction of Shiloh's daughters. This duality of good and evil is expressed in Jacob's blessing to Benjamin:

> *Benjamin shall ravin as a wolf in the morning he shall devour the prey and at night he shall divide the spoil.* (Genesis 49:27)

The wolf standing over his prey has become the symbol of the tribe and it appears at the bottom of the window as a predatory animal, reminiscent of a lion with bloodshot eyes, coloured in hues of blue-purple and adding a dramatic, nocturnal dimension.

In the centre there is a kind of round rosette, surrounding a flower with secondary arcs, which introduce a dynamic circular motion as a symbol and reminder of day and night, and the cyclical nature of life. Thus one can find colours both of the day – white, yellow and green – and of the night – black, dark blue and purple. Around the rosette there are four animals that are familiar symbols of Jewish faith. In the background appears golden Jerusalem, which was included in Benjamin's patrimony as mentioned in the blessing of Moses. The name 'Benjamin' appears divided in two, with three Hebrew letters on either side of the circle, as a reminder of the duality of the nature of this tribe.

## COMPARATIVE ANALYSIS
### *The Slave* and Hadassah Medical Centre Synagogue's stained-glass windows

The Bible, the Jewish tradition and concepts with which both works are infused, are the basis for this comparison. It appears that despite their 'creative license', Bashevis-Singer and Chagall both choose to remain very loyal to the Jewish Biblical source. These two works do not reflect literary or artistic devices but a way of life. They express the unwavering faith of Jacob, the protagonist of *The Slave*, and the way Chagall interprets the Biblical foundation on which the twelve windows are based. These two compositions remain remarkably close to the letter and the spirit of the Bible.

It would seem that in *The Slave*, despite his occasional doubts, Jacob is a hero who is honest with himself, with God and with his surroundings. He is the Jewish figure most complete and at peace with his religion out of all of Bashevis-Singer's literary figures. Jacob has no doubts as to which path to take: he has no intention of forsaking his Judaism, not even temporarily. True, he is occasionally exposed to temptation but at no cost will he abandon his faith. Because of his desire to remain a loyal and devoted Jew, the tone of the book, reflecting the gravity of his resolution, might mar the reader's enjoyment. Still, no attempt is made to curry the reader's favour.[32]

There are other works by Bashevis-Singer that speak of observant, Orthodox Jews. In *The Penitent*, for example, one gets the impression that it is the invisible narrator speaking through the main character's doubts and deliberations, and that although the hero understands that his chosen path is the best option, he is not at peace with it. In other books containing the same theme, there is a tendency to prefer Judaism as a way of life. Yasha Mazur in *The Magician of Lublin* chooses the Jewish lifestyle, but he only does so at the end of the novel. The Holocaust survivors in *Shosha* arrive in the Land of Israel – as a choice not necessarily based on religious grounds. In *The Slave*, however, a choice is made, unequivocally, right from the start, even though there are ethical, theological and philosophical questions that have to be dealt with.

In the stained-glass windows Chagall, too, approaches the spirit of the Bible and the depths of Judaism probably more than in any other work. Certainly, one should not forget his grand project of Biblical illustrations. However, it appears that the creation of the windows is an end rather than a means; it is no ordinary illustration or

decoration. Chagall became completely involved and felt that forces from above were inspiring and directing him as he poured the entirety of his 'Jewishness' into them.

Both artists rely on patterns of Biblical foundations and their narrative. In the novel there are many allusions to Jacob the Patriarch, just as Wanda-Sarah has similarities to Rachel the Matriarch: both were the preferred, beautiful wife, and both died in childbirth, giving birth to a son. One of the many differences, though, is that the Biblical Jacob and Rachel are united in their youth, whereas Jacob and Wanda-Sarah only truly come together in the afterlife.

In the portrayal of the tribes, Chagall relies on additional Jewish sources as well: Jacob's blessings to his sons, Moses' farewell to the people, legends, Jewish folk art and the *Kabbalah*. He does not always introduce all his sources at once; sometimes he takes the entire blessing by Jacob, while elsewhere he uses some of it and adds parts of Moses' farewell. Thus he describes the unique characteristics of each tribe as an archetype in its specific sphere: Reuben – Creation and the universe; Simeon – violence; Levi – light and the sanctity of the Levites; Judah – the monarchy, plenty and possibly the redemption of the People of Israel; Zebulun – seafaring; Issachar – settling on the land and physical labour; Dan – law and justice; Gad – heroism and fighting; Asher – happiness and tranquillity; Naphtali – agility and vitality; Joseph – physical and spiritual perfection; Benjamin – a lion with its prey.

While depicting the tribes of Israel, Chagall includes a universal aspect as well. These are also the components of humanity, starting with the Creation, through the good and the evil, the practical and the spiritual. In the novel as well, individual Jews are described alongside Jewish society as a whole.

*The Slave* represents the archetypal Jew who suffers both physically and mentally, living through humiliation, pain and anguish on a daily basis, yet surviving personally and symbolically through his son. Jacob remains an observant Jew among pagan and savage peasant mountaineers, who intend to kill him. He is thus both a Jewish and a universal figure who represents monotheism among idol worshippers living in the darkness of seventeenth-century Poland.

The personal, national and universal archetypes formed on the basis of the Bible help create a symbol-centric pattern at the centre of each work that gives them their metarealistic facet.

In both works there is a connection to the 'beyond', the transcendental: in *The Slave* it is to the *Kabbalah*, to a fate which cannot be explained rationally, and to a mystical union at the end of the novel; all this exists together with Jacob's link to Messianism and his fervent, exhilaratingly zealous trust in God's power.

In the windows, a Divine light comes in from the 'beyond': in Judah, this is the pure white light which radiates between the blessing hands, and descends on the city of Jerusalem; in Reuben it is a primeval, spiritual light, depicted by means of rays flooding the universe; in Joseph it is the full blessing which comes down from heaven to earth and unites the two and the Deep. In Judaism, as in the Bible, the real and the metareal constantly intertwine.

Yet another sphere in which the two works meet is the link to nature, the cosmos and Creation, to God's world, with the creatures and plants in it. In *The Slave*, Nature plays an important role. Because of the condition of the Jews in the Diaspora, including the prohibition to engage in agriculture and to own land, they were

confined to a limited number of occupations: peddlers, lenders at interest, merchants and the like. For this reason, Bashevis-Singer usually describes urban life or life in a village. He almost never describes nature or life in the countryside.[33] Nature is a central theme in the book and not just a background setting. The author provides a comprehensive, sensitive and poetic description of Jacob and his life in the countryside, among animals, isolated in the mountains and yet living in full harmony with his pastoral surroundings.

The natural world, especially the animal world – donkeys, horses, birds, fish, lions and deer – is an integral part of Chagall's artistic language. Chagall perceives a special relationship between man and animals, many of which he personifies in his works or turns into symbols of human emotions or traits.[34] Because of the Biblical prohibition against the portrayal of human images in a synagogue, they are expressed instead by animals and nature: the lion standing guard over Judah and Jerusalem, signifying strength and power; the fish darting out of the water, expressing the vitality of the tribe of Zebulun; the ass lying down between the two sacks in the midst of the verdant fields of the tribe of Issachar, reflecting the tribe's settlement in its land, while the sheep and the crowned bird suggest Joseph's prosperity and rule.

Creation is a theme addressed by both artists. In the first window of Reuben the firstborn, Creation is expressed through the blues of water and sky that fill it. Birds, fish, sheep and vegetation convey something primeval, a feeling of the simultaneousness of water and sky in the universe, but possessing order and harmony. Everything is suffused with Divine light coming from above, radiating from a white circle representing God's sanctity. It is characterised by movement, activity and dynamism, in addition to harmony and tranquillity. Fish swim and birds fly in different directions, and a strip of land and hills gently separates sky and water. Hues of blue, green and white contrast with a stormy red; the calm blue comes with a reminder of the ending of the Flood, in the form of a dove with an olive branch in its beak.

*The Slave* opens with: "A single bird call began the day. Each day the same bird, the same call. It was as if the bird signalled the approach of dawn to its brood" (ibid., p. 9), alongside a description of the landscape at the magical moment of dawn, when the sun's first rays announce the beginning of a new day. This is a special moment, emphasising the uniqueness of Creation. Jacob is surrounded by mountains, which introduce the mystery of Creation and the sense of deep space which it evokes. The description expresses something pure and absolute: ". . . the mountains stretching into the distance. Some of the peaks, their slopes overgrown with forests, seemed close at hand giants with green beards . . . the ascending, a heavenly lamp, cast a fiery sheen over everything" (ibid., p. 10). He feels the mystery-laden primeval splendour: "The day was nearing its end. High overhead an eagle glided, large and slow, like a celestial sailboat. The sky was still clear but a milk-white fog was forming in the woods. Twisting itself into small ovals, the mist thrust out tongues, and sought to evolve into some coherent shape" (ibid., p. 17).

It is a universe filled with God's creatures such as the hawk hovering in the sky, giving Jacob a taste of the world's primordial state: "A hawk wings outstretched, glided tranquilly with a strange slowness beyond all earthly anxieties. It appeared to Jacob that the bird had been flying without interruption since Creation" (ibid., p. 10). It is interesting to note that both creators choose to open their respective works

with the theme of Creation, whereby the environment is suffused with the aura of Genesis. This is a case where form meets content.

In both the novel and the windows there are two aspects which co-exist in nature: threat and harmony, fear and calm. The dove in the Reuben window hints at the Flood, but also at the covenant; the red spots point to an imminent threat, but at the same time the calm bird and the Divine light are present. In the novel, there is the bird's scream or the threatening hawk introducing an anxious atmosphere of fear, while at the same time these blend with Jacob's harmonious integration into nature, expressed by his close relationship with the cows, which provide him with companionship in his solitude.

Both compositions raise insoluble philosophical issues – Jewish and universal – of good and evil, and reward and punishment; they bring up the puzzling questions of the Chosen People's unbearable and severe lot,[35] and the dissimilar destinies of the various tribes. Both artists evoke Divine Providence – universal and personal.

Chagall and Bashevis-Singer, each in his own way, convincingly and imaginatively, embraces and preserves the old world: its way of life, its stories, the streets and characters. The world they had physically left behind remained an integral part of their internal truth, as a memory and a feeling expressed in their art. Alongside the daily complex life, hope springs up between the hardships – stemming from the transcendental, mystical aspect of life, providing refuge from the plights of the present and tightly tied to the magic and to the cosmic logic of the Creator. Hence, the two artists move freely between daily existence and a yearning for redemption when one will be able to rise above the alienated and alienating real world, between exile and revelation.

# Notes

1   Bilha Rubinstein, *The Concealed Beyond the Revealed*, Hakibbutz Hameuchad, Tel Aviv, 1994, p. 8: Bilha Rubinstein deals with the *Kabbalist* infrastructure in the works of Bashevis-Singer in comparison with writer Yehoshua Bar-Yosef. In her book she relates to Bashevis-Singer's connection to the Lurian *Kabbalah* and its influence on his writing.

2   See: Isaac Bashevis-Singer, *Lost in America*, Doubleday, N.Y., 1981, p. 16.

3   See: Paul Rosenblatt & Gene Koppel, "Isaac Bashevis-Singer, On Literature and Life", an interview, the University of Arizona Press, Tucson, Arizona, 1979, p. 19: "I believe much in the *Kabbalah* . . . I believe that there is no basic difference between God and the world, that the world is a part of God, and this might have influenced my writing."

4   See: Richard Burgin, *Conversations with Isaac Bashevis-Singer*, Doubleday & Company Inc., Garden City, N.Y., 1985, p. 46.

5   See: Isaac Bashevis-Singer, *In My Father's Court*, Farrar, Straus & Giroux, N.Y., 1962.

6   Ibid., p. 78.

7   See: Isaac Bashevis-Singer, *Lost in America*, Doubleday, N.Y., 1981.

8   See: Lawrence, S. Friedman, *Understanding Isaac Bashevis-Singer*, University of South Carolina Press, 1988, p. 145: "Joseph's new way of life is mandated by overpowering modern challenges to Jewish identity, safe from outside pressures and temptations in 'Meah Shearim', he does penance not only as an act of atonement for his sins but as a strategy for maintaining Jewish identity in the modern world."

9   See: Isaac Bashevis-Singer, *Passions and Other Stories*, Farrar, Straus & Giroux, N.Y., 1975.

10  See: Richard Burgin, *Conversations with Isaac Bashevis-Singer*, Doubleday & Company Inc., Garden City, N.Y., p. 135.

11  See: Charles Sorlier (ed.), *Chagall by Chagall*, Harry Abrams, N.Y., 1979, p. 12: "It is wrong of certain people to be afraid of the word 'Mystic', giving it as they do a too-religiously-Orthodox

color. One should strip this term of its obsolete musty exterior. It should be taken in its high, pure, unblemished form."

12 See: Sidney Alexander, *Chagall* , Translation: Shulamit Kedem, Ladori, Tel Aviv, 1990, Vol. 1, p. 32: "I don't know where these images of his come from; it seems that he has an angel inside his head." Picasso on Chagall's creative world.

13 See: André Verdet, *Chagall's World, Conversations with André Verdet*, Dial Press Inc., Garden City, N.Y., 1984, p. 65: "One ought to look at a painting as one looks at Nature. Set a painting up in Nature among the trees and bushes and flowers; it has to stand the comparison; it mustn't clash; it has to harmonize; it has to be a continuation of Nature."

14 See: Isaac Bashevis-Singer, *The Slave*, Avon Books, N.Y., 1978.

15 See: Leonard Prager, "Bilom in Bashevis's 'Der Knecht' ", in *The Hidden Isaac Bashevis-Singer*, L. Wolitz (ed.), University of Texas Press, Austin, 2001, p. 82: Because of this essential difference in *The Slave*, in his article about the dog, Bilom, Leonard Prager believes that Bashevis-Singer was influenced by the lyric-romantic novel *Victoria* by Knut Hamsun, which was translated into Yiddish by Bashevis-Singer. when he was 25 years old.

16 See: Joseph Roddy "Marc Chagall", *Look*, October 24, 1961, p. 85.

17 Jacob Baal-Teshuva, *Marc Chagall*, Taschen, Spain, 2000, p.243.

18 *Marc Chagall on Art and culture*, Benjamin Harshav (ed.), Stanford University Press, California, 2003, p. 145.

19 See: Jacob Baal–Teshuva, *Marc Chagall*, Taschen, Köln, 2000, p. 243: "There is something very simple about a stained-glass window: just material and light. Whether it is in a cathedral or a synagogue it is all the same – something mystical passes through the window."

20 See: Ziva Amishai-Meisels, "Chagall's Jerusalem Windows, iconography and sources", *Studies in Art*, vol. xxIv, Moshe Barasch (ed.), Magnes Press Jerusalem, 1972.
   Ziva Amishai-Meisels claims that in addition to these sources, he added legends from the Midrash and other topics in order to broaden the field of symbolic and universal meaning.

21 Marc Chagall, "The Biblical Message" – Catalogue, The National Museum, Nice, France, 1973.

22 See: Franz Meyer, *Chagall*, Thames & Hudson, London, 1964, p. 589: "In Chagall's windows as befits the true sense of glass painting, light is the real medium and his great work for Jerusalem is the outcome of 'work of light'."

23 See: Jean Leymarie, *The Jerusalem Windows*, Translation: Elaine Desautels, Park-Lane N.Y., 1988.

24 See: Ziva Amishai Meisels, "Chagall's Jerusalem Windows", *Studies in Art*, volume xxIv, Moshe Barasch (ed.), Magnes Press, Jerusalem, 1972, p. 152.
   In Ziva Amishai-Meisel's opinion, the mandrakes appeared on Reuben's flag, which was red.

25 Ibid., pp. 157–159.

26 Ziva Amishai-Meisels cites in the article the iconographic sources of the crown and the position of the hands.

27 Ibid., p. 160.

28 The fish have different origins: first, the fish are linked directly with the sea as part of marine life, they are the living of the fisherman who "will live along the sea shore". Likewise, in the Jewish tradition, fish are the symbol of plenty. According to Jean Leymarie, fish had been part of the Jewish painting tradition in Eastern Europe since the seventeenth century. Similarly, fish, like other animals – donkeys, sheep, cows, etc. – are part of Chagall's personal tradition.

29 The combination of the two olive trees and the Menorah between them already appears in a sketch by Chagall of Zachariah's fifth revelation (Zachariah 4:1–14).

30 Pots with animal heads are frequently found in ancient and medieval Eastern art.

31 In the *Babylon Talmud*, Tractate Sukkah, leaf 52B, it says "Rabbi Hanna Bar Bizna said, Rabbi Shimon Hasida said: the Messiah Son of David and the Messiah Son of Joseph. . ." and in the Tosafot, Tractate Eruvin, leaf 43B, it says: "The Messiah Son of Joseph must come first."

32 The novel conveys sincerity and a feeling that the author did not intend it to be a bestseller. One must remember that some of Bashevis-Singer's books were published in the *Forward*, and were meant to provide entertainment as a story in instalments. This fact is not expressed in this novel.

33 In this novel Isaac Bashevis-Singer speaks of living in Nature and being embraced by it, though Jews are talked about only indirectly as the main subject is pre-civilization Poland. Isaac Bashevis-Singer, *King of the Fields*, Farrar, Straus & Giroux, N.Y., 1991.

34 See: André Verdet, *Chagall's World, Conversations with André Verdet*, Dial Press Inc., Garden City, N.Y., 1984, p. 38: "The comparability of people and animals in my paintings isn't accidental or just an aesthetic or pictorial need . . . I try to create as much as I can with my heart, in the brotherhood of the heart."

35 See: Lawrence S. Friedman, *Understanding Isaac Bashevis-Singer*, University of South Carolina Press, 1988, p. 80: "Anticipatory tremors reverberate through such novels as *The Slave*, in which Chmielnicki's barbarities clearly prefigure those of Hitler."

# Bibliography

## Issac Bashevis-Singer (1904–1991)

### NOVELS

*The Family Moskat*, Alfred A. Knopf, N.Y., 1950.
*Satan in Goray and Other Stories*, Noonday Press, N.Y., 1955.
*The Magician of Lublin*, Noonday Press, N.Y., 1960.
*The Slave*, Farrar, Straus & Giroux, N.Y., 1962.
*The Manor*, Farrar, Straus & Giroux, N.Y., 1967.
*The Estate*, Farrar, Straus & Giroux, N.Y., 1969.
*Enemies, A Love Story,* Farrer, N.Y., 1972.
*Shosha*, Farrar, Straus & Giroux, N.Y., 1978.
*The Penitent*, Farrar, Straus & Giroux, N.Y., 1984.
*King of the Fields*, Farrar, Straus & Giroux, N.Y., 1988.
*Scum*, Farrar, Straus & Giroux, N.Y., 1991.
*The Certificate*, Farrar, Straus & Giroux, N.Y., 1992.
*Meshuga*, Farrar, Straus & Giroux, N.Y., 1994.

### MEMOIRS

*In My Father's Court*, Farrar, Straus & Giroux, N.Y., 1966.
*A Young Boy in Search of God*, Doubleday, N.Y., 1976.
*A Young Man in Search of Love*, Doubleday, N.Y., 1978.
*Lost in America*, Doubleday, N.Y., 1981.

### COLLECTIONS OF SHORT STORIES IN ENGLISH

*Gimpel the Fool and Other Stories*, Noonday Press, N.Y., 1957.
*The Spinoza of Market Street*, Farrar, Straus & Cudahy, N.Y., 1961.
*Short Friday and Other Stories*, Farrar, Straus & Giroux, N.Y., 1964.
*The Seance and Other Stories*, Farrar, Straus & Giroux, N.Y., 1968.
*A Friend of Kafka and Other Stories*, Farrar, Straus & Giroux, N.Y., 1970.
*A Crown of Feathers and Other Stories*, Farrar, Straus & Giroux, N.Y., 1973.
*Passions and Other Stories*, Farrar, Straus & Giroux, N.Y., 1975.
*Old Love and Other Stories*, Farrar, Straus & Giroux, N.Y., 1979.
*The Image and Other Stories*, Farrar, Straus & Giroux, N.Y., 1985.
*The Death of Methuselah and Other Stories*, Farrar, Straus & Giroux, N.Y., 1989.

### INTERVIEWS

Blocker, Joel and Elman, Richard, "An Interview with Isaac Bashevis-Singer", in *Critical Views of Isaac Bashevis-Singer*, edited by Irving Malin, New York University Press, 1969, pp. 3–26.
Rosenblatt, Paul and Koppel, Gene, "Isaac Bashevis-Singer, On Literature and Life, an Interview", the University of Arizona Press, Tucson, Arizona, 1979.
Singer, Isaac, Bashevis, and Howe, Irving, "Yiddish Tradition vs. Jewish Tradition", a Dialogue in *Midstream*, June / July 1973, N.Y., pp. 33–38.

Singer, Isaac, Bashevis, and Burgin, Richard, *Conversations with Isaac Bashevis-Singer*, Farrar, Straus & Giroux, N.Y., 1978.

## BOOKS – CRITICAL AND BIOGRAPHICAL

Alexander, Edward, *Isaac Bashevis-Singer*, Twayne Publishers, Boston, 1980.

Allentuck, Marcia (ed.), *The Achievement of Isaac Bashevis-Singer*, Carbondale: Southern Illinois University Press, 1970.

Buchen, Irving H., *Isaac Bashevis-Singer and the Eternal Past*, New York University Press, N.Y., 1968.

Vagas Gibbons, Frances, *Trangression and Self-Punishment in Isaac Bashevis-Singer's Searches*, Peter Lang, N.Y., 1995.

Friedman, Lawrence, S., *Understanding Isaac Bashevis-Singer*, University of South Carolina Press, 1988.

Kresh, Paul, *Isaac Bashevis-Singer*, Dial Press, N.Y., 1979.

Malin, Irving (ed.), *Critical Views of Isaac Bashevis-Singer*, New York University Press, N.Y., 1969.

Malin, Irving, *Isaac Bashevis-Singer*, Frederick Ungar, N.Y., 1972.

Miller, David Neal (ed.), *Recovering the Canon, Essays on Isaac Bashevis-Singer*, Brill Publishers, Leiden, 1986.

Miller, David Neal, *Biography of Isaac Bashevis-Singer, 1924–1949*, Peter Lang Publishers, N.Y., 1983.

Prager, Leonard, "Bilom in Bashevis's *Der Knecht*", in *The Hidden Isaac Bashevis-Singer*, edited by L. Wolitz, University of Texas Press, Austin, 2001.

Rosenblatt, Paul, and Koppel, Gene, *A Certain Bridge: Isaac Bashevis-Singer*, University of Arizona, Tucson, 1971.

Siegel, Ben, *Isaac Bashevis-Singer*, University of Minnesota Press, Minneapolis, 1969.

Wisse, Ruth R., *The Schlemiel as Modern Hero*, University of Chicago Press, Chicago, 1971.

Zamir, Israel, *Journey to my Father, Isaac Bashevis-Singer*, Arcade Publishing, N.Y., 1995.

## ARTICLES

Fixler, Michael, "The Redeemers: Themes in the Fiction of Isaac Bashevis-Singer", *Kenyon Review*, 26 Spring, 1964, pp. 371–386.

Howe, Irving, and Greenberg, Eliezer (eds.), *A Treasury of Yiddish Stories*, Viking Press, N.Y., 1953.

Hughes, Ted, "The Genius of Isaac Bashevis-Singer", *New York Review of Books*, 1965, p. 810.

Kazin, Alfred, "Isaac Bashevis-Singer and the Mind of God" Miller, edited by David Neal, op. cit., 1986, pp. 149–153.

Singulowsky, Joseph, "I.B. Singer and Tshuvah", *Midstream*, N.Y., June / July 1994, pp. 34–36.

Schulz, Max, F., "Isaac Bashevis-Singer, Radical Sophistication, and the Jewish-American Novel", in Irving Malin (ed.), op. cit., pp. 135–148.

Shmeruch, C., "Monologue as Narrative Strategy in the Short Stories of I.B.S.", in David Neal Miller (ed.), op. cit., 1986, pp. 39–49.

Wirth-Nesher, Hana, "Isaac Bashevis-Singer and the Mind of God", in David Neal Miller (ed.), op. cit., 1986, pp. 39–49.

# Marc Chagall (1887–1985)

## WRITINGS OF CHAGALL

*My Life*, Orion Press, N.Y., 1960.

*Poèmes* (1909–1972), Genève, 1975.

## MONOGRAPHS – *GENERAL*

Alexander, Sidney, *Marc Chagall, A Biography*, Putnam, N.Y., 1978.

Baal-Teshuva, Jacob, *Chagall*, Taschen, Köln, 2000.

Cogniat, André, *Chagall*, Flammarion, Paris, 1968.

Harshav, Benjamin, *Marc Chagall and the Lost Jewish World, Rizzoli, N.Y., 2006.*

Harshav, Benjamin (ed.), *Marc Chagall on Art and* Culture, Stanford University Press, California, 2003.

Kampf, Avram, *Chagall to Kitaj* (Jewish Experience in 20th Century Art), Lund Humphries, London, 1994.

Lassaigne, Jacques, *Chagall*, Paris, 1957.

Meyer, Franz, *Marc Chagall, Life and Work*, Abrams, N.Y., 1963.

Michel, Makarius, *Chagall*, Hazan, Paris, 1987.

Venturi, Lionello, *Chagall, a Biographical and Critical Study*, A. Skira, Geneva, 1956.

## BOOKS ON DIFFERENT PERIODS OF CHAGALL'S WORK

Compton, Susan, *Marc Chagall, My Life – My Dream* (Berlin–Paris, 1922–1940), Prestel Verlag, Munich, 1990.

Forestier, Sylvie (ed.), *Marc Chagall, Les Annéés Mediterranéennes (1949–1985)*, ADAGP, Paris, 1994.

Kamensky, Alexander, *Chagall, the Russian Years* (1907–1922), Rizzoli, N.Y., 1989.

Verdet, André, "Chagall's world – conversations with André Verdet", The Dial Press, Garden City, N.Y., 1984.

Vitali, Christoph, *Chagall, the Russian Years* (1906–1922), Frankfurt, 1991.

## CATALOGUES OF IMPORTANT EXHIBITIONS

Grand Palais, Hommage à Marc Chagall, Paris, 1970.

Musée National Message Biblique Marc Chagall, Nice, edited by Jean Leymarie, Paris, 1973

Centre Georges Pompidou, Paris, *Chagall, Oeuvre sur Papier*, edited by D. Bozo, 1984.

Fondation Maeght, Exposition Rétrospective de L'oeuvre Peint, edited by Jean Louis Prat, 1984.

Royal Academy of Arts, London, edited by Susan Compton, 1985.

Musée d'Art Moderne de la Ville de Paris, *Chagall*, 1995.

Musée Juif de Belgique, *Hommage à Marc Chagall*, La Bible de Chagall et son Monde par Izis, 1995.

## WORKS ON SPECIAL SUBJECTS OR IN SPECIAL TECHNIQUES

Amishai-Maisels, Ziva and Yeshayahu, Israel, *Marc Chagall at the Knesset*, N.Y., 1973.

Chatelain, Jean, *The Biblical Message of Marc Chagall*, N.Y., 1973.

Chagall, Marc, "L'Oeuvre gravée", edited by Franz Meyer, Stuttgart, 1957.

Chagall, Marc, *The Lithographs*, edited by Julien Cain and Fernand Mourlot, Vol. I, Braziller, N.Y., 1960. Vols II and III, Boston Book and Art Shop, Boston, 1963, 1969.

Chagall, Marc, *Le Cirque*, Verve, Paris, 1967.

Chagall, Marc, "Posters" ("Affiches"), Praeger, Paris, 1975.

Chagall, Marc, *The Bible, 105 Hand-Colored Etchings*, Gerhard Wurzer Gallery, Houston, Texas, 1983.

Leymarie, Jean, *The Jerusalem Windows*, Sauret, Monte Carlo, 1962, and Braziller, N.Y., 1962.

Malraux, André and Sorlier, Charles, *The Ceramics and Sculptures of Chagall*, Sauret, Monte Carlo, 1972.

Rotermund, H.M., *Marc Chagall und die Bibel*, Goettingen, 1970.

Wullschlager, Jackie, *Chagall*, Alfred A. Knopf, N.Y. 2008.

## ARTICLES

Amishai-Maisels, Ziva, "Chagall and the Jewish Revival: Center or Periphery", in *Tradition and Revolution, The Jewish Renaissance in Russian Avant Garde Art 1912–1928*, The Israel Museum, Jerusalem, 1987.

Blessing, Jennifer, "The Upside Down World of Marc Chagall", *Art News*, N.Y., March 1993, pp. 100–105.

Compton, Susan, "Chagall in Russia", *Burlington Magazine*, London, June 1991, pp. 403–411.

De Francia, Peter, "Chagall at the Royal Academy", *Burlington Magazine,* London, March 1985, pp. 177–81.

Duchen, Monica Bohm, "Religion and Marc Chagall at the Royal Academy", in *Art and Artists,* London, Jan. 1985, pp. 18–23.

Friedman, Mira, "Metamorphoses in Chagall – the Creation of Man", in *Norms and Variations.* The Magnes Press, The Hebrew University, Jerusalem, 1983, pp. 260–280.

Friedman, Mira, "The Prophet Elijah's Ascension in the Works of Chagall", *Journal of Jewish Art,* Vol. 10, 1984, Jerusalem, pp. 102–113.

Friedman, Mira, "The Tree of Jesse and the Tree of Life in Chagall", *Jewish Art,* Jerusalem, Vol. 15, 1989, pp. 58–80.

Friedman, Mira, "The Paintings of Chagall – Sources and Developments", The Marcus Diener Collection, Tel Aviv University, Tel Aviv, 1987, p. 167.

Harshav, Benjamin, "Chagall: Postmodernism and Fictional Worlds in Painting", in *Marc Chagall and the Jewish Theatre,* The Guggenheim Museum, N.Y. and the Art Institute Chicago, 1993, pp. 15–63.

Harshav, Benjamin, "The role of language in modern art: on texts and subtexts in Chagall's paintings". *Modernism / modernity,* Vol. 1, No. 2, The Johns Hopkins University Press, 1994, pp. 51–87.

Riedel, Ingrid, "Chagalls' Engel", *DU,* No. 12, Bern, 1986, pp. 60–72.

Roddy, Joseph, "Marc Chagall", *Look,* October 24, 1961, p. 85.

Sorlier, Charles (ed.), "Chagall by Chagall", Harry Abrams, N.Y., 1979.

## GENERAL BOOKS ON LITERATURE, ON ART AND ON LITERATURE AND ART

Breton, André, *Manifestes du Surréalisme,* Gallimard, Paris, 1967.

Mitchell, W.J.T. (ed.), *The Language of Images,* The University of Chicago Press, Chicago and London, 1985.

Paulson, Ronald, *Book and Painting: Shakespeare, Milton and the Bible,* Knoxville, Tenn., U.S.A., 1980.

Paulson, Ronald, *Literary Landscape: Turner and Constable,* Yale University Press, New Haven, 1982.

Praz, Mario, *The Romantic Agony,* Oxford University Press, 1934.

Praz Mario, *Mnemosyne – The Parallel between Literature and the Visual Arts,* Oxford University Press, London, 1980.

Rosenblum, Robert and Janson, H. W., *Art of the 19th Century,* London and N.Y., 1984.

Roston, Murray, *Renaissance Perspectives in Literature and the Visual Arts,* Princeton University Press, London, 1987.

Roston, Murray, *Changing Perspectives in Literature and the Visual Arts,* Princeton University, London, 1990.

Schapiro, Meyer, *Modern Art, 19th and 20th Centuries,* London, 1978.

Schultz, Elizabeth, A., *Unpainted to the Last, Moby Dick and Twentieth-Century American Art,* University Press of Kansas, 1995.

Seghers, P. (ed.), *L'Art de la Peinture,* Seghers, Paris, 1957.

Sypher, Wylie, *Four Stages of Renaissance Style* (Transformations in Art and Literature 1400–1700), Doubleday & Company Inc., N.Y., 1955.

Sypher, Wylie, *Rococo to Cubism in Art and Literature,* Random House, N.Y., 1960.

Wellek, René & Warren, Austin, *Theory of Literature,* Harcourt Brace, N.Y., 1956.

# Index

Fictional characters are identified by the gloss (fictional) after the name. Where surnames for characters have been used in the book, characters are filed under their surname. If surnames are not given, characters are filed under their first name.

Abimelech (Biblical character), 89
Abraham (Biblical Patriarch), 17, 86, 89
Abstract Expressionism, 5
Agnon, Shmuel Yosef, 7
Alexander, Sidney, 108*n*
"America" (Kafka), 8
Amishai-Meisels, Ziva, 53*n*, 108*n*
angel motif (Chagall), 85
    *L'Apparition de la Famille de 1'Artiste*, 86
    *The Bridal Pair with the Eiffel Tower*, 86
    *The Falling Angel*, 76–9, 80
    *Solitude*, 14
animal motif (Chagall), 36*n*, 85
    *L'Apparition de la Famille de 1'Artiste*, 86
    *Between Darkness and Light*, 67, 86
    *The Cattle Dealer*, 18–23, *20*
    *The Falling Angel*, 78
    Hadassah Medical Centre stained-glass
        windows, 96, 99–100, 101, 102–3, 104,
        106, 107
    *I and the village*, 86
    *My Village*, 32–3
    *Self-portrait with Seven Fingers*, 49
    *Solitude*, 14
    *The Stable*, 86
    *To Russia, Asses and Others*, 49, *50*
    *War*, 73
Apollinaire, Guillaume, 47
Asher, Hadassah Medical Centre stained-glass
    windows, 101, 105

Baal Shem-Tov, Israel, 2
Baal-Teshuva, Jacob, 36*n*, 37*n*, 53*n*, 108*n*
Bakst, Leon, 4
Bar-El, Yosef, 10*n*
Barzel, Hillel, 7
Basha, Channah (fictional), 13, 57, 58, 59, 62,
    63, 64, 72
Bashevis-Singer, Isaac
    family background, 1–2, 12
    *Hassidic* influence, 1, 2, 83
    Holocaust and World War II motif
        "The Briefcase", 72
        "A Day in Coney Island", 72

*Enemies, A Love Story*, 54, 73–6, 79–81
    "The Little Shoemakers", 26, 27, 72
    "Sam Palka and David Vishkover", 58, 72
    *Shosha*, 66, 69, 71, 104
    *The Slave*, 72
Jewish artist motif, 38–9, 40–7, 50–2
Jewish cultural influences, 1–3, 12–13, 15–18,
    20–1, 22–7, 33–5
Jewish religious motifs, 83–5, 86–91, 104,
    105–7
Jewish *shtetl* motif, 2, 6
    *Enemies, A Love Story*, 12
    *The Family Moskat*, 12–13
    "Gimpel the Fool", 13, 23
    "The Little Shoemakers", 13, 23–7, 33–5, 72
    *The Magician of Lublin*, 12
    *The Old Man*, 15–18, 20–1, 22–3
    "Sam Palka and David Vishkover", 13,
        57–9, 62
    *Shosha*, 12, 66, 68
    "The Son from America", 13, 23
*Kabbalistic* influences, 5–6, 83–4
literary influences, 3–4
love and lovers motif
    "The Briefcase", 55
    *Enemies, A Love Story*, 12, 54–5, 74–6,
        79–81, 89
    *The Magician of Lublin*, 12, 41–4, 51, 54
    *The Penitent*, 54
    "Sam Palka and David Vishkover", 57–9,
        61–3, 64
    *Shosha*, 54, 64–6, 68, 69–70, 89
    *The Slave*, 55, 86–90
'luft mentsch' motif, "The Old Man", 15–18,
    20–1, 22–3
Metarealism, 3, 5, 9
    *Enemies, A Love Story*, 75, 81
    "The Little Shoemakers", 24, 34–5
    *The Magician of Lublin*, 40, 46–7, 52
    "The Old Man", 16–17, 21, 22
    "Sam Palka and David Vishkover", 62
    *Shosha*, 64, 66, 70
    *The Slave*, 86, 90, 105
*Misnagdim* influence, 1

Bashevis-Singer, Isaac – *continued*
  mysticism, 2, 3, 39, 83–5
    *Enemies, A Love Story*, 81
    *Lost in America*, 84
    "The Yearning Heifer", 85
  mysticism and religion, 84
  nature motif
    *The Slave*, 87, 105–7
    "The Yearning Heifer", 85
  occultism, 3, 9, 39, 83, 85
    *Enemies, A Love Story*, 81
    *The Magician of Lublin*, 40, 41, 52, 84
    "Sabbath in Portugal", 84
    *The Slave*, 89, 90, 91
  rationalism, 2
  Realism, 3, 5
    *Enemies, A Love Story*, 75, 81
    "The Little Shoemakers", 23–4, 35
    *The Magician of Lublin*, 40, 45–6, 47
    "The Old Man", 15–16, 22
    "Sam Palka and David Vishkover", 57, 62
    *Shosha*, 64, 66, 70
    *The Slave*, 86
  secular influences, 3
  self-depiction in works, 5
  surrealistic style, *The Magician of Lublin*, 46, 47
  ties to Western culture, 2–3
  *Torah* learning, 2
  translation of works into English, 2, 4
  visual dimension of works, 6
  Works
    "The Admirer", 39
    "The Briefcase", 38, 55, 72
    "The Captive", 6
    "The Chimney Sweep", 84
    "A Day in Coney Island", 72
    *Enemies, A Love Story*, 12, 38, 54–5, 73–6,
      79–81, 88, 89
    *The Family Moskat*, 12–13
    "First Entry into the Writers' Association",
      39
    "Gimpel the Fool", 13, 23
    *In My Father's Court*, 1–2, 84
    "The Jew from Babylon", 84
    "The Kabbalist of East Broadway", 84
    "The Key", 4
    "The Little Shoemakers", 13, 23–7, 33–5, 72
    *Lost in America*, 84
    *The Magician of Lublin*, 12, 40–7, 50–2, 54,
      66, 84, 88, 89, 104
    "Musings on My Manuscript", 39
    "The Old Man", 15–18, 20–1, 22–3
    "The Parrot", 84
    *The Penitent*, 54, 84, 104
    "Sabbath in Portugal", 84
    "Sam Palka and David Vishkover", 13,
      57–9, 61–3, 64, 72
    *Shosha*, 12, 38, 54, 64–6, 68, 69–70, 71–2,
      88, 89, 104
    *The Slave*, 55, 72, 86–91, 104, 105–7
    "The Son from America", 13, 23
    "Why the Geese Shrieked", 1–2
    "The Yearning Heifer", 85
  writing in Yiddish, 2, 4
Bathsheba (Biblical character), 58
Benjamin, Hadassah Medical Centre stained-
  glass windows, 103–4, 105
Benjamin (Biblical character), 90
Benjamin-Eliezer (fictional), 90
Ber, Reb Moshe (fictional), 15–18, 21
Bergelson, David, 3
Besheleh (fictional), 64, 65
Bessy (fictional), 57, 58
Boaz (Biblical character), 89
Braque, Georges, 92
Broder, Herman (fictional), 12, 38, 54–5, 74,
  75–6, 79, 80–1, 88, 89
Broder, Shmuel-Leib (fictional), 80–1
Buber, Martin, 7
Buchen, Irving H., 53*n*
Burgin, Richard, 39, 83
Byzantine art, 4
Bzik, Jan (fictional), 86, 87

Camus, Albert, 7
Celia (fictional), 65
Cendrars, Blaise, 47
Chagall, Bella, *plate 12*
  *The Apparition: Self-portrait with Muse*, 39–40
  *Between Darkness and Light*, 67–8, 69, 70
  *Birthday*, 56
  *Double Portrait with Wineglass*, 56
  *Lovers in Black*, 55
  *Lovers in Blue*, 55–6
  *Lovers in Green*, 56
  *Lovers over the Town*, 59–61, 62, 63–4
  *A Ma Femme*, 56–7
  *The Promenade*, 56
Chagall, Marc
  angel motif, 85
    *L'Apparition de la Famille de l'Artiste*, 86
    *The Bridal Pair with the Eiffel Tower*, 86
    *The Falling Angel*, 76–9, 80
    *Solitude*, 14
  animal motif, 36*n*, 85
    *L'Apparition de la Famille de l'Artiste*, 86
    *Between Darkness and Light*, 67, 86
    *The Cattle Dealer*, 18–23, 20
    *The Falling Angel*, 78
    Hadassah Medical Centre stained-glass
      windows, 96, 99–100, 101, 102–3, 104,
      106, 107
    *I and the village*, 86
    *My Village*, 32–3

Chagall, Marc (animal motif) – *continued*
  *Self-portrait with Seven Fingers*, 49
  *Solitude*, 14
  *The Stable*, 86
  *To Russia, Asses and Others*, 49, 50
*War*, 73
artistic influences, 4–5
colour
  *Between Darkness and Light*, 67, 69
  *The Blue House*, 20, 27–8, 34
  *The Cattle Dealer*, 18, 19, 20
  *The Falling Angel*, 77, 78, 79, 80
  *The Gray House*, 30
  Hadassah Medical Centre stained-glass
    windows, 93–4, 95, 96, 97, 98, 99–100,
    101, 102, 104
  *I and the Village*, 20
  *Lovers in Blue*, 55
  *Lovers in Green*, 56
  *Lovers over the Town*, 60, 61, 62
  *The Newspaper Vendor*, 14
  *Self-portrait with Seven Fingers*, 48, 49
crucifixion scenes, 73, 77, 80, 85
Cubism, 5
  *The Blue House*, 29
  *The Cattle Dealer*, 20, 22
  *The Falling Angel*, 77
  Hadassah Medical Centre stained-glass
    windows, 98, 99
  *Lovers in Green*, 56
  *Lovers over the Town*, 60, 62
  *The Promenade*, 56
  *Self-portrait with Seven Fingers*, 47, 48, 49, 51
Expressionism
  *The Blue House*, 29
  *The Cattle Dealer*, 18, 20, 22
  *Self-portrait with Seven Fingers*, 47
family background, 2
Fauvism, *The Cattle Dealer*, 20, 22
floating motif, 85
  *L'Apparition de la Famille de l'Artiste*, 86
  *Between Darkness and Light*, 67
  *Birthday*, 56
  *Double Portrait with Wineglass*, 56
  *The Dream*, 40
  *The Falling Angel*, 77
  *Lovers over the Town*, 59–61, 62, 63
  *Over Vitebsk*, 14–15
  *The Painter to the Moon*, 40
  *The Promenade*, 56
  *Self-portrait with Seven Fingers*, 49
  *Study for Rain*, 31
  *War*, 73
*Hassidic* influence, 2, 85
Holocaust and World War motif
  II, 73, 76–9, 80
importance of Yiddish, 4

Jewish artist motif, 38, 39–40, 47–51, 52
Jewish cultural influences, 1, 2–3, 13–15,
    18–23, 27–35
Jewish religious motifs, 83, 85–6, 91–105,
    106–7
Jewish *shtetl* motif, 2, 6, 12, 55
  *Between Darkness and Light*, 67, 68, 70
  *The Blue House*, 27–9, 33–5
  *The Cattle Dealer*, 18–23
  *The Dead Man*, 13–14
  *The Falling Angel*, 76–7, 80, 81
  *The Father*, 14
  *Fire in the Town*, 73
  *The Gray House*, 29–30
  *The Green Fiddler*, 15
  *A Jew Sniffing Tobacco*, 14
  *Lovers over the Town*, 60
  *My Village*, 32–3
  *The Newspaper Vendor*, 14
  *Over Vitebsk*, 14–15
  *Red Roofs*, 15
  *The Revolution*, 73
  *Self-portrait with Seven Fingers*, 51
  *Solitude*, 14
  *Souvenir*, 32
  *Study for Rain*, 31
  *View of Vitebsk*, 14
  *Village Street*, 31
  *Vitebsk*, 32
  *War*, 73
  *The Window*, 14
links to literature world, 6
love and lovers motif
  *Between Darkness and Light*, 67–8, 69, 70
  *Birthday*, 56
  *Double Portrait with Wineglass*, 56
  *Lovers in Black*, 55
  *Lovers in Blue*, 55–6
  *Lovers in Green*, 56
  *Lovers over the Town*, 59–62, 63–4
  *A Ma Femme*, 56–7
  *Portrait of Vava*, 57
  *The Promenade*, 56
  *Time Is a River without Banks*, 56
'luft mentsch' motif
  *The Cattle Dealer*, 18–23
  *The Falling Angel*, 76–9, 80
  *Over Vitebsk*, 14–15
  *Vitebsk*, 32
Metarealism, 5, 9
  *Between Darkness and Light*, 67, 70
  *The Blue House*, 34–5
  *The Cattle Dealer*, 21, 22
  *The Falling Angel*, 77, 81
  Hadassah Medical Centre stained-glass
    windows, 105
  *Lovers over the Town*, 61, 62

Chagall, Marc (Metarealism) – *continued*
  *Self-portrait with Seven Fingers*, 52
  *My Life*, 5, 6
  mysticism, 2, 53*n*, 83, 85–6
  nature motif
    Hadassah Medical Centre stained-glass
      windows, 106–7
    *Lovers in Blue*, 55
    *Lovers in Green*, 56
    *Lovers over the Town*, 60, 61
    *My Village*, 33
  poems in Yiddish, 6
  portrayal of Vitebsk
    *Between Darkness and Light*, 67, 68, 69
    *The Blue House*, 20, 27–9, 28, 30, 32, 33–5
    *The Falling Angel*, 77
    *The Gray House*, 29–30, 30, 32
    *Lovers over the Town*, 60, 62
    *A Ma Femme*, 56–7
    *Over Vitebsk*, 14–15
    *Red Roofs*, 15
    *Self-portrait with Seven Fingers*, 49–50, 51, 52
    *View of Vitebsk*, 14
    *Vitebsk*, 32, 32
  Realism, 5
    *Between Darkness and Light*, 67
    *The Blue House*, 35
    *The Cattle Dealer*, 18–19, 22
    *The Falling Angel*, 77, 81
    *Lovers over the Town*, 61, 62
  self-depiction in paintings, 5
  Surrealism
    *Birthday*, 56
    *The Cattle Dealer*, 18, 20, 22
    *Self-portrait with Seven Fingers*, 47
  ties to Western culture, 2–3
  "To My City, Vitebsk" speech, 15
  value of human love, 5
  windows motif
    *Village Street*, 31
    *The Blue House*, 28
    *The Gray House*, 30
    *My Village*, 32
    *Souvenir*, 32
    *Study for Rain*, 31
    *The Window*, 14
  Works
    *The Apparition: Self-portrait with Muse*, 39–40
    *L'Apparition de la Famille de 1'Artiste*, 86
    *Between Darkness and Light*, 67–8, 69, 70,
      86, plate 14
    *Birthday*, 56
    *The Blue House*, 20, 27–9, 30, 32, 33–5,
      plate 2
    *The Bridal Pair with the Eiffel Tower*, 86
    *The Cattle Dealer*, 18–23, plate 1
    *The Dead Man*, 13–14

*Double Portrait with Wineglass*, 56
*The Falling Angel*, 76–9, 80, plate 15
*The Father*, 14
*Fire in the Snow*, 73
*Fire in the Town*, 73
*The Gray House*, 29–30, 32, plate 4
*The Green Fiddler*, 15
Hadassah Medical Centre stained-glass
  windows, 85, 91–105, 106–7, plate 16
  Asher, 101, 105
  Benjamin, 103–4, 105
  Dan, 100–1, 105
  Gad, 101, 105
  Issachar, 99, 100, 101, 103, 105, 106
  Joseph, 94, 101–3, 105, 106, *plate19*
  Judah, 94, 98–9, 100, 101, 103, 105,
    plate 18
  Levi, 97, 101, 105
  Naphtali, 101, 105
  Reuben, 94–6, 100, 105, 106, 107, plate 17
  Simeon, 97, 105
  Zebulun, 99–100, 105, 106
*I and the Village*, 20, 86
*Interior of a Synagogue in Safed*, 86
*A Jew Sniffing Tobacco*, 14
Knesset building carpets and mosaics, 85
*Lovers in Black*, 55
*Lovers in Blue*, 55–6
*Lovers in Green*, 56
*Lovers over the Town*, 59–62, 63–4, plate 13
*A Ma Femme*, 56–7
*My Village*, 32–3, plate 9
*The Newspaper Vendor*, 14
*Over Vitebsk*, 14–15
*The Painter to the Moon*, 40
*Portrait of Vava*, 57
*The Promenade*, 56
*Rebecca at the Well*, 86
*Red Roofs*, 15, 40
*The Revolution*, 73
*Self-portrait with Seven Fingers*, 47–51, 52,
  plate 10, 67, 70*n*
*The Shepherd Joseph*, 86
*Solitude*, 14
*Souvenir*, 32, plate 8
*The Stable*, 86
*Study for Rain*, 31, plate 6
*Time Is a River without Banks*, 56
*To Russia, Asses and Others*, 48, 49, 52,
  plate 11
*View of Vitebsk*, 14
*Village Street*, 31, plate 5
*Vitebsk*, 32, plate 7
*War*, 73
*The Window*, 14
Chagall, Valentina, 57
Chentshiner, Haiml (fictional), 66, 69, 71

Chmielnicki, Bogdan, 72, 86
Cohen, Sarah Blacher, 82*n*
Constructivism, 5
Cubism (Chagall), 5
    *The Blue House*, 29
    *The Cattle Dealer*, 20, 22
    *The Falling Angel*, 77
    Hadassah Medical Centre stained-glass
        windows, 98, 99
    *Lovers in Green*, 56
    *Lovers over the Town*, 60, 62
    *The Promenade*, 56
    *Self-portrait with Seven Fingers*, 47, 48, 49, 51

Dadaism, 5
Dan, Hadassah Medical Centre stained-glass
    windows, 100–1, 105
David, King, 58, 76, 86, 89, 99, 103
de Soler, Elizabeth Abigail (fictional), 39
*Dead Souls* (Gogol), 6
Deuteronomy, Book of, 92, 94, 97, 98, 100, 102
Dinah (Biblical character), 97
Dora (fictional), 65
Dreiman, Sam (fictional), 71
Duma (fictional), 22

Ehud Ben Gera, 103
Elka (fictional), 13
Emilia (fictional), 41–2, 43, 44, 51, 54
Esther (fictional - *The Magician of Lublin*), 12, 41,
    42, 51, 54, 89
Esther (fictional – "Sabbath in Portugal"), 84
Esther (fictional – "Sam Palka and David
    Vishkover"), 58
Even-Zohar, Itamar, 4
Exodus, Book of, 93
Expressionism (Chagall)
    *The Blue House*, 29
    *The Cattle Dealer*, 18, 20, 22
    *Self-portrait with Seven Fingers*, 47

*Fables* (La Fontaine), 6
Fauvism, 5
    Chagall's *The Cattle Dealer*, 20, 22
floating motif (Chagall), 85
    *L'Apparition de la Famille de 1'Artiste*, 86
    *Between Darkness and Light*, 67
    *Birthday*, 56
    *Double Portrait with Wineglass*, 56
    *The Dream*, 40
    *The Falling Angel*, 77
    *Lovers over the Town*, 59–61, 62, 63
    *Over Vitebsk*, 14–15
    *The Painter to the Moon*, 40
    *The Promenade*, 56
    *Self-portrait with Seven Fingers*, 49
    *Study for Rain*, 31

*War*, 73
*Forward* newspaper, 4, 108*n*
*Franz Kafka* (Welch), 7
Freud, Sigmund, 39
Freund, Miriam, 92
Friedman, Lawrence S., 36*n*, 107*n*, 108*n*
Friedman, Mira, 53*n*, 82*n*

Gad, Hadassah Medical Centre stained-glass
    windows, 101, 105
Genesis, Book of, 88, 92, 94, 96, 97, 98, 101–2,
    103
Gimpel the Fool (fictional), 13
Gimpel the shoemaker (fictional), 25–6
Gogol, Nikolai, 6
Greidinger, Aaron (fictional), 38, 54, 64–5, 66,
    68, 69–70, 71, 88, 89

Hadassah Medical Centre stained-glass windows,
    85, 91–104, 95
Hamor (Biblical character), 97
Hamsun, Knut, 3
Harshav, Benjamin, 10*n*, 36*n*
*Hassidic* movement
    foundation of, 2
    influence on Bashevis-Singer, 1, 2, 83
    influence on Chagall, 2, 85
Heidegger, Martin, 8
Heschel, Ozer (fictional), 13
Hitler, Adolf, 66, 69, 71
Holocaust
    Bashevis-Singer's works
        "The Briefcase", 72
        "A Day in Coney Island", 72
        *Enemies, A Love Story*, 54, 73–6, 79–81
        "The Little Shoemakers", 26, 27, 72
        "Sam Palka and David Vishkover", 58, 72
        *Shosha*, 66, 69, 71, 104
        *The Slave*, 72
    Chagall's works, 73, 76–9, 80
Howe, Irving, 82*n*
*Hunger* (Hamsun), 3

Icarus, 45
Impressionism, 5
Imri Sheila, Rabbi, 99
Isaac (Biblical Patriarch), 17, 21, 86, 92, 103
Isaac (fictional), 17, 21
Issachar, Hadassah Medical Centre stained-glass
    windows, 99, 100, 101, 103, 105, 106

Jacob (Biblical Patriarch), 26, 58, 87, 88, 90
    Hadassah Medical Centre stained-glass
        windows, 92, 93, 94, 95, 96, 97, 98, 99,
        100, 101, 102, 103, 105
Jacob (fictional), 55, 86, 87–8, 89–90, 91, 104,
    105, 106, 107

Jesus of Nazareth, 77, 80
Joseph (son of Jacob), 26
    Hadassah Medical Centre stained-glass
        windows, 94, 101–3, *103*, 105, 106
Joyce, James, 39
Judah, Hadassah Medical Centre stained-glass
        windows, 94, 98–9, *99*, 100, 101, 103, 105
Jung, Carl Gustav, 39

*Kabbalah*, 2, 5–6, 83–4, 87, 90, 105
Kaddish, Rosalie (fictional), 38, 55
Kafka, Franz, 7–8, 39
Kamensky, Aleksander, 53n, 70n
Klee, Paul, 6

La Fontaine, Jean de, 6
Laban (Biblical character), 87
Lampert, Rabbi (fictional), 38, 76
Landau, Dov, 36n
Leah (Biblical character), 96
Léger, Fernand, 47, 92
Lenin, Vladimir, 73
Levi, Hadassah Medical Centre stained-glass
        windows, 97, 101, 105
Leymarie, Jean, 108n
Lobok Russian-Slavic art, 4
love and lovers motif
    Bashevis-Singer's works
        "The Briefcase", 55
        *Enemies, A Love Story*, 12, 54–5, 74–6,
            79–81, 89
        *The Magician of Lublin*, 12, 41–4, 51, 54
        *The Penitent*, 54
        "Sam Palka and David Vishkover", 57–9,
            61–3, 64
        *Shosha*, 54, 64–6, 68, 69–70, 89
        *The Slave*, 55, 86–90
    Chagall's works
        *Between Darkness and Light*, 67–8, 69, 70
        *Birthday*, 56
        *Double Portrait with Wineglass*, 56
        *Lovers in Black*, 55
        *Lovers in Blue*, 55–6
        *Lovers in Green*, 56
        *Lovers over the Town*, 59–62, 63–4
        *A Ma Femme*, 56–7
        *Portrait of Vava*, 57
        *The Promenade*, 56
        *Time Is a River without Banks*, 56
    Lurie, Yitzhak, 6, 83

Madisson, Charles A., 82n
Magda (fictional), 42, 43, 44, 46, 54
Makarius, Michel, 37n, 53n, 70n
Malraux, André, 93
Marq, Charles, 92
Mary of Nazareth, 77

Masha (fictional girl), 76, 81, 89
Masha (fictional woman), 54, 74, 75, 76, 89
Matisse, Henri, 92
Mayer, Franz, 53n
Mazur, Yasha (fictional), 12, 40–7, 50, 51, 52,
        54, 84, 88, 104
Metamaterialism, 7
Metarealism, 7–9
    Bashevis-Singer's works, 3, 5, 9
        *Enemies, A Love Story*, 75, 81
        "The Little Shoemakers", 24, 34–5
        *The Magician of Lublin*, 40, 46–7, 52
        "The Old Man", 16–17, 21, 22
        "Sam Palka and David Vishkover", 62
        *Shosha*, 64, 66, 70
        *The Slave*, 86, 90, 105
    Chagalls works, 5, 9
        *Between Darkness and Light*, 67, 70
        *The Blue House*, 34–5
        *The Cattle Dealer*, 21, 22
        *The Falling Angel*, 77, 81
        Hadassah Medical Centre stained-glass
            windows, 105
        *Lovers over the Town*, 61, 62
        *Self-portrait with Seven Fingers*, 52
    hidden meaning, 8
    inscrutability, 8–9
    inventiveness and imagination, 7–8
    symbolic and allegorical elements, 8
*Metarealistic Hebrew Prose* (Barzel), 7
Meyer, Franz, 70, 82n, 108n
Michaelangelo, 6
Modernism, 5, 13, 51
Modigliani, Amedeo, 85
Moses, 17, 88
    Hadassah Medical Centre stained-glass
        windows, 92, 96, 97, 99, 100, 103, 104,
        105
mysticism
    Bashevis-Singer's works, 2, 3, 39, 83–5
        *Enemies, A Love Story*, 81
        *Lost in America*, 84
        "The Yearning Heifer", 85
    Chagall's works, 2, 53n, 83, 85–6
    *see also* Metarealism

Naomi (Biblical character), 76
Naphtali, Hadassah Medical Centre stained-glass
        windows, 101, 105
nature motif
    Bashevis-Singer's works
        *The Slave*, 87, 105–7
        "The Yearning Heifer", 85
    Chagall's works
        Hadassah Medical Centre stained-glass
            windows, 106–7
        *Lovers in Blue*, 55

nature motif (Chagall's works) – *continued*
    *Lovers in Green*, 56
    *Lovers over the Town*, 60, 61
    *My Village*, 33
Neufeld, Joseph, 92
Nietzsche, Friedrich Wilhelm, 8

occultism
    Bashevis-Singer's works, 3, 9, 39, 83, 85
      *Enemies, A Love Story*, 81
      *The Magician of Lublin*, 40, 41, 52, 84
      "Sabbath in Portugal", 84
      *The Slave*, 89, 90, 91
    Chagall's works, 85
    Zeitlin's works, 9, 11*n*
    *see also* Metarealism
*The Other Reality* (Zeitlin), 3–4, 11*n*, 83

Palka, Sam (fictional), 57, 59, 62, 63, 64
Pen, Yehuda, 4
Picasso, Pablo, 108*n*
Pissarro, Camille, 85
Poe, Edgar Allen, 3
Pop Art, 5
Prager, Leonard, 108*n*
Psalms, Book of, 16

Rachel (Biblical Matriarch), 58, 86, 87, 90
    Hadassah Medical Centre stained-glass
        windows, 96, 102, 103, 105
Realism
    Bashevis-Singer's works, 3, 5
      *Enemies, A Love Story*, 75, 81
      "The Little Shoemakers", 23–4, 35
      *The Magician of Lublin*, 40, 45–6, 47
      "The Old Man", 15–16, 22
      "Sam Palka and David Vishkover", 57, 62
      *Shosha*, 64, 66, 70
      *The Slave*, 86
    Chagall's works, 5
      *Between Darkness and Light*, 67
      *The Blue House*, 35
      *The Cattle Dealer*, 18–19, 22
      *The Falling Angel*, 77, 81
      *Lovers over the Town*, 61, 62
Reizel (fictional), 72
religious motifs
    Bashevis-Singer's works, 83–5, 86–91, 104,
      105–7
    Chagall's works, 83, 85–6, 91–105, 106–7
Reuben, Hadassah Medical Centre stained-
    glass windows, 94–6, 97, 100, 105, 106,
    107
Rubinstein, Bilha, 107*n*
Russell, Bertrand, 8
Russian iconic art, 4
Ruth (Biblical character), 76, 89

Sachar, Chaim (fictional), 15, 16, 18
Sarah (Biblical Matriarch), 17, 88–9
Saul, King of Israel, 103
Shabbtai Zevi, 90
Shapira, Joseph (fictional), 54, 88
Sheba, Queen of, 58
Shechem (Biblical character), 97
Shmeruk, Chone, 4
Shmuel (fictional), 13
Shosha (fictional), 12, 38, 64–5, 66, 69–70, 71,
    89
*shtetl*, Jewish
    Bashevis-Singer's works, 2, 6
      *Enemies, A Love Story*, 12
      *The Family Moskat*, 12–13
      "Gimpel the Fool", 13, 23
      "The Little Shoemakers", 13, 23–7, 33–5, 72
      *The Magician of Lublin*, 12
      *The Old Man*, 15–18, 20–1, 22–3
      "Sam Palka and David Vishkover", 13,
        57–9, 62
      *Shosha*, 12, 66, 68
      "The Son from America", 13, 23
    Chagall's works, 2, 6, 12, 55
      *Between Darkness and Light*, 67, 68, 70
      *The Blue House*, 27–9, 33–5
      *The Cattle Dealer*, 18–23
      *The Dead Man*, 13–14
      *The Falling Angel*, 76–7, 80, 81
      *The Father*, 14
      *Fire in the Town*, 73
      *The Gray House*, 29–30
      *The Green Fiddler*, 15
      *A Jew Sniffing Tobacco*, 14
      *Lovers over the Town*, 60
      *My Village*, 32–3
      *The Newspaper Vendor*, 14
      *Over Vitebsk*, 14–15
      *Red Roofs*, 15
      *The Revolution*, 73
      *Self-portrait with Seven Fingers*, 51
      *Solitude*, 14
      *Souvenir*, 32
      *Study for Rain*, 31
      *View of Vitebsk*, 14
      *Village Street*, 31
      *Vitebsk*, 32
      *War*, 73
      *The Window*, 14
Shuster, Abba (fictional), 23, 24–5, 26–7, 34,
    35, 72
Simeon, Hadassah Medical Centre stained-glass
    windows, 97, 105
Singer, Joshua, 3
Slonim, Betty (fictional), 38, 65, 66, 69, 71
Solomon, King, 58
Soutine, Chaim, 85

Spinoza, Baruch, 39
Stalin, Joseph, 66
Suprematism, 5
Surrealism, 5
  Bashevis-Singer's works
    *The Magician of Lublin*, 46, 47
  Chagall's works
    *Birthday*, 56
    *The Cattle Dealer*, 18, 20, 22
    *Self-portrait with Seven Fingers*, 47
Sutzkever, Abraham, 10*n*, 15
Sweeney, James Johnson, 36*n*

*Talmud*, 2, 99, 108*n*
  Bashevis-Singer's works, 17, 47
Tamara (fictional), 74, 75, 76, 81
*Torah*
  Bashevis-Singer's works, 83
    *Enemies, A Love Story*, 81
    *The Magician of Lublin*, 47
    "The Old Man", 21
    *The Slave*, 87, 88, 89
  Chagall's works, 83
    *The Falling Angel*, 76, 77, 78–9, 80, 81
    Hadassah Medical Centre stained-glass
      windows, 97, 100
    *Red Roofs*, 15
    *The Revolution*, 73
    *Solitude*, 14
  influence on Bashevis-Singer, 2
*The Trial* (Kafka), 8

Vagas Gibbons, Frances, 70*n*
Verdet, André, 5, 108*n*
Villon, Jacques, 92
Vishkover, David (fictional), 57, 58–9, 62, 63
Vitebsk, *plate 3*
  *Between Darkness and Light*, 67, 68, 69

*The Blue House*, 20, 27–9, *28*, 30, 32, 33–5
*The Falling Angel*, 77
*The Gray House*, 29–30, *30*, 32
*Lovers over the Town*, 60, 62
*A Ma Femme*, 56–7
*Over Vitebsk*, 14–15
*Red Roofs*, 15
*Self-portrait with Seven Fingers*, 49–50, 51, 52
*View of Vitebsk*, 14
*Vitebsk*, 32, *32*

Wanda-Sarah (fictional), 55, 86, 87, 88–90,
  105
Welch, Felix, 7
Whitehead, Alfred, 9
windows motif (Chagall)
  *Village Street*, 31
  *The Blue House*, 28
  *The Gray House*, 30
  *My Village*, 32
  *Souvenir*, 32
  *Study for Rain*, 31
  *The Window*, 14
Wirth-Nesher, Hana, 70*n*
Wisse, Ruth R., 53*n*
Wolkenfeld, J.S., 53*n*
Wullschlager, Jackie, 36*n*

Yadwiga (fictional), 12, 74, 75–6, 80, 81, 89
Yohanan, Rabbi, 99
Yppe (fictional), 66
Zamir, Israel, 4, 9, 10*n*
Zebulun, Hadassah Medical Centre stained-glass
  windows, 99–100, 105, 106
Zeftel (fictional), 42, 44, 46, 54
Zeitlin, Aaron, 3–4, 9, 11*n*, 83
Zelig (fictional), 65
Zvanseva Art School, 4